To the memory of Okwui Enwezor. May the generation
he trained and inspired do justice to his immense
curatorial legacy and also to his grace.

Waiting for Omar Gatlato:
A Survey of Contemporary Art from Algeria and Its Diaspora

Edited by
Natasha Marie Llorens

The Miriam and Ira D. Wallach Art Gallery,
Columbia University in the City of New York

MIRIAM AND IRA D.
WALLACH ART GALLERY
COLUMBIA UNIVERSITY IN THE CITY OF NEW YORK

Sternberg Press

This publication is issued in conjunction with the exhibition "Waiting for Omar Gatlato," curated by Natasha Marie Llorens and organized by the Miriam and Ira D. Wallach Art Gallery, Columbia University in the City of New York, October 26, 2019–March 15, 2020. wallach.columbia.edu

The exhibition and publication have been made possible through an endowment established by Miriam and Ira D. Wallach. Additional support is provided by the Andy Warhol Foundation for the Visual Arts and Etant Donnés Contemporary Art, a program developed by FACE Foundation and the Cultural Services of the French Embassy in the United States, with lead funding from the French Ministry of Culture and Institut Français–Paris, the Florence Gould Foundation, The Ford Foundation, the Helen Frankenthaler Foundation, Chanel USA, the ADAGP, and the CPGA.

Design by Eider Corral Set in Basis Grotesque & Basis Grotesque Mono Printed on Colorplan 350 gsm with Damask embossing (cover), Munken Lynx 120 gsm and CreatorVol 135 gsm in Spain by Agpograf

Distributed by The MIT Press, Art Data, and Les presses du réel

Library of Congress Control Number: 2019944297

ISBN 978-1-884919-35-0

The Andy Warhol Foundation for the Visual Arts

CULTURAL SERVICES
FRENCH EMBASSY
IN THE UNITED STATES

@dagp
For artists' rights

TABLE OF CONTENTS

Preface
Alexander Alberro

"Waiting for Omar Gatlato," the first major survey in the United States of contemporary art by artists from Algeria and its diaspora, responds to the imperative to attend to the cultural specificity of postcolonial national contexts. The infrastructure of contemporary art has expanded globally over the past three decades, and Algeria is poised to play a key role in this newly widespread matrix. Accordingly, meticulous research and fieldwork, such as that conducted in the preparation of "Waiting for Omar Gatlato," have become crucial to any attempt to understand not only the diverse histories of form operating within these localities, including the manner in which North African countries have mediated their histories and developed their own critical value systems, but also the ways in which the diversity of these countries has met with the homogenizing tendencies of globalization.

Curated by Natasha Marie Llorens, "Waiting for Omar Gatlato" is the product of years of study and an immersion of languages, films, exhibitions, literature, and numerous studio visits with both established and emerging artists in Algeria and its European diaspora. The exhibition aims to present what is distinct about these contexts, while contributing to a multipolar narrative of contemporary art that takes into account various kinds of art practices flourishing in parallel to the official art world of powerful galleries, museums, and mega-events such as biennials and art fairs sanctioned by the international art market. By foregrounding the differences and historical specificity of local cultures, and by acknowledging the effects that working and living abroad have on artists, contemporary art audiences can better comprehend not only what distinguishes these cultures but also what they share with broader narratives of global art history.

The invaluable catalogue that accompanies "Waiting for Omar Gatlato" translates into English the writings of several key Algerian figures, including Nadira Laggoune-Aklouche and Daho Djerbal, and provides an important resource for anglophone scholars of contemporary art to expand their knowledge of North African culture. Although the volume doesn't claim to be definitive, it reflects on the aesthetic forms, institutions, and values that generate Algerian art and culture, tracking key traditions and conventions that continue to inform their production, as well as some of the ways it intersects with the global register of the contemporary. At the same time, the volume recognizes that not all artists of the Algerian diaspora identify immediately or simply as Algerian artists, which is crucial particularly given the history of Algeria's colonial relationship with France. The publication also functions as a platform for the voices of some of the many women who have played a significant role in the development of contemporary art in Algeria. Both the exhibition and its accompanying catalogue bring together the texture and nuance of Algeria's unique visual languages and those aspects of aesthetics that the nation's art history shares with other cultures.

Alexander Alberro
Professor of Art History, Barnard College and Columbia University

Risking the Perception of Poetics:
An Introduction

Natasha
Marie Llorens

"Thinking thought usually amounts to withdrawing into a dimensionless place in which the idea of thought alone persists. But thought in reality spaces itself out into the world. It informs the imaginary of peoples, their varied poetics, which it then transforms, meaning, in them its risk becomes realized."
— Édouard Glissant, *Poetics of Relation*[1]

I was at a party, a small gathering, in the Sacré Coeur neighborhood of Algiers late one evening in March 2016. Djalila Kadi-Hanifi, an author and professor of mathematics, handed me a book bound in thick white paper stock that had been very simply printed in 1979. *En attendant Omar Gatlato* (Waiting for Omar Gatlato), price 25 dinars, written and edited by Wassyla Tamzali. It is an early sourcebook on Algerian experimental cinema, focusing roughly on the period from the end of the 1960s through the late 1970s. Stills from a handful of films, shooting notes, production documentation, and interviews with individual filmmakers make up the bulk of the volume. It aims to constitute the existence of Algerian cinema despite the challenges of everyday life and the struggle to establish infrastructures for culture after the war.

 En attendant Omar Gatlato posits that in the mid-1970s, the filmic representation of the Algerian everyman replaced heroic and mythologizing war movies. "Today we must leave the common ground of 'film born in the flames' (films that rise out of and are devoted to the War of Liberation) in order to support filmmakers, to take part in their efforts," Tamzali writes in the book's preface. She identifies the transition, and then articulates the responsibility it imposes on its public: "We must let go of the astonishment, of the indulgent joy in the existence of film in Algeria. We must analyze Algerian films in order to measure the road already traveled and that which remains to be traveled."[2]

 En attendant Omar Gatlato expresses the exceptionalism of the 1970s in the country, which historian James McDougall describes as the era of a "new, young and profoundly transformed Algeria."[3] The book, an excerpt of which has been translated and is included in this volume, takes its framing metaphor from Merzak Allouache's film *Omar Gatlato*, an extraordinary cinematic portrait of Algerian youth released in 1976, fourteen years after the end of the War of Liberation. For Tamzali, *Omar Gatlato* was not only paradigmatic of a period saturated with the claim for subjective emancipation, it inaugurated an awareness of that freedom: "Now we know. We were waiting for *Omar Gatlato*. Merzak Allouache clasps the old mummy that film had become, and plunges Algerian cinema into a pool of tenderness and rebellion."[4]

 "Waiting for Omar Gatlato" is an exhibition conceived in response to Tamzali's insight and to the film of which that insight is born. This layering of thought has provided a curatorial framework ambivalent enough to encompass a survey of artworks by artists from Algeria and its diaspora in Europe. It also allows for a full acknowledgment of the impossibility, both political and aesthetic, of representing an artistic context that is at odds with its own national

1 Édouard Glissant, *Poetics of Relation*, trans. Betsy Wing (Ann Arbor: University of Michigan Press, 2010), 1.

2 Wassyla Tamzali, "Eloge au cineastes, " in *En attendant Omar Gatlato: regards sur le cinéma algérien* (Algiers: En. A.P., 1979) n.p. Translation mine.

3 James McDougall, "Culture as War by Other Means: Community, Conflict and Cultural Revolution, 1967–81," in *Algeria Revisited: History, Culture and Identity*, ed. Rabah Aissaoui and Claire Eldridge (London: Bloomsbury Academic, 2018), 243.

4 Wassyla Tamzali, "The Birth of a Cinematographer: Merzak Allouache's *Omar Gatlato*," page 27 in this volume.

5 Émilie Goudal, "Frantz Fanon, an Icon? Thoughts to See: Fanon's Algeria in the Visual Arts," page 104 in this volume.

6 Benjamin Stora, *La gangrène et l'oubli: La mémoire de la guerre d'álgérie* (Paris: La Découverte, 1991), and Benjamin Stora, *La guerre invisible: Algérie, années 90* (Paris: Presses de Sciences Po, 2001). The War of Liberation was waged primarily between the Front de Libération Nationale (FLN) and the French military between 1954 and 1962, ending with the signing of the Evian Accords. For a canonical account of this conflict see Alistair Horne, *A Savage War of Peace: Algeria, 1954–1962* (New York: New York Review Books, 2006). The Black Decade, which is the preferred term in Algeria, rather than the Algerian civil war, was an armed conflict between an FLN-backed single party government and various Islamic militias which began in 1991 and continued at various intensities through the early 2000s. See Martin Evans and John Phillips, *Algeria: Anger of the Dispossessed* (New Haven, CT: Yale University Press, 2007). For an in-depth study of this conflict, see Luis Martínez, *The Algerian Civil War, 1990–1998* (New York: Columbia University Press / Centre d'études et de recherches internationales, 2000).

mythology. *Waiting for Omar Gatlato* is also the title of this volume, which anthologizes new translations of texts that flesh out the complexity of the Algerian and Franco-Algerian artistic contexts. Both the exhibition and this volume respond to the impossibility of representing Algeria with the conviction that is necessary to face the task as an impossibility and to act in spite of that fact. Why? Because the attempt at perception across difference is the ground for politics, here defined as a contestation of how power is organized. Without resolving any of the contradictions involved in such an attempt, "Waiting for Omar Gatlato" proposes that the decolonization of art requires an effort to perceive Algeria and places with similar histories of liberation. Émilie Goudal has referred to a similar idea in her essay in this volume as the effort to think "visuality in Algeria through the prism of an *aesthesis* of emancipation."[5] The curatorial responsibility entailed by such a notion means directing resources, organizing exhibitions and printed matter, and drawing public attention to artwork related to postcolonial contexts, of which Algeria is an example, and especially to artists and their work that respond with subtlety and sociocultural sensitivity to the contradictions that structure it.

Waiting for Omar Gatlato is a cacophonous project, intuitively pursued, and based on relationships. Guided by an imperative to privilege long discussions with artists and writers over the presentation of any single authored idea about Algeria or its diaspora, it is presented without absolute justification. Rather than tie the selected artworks together into a unified picture with the authority of the curatorial text, an open-ended analysis of every artist's work is included in this volume. These texts are conceived as an extension of the curatorial framework in the sense that they constitute a record of what I have been able to perceive through discussion and negotiation with each artist. They follow the epigraph's imperative to *space thinking out in the world*, in Glissant's sense. They honor the artists' varied poetics and the risk of thought that is realized in each artwork.

To make decolonial exhibitions is, necessarily, an exercise in trying to unknow the order of the world. This means avowing the impossibility of providing a coherent vision of the effect Algeria has on the imaginations of artists who belong to it. I urge readers and viewers to relinquish their desire to know, in order to find some other mode of encounter with the art and writing presented.

*

Waiting for Omar Gatlato responds specifically to the visual and imaginative obscurity that blankets Algeria, a phenomenon that historian Benjamin Stora has linked to collective amnesia born of trauma in his work on the both the War of Liberation and the Black Decade.[6] The reasons for Algeria's lack of artistic representation at the international level, even in comparison to its Maghrebi neighbor Morocco, are complex: 130 years of settler colonialism by the French engendered both a robust literary and artistic legacy in its

own image and, simultaneously, a strong rejection of that legacy by postcolonial authors such as Kateb Yacine and by artists such as Mohammed Khadda. As a result of an unrelenting yet ambivalent struggle for self-determination at every level of the sociocultural sphere, no digestible, unified narrative has emerged for the West to read Algeria.

Further contributing to this obscurity is the fact that cultural production across all sectors—in fact much of public life in Algeria— came to grinding halt in the 1990s during the Black Decade. In December 1991, the ruling government canceled national elections when it became clear that the Islamic Salvation Front (FIS) would carry the popular vote. In the aftermath of this decision, the military took over the government, banning the FIS and arresting its members, but a violent Islamist coalition movement emerged in its place. The various groups that comprised this movement targeted journalists, theater producers, writers, artists, and professors specifically, but they also massacred entire villages. Unveiled and professional women were shot in public, and tens of thousands of people thought to be collaborating with either the military or the militias were disappeared. Because it was often a case of violence perpetrated between neighbors, people who knew one another, the effects of the conflict chilled all forms of shared experience. People stayed home, locked themselves into the space of the family behind reinforced metal doors. The infrastructures for cinema, music, and art atrophied.

Artists, journalists, and intellectuals responded to the threat against them in various ways, but many left Algeria. This exodus and its repercussions on artists' lives and professional trajectories is part of the reason the diaspora remains important to a nuanced understanding of artistic production in Algeria, but it is not the only reason. Fifteen years after the end of the conflict, in 2004, there is still a systematic disinvestment on the part of the Algerian cultural ministry, especially with regard to the visual arts and film, which is due in part to a lingering fear of artistic expression as a vector for sociopolitical destabilization in a country that has experienced enough of violent conflict on ideological grounds. The government's neglect of the arts not only affects the opportunity to exhibit within Algeria, it also impacts the intellectual infrastructure for critical debate about the function and value of art. There are very few dedicated art critics, no pedagogical structures to train curators or art writers, apart from independent initiatives such as Aria, a residency and professional development organization in Algiers founded by Yasmina Reggad and Zineb Sedira, and the more free-form Rhizome Culture, cofounded by Myriam Amroun and Khaled Bouzidi in 2017, which is described in more depth by Bouzidi in the final pages of this volume.

The ground of political contestation is moving, nevertheless. On March 11, 2019, Algerian president Abdelaziz Bouteflika dropped his bid for a fifth term, and citizens filled the Place Audin in the center of Algiers, the colonial orientalist portico of the Grande Poste, and other major urban intersections, such as Martyr's Square and May 1st

7 Sky News Arabia is an Arabic news channel broadcasting 24/7 to audiences in the Middle East and North Africa. It is a joint venture between UK-based Sky and Abu Dhabi Media.

Square. A reporter for Sky News Arabia stood on the sidewalk near Place Audin with a microphone, narrating the events behind her in Modern Standard Arabic, speaking of demonstrators' happiness at Bouteflika's decision not to run.[7] A man stepped into the frame, was held back, pushed into the frame again—not aggressive, but firm. The reporter passed the microphone to him and he explained, Algerians are not happy, the people want the government to change, not simply its figurehead. As he was speaking, she repeated the same word over and over, "Arabia, Arabia, Arabia..." She wanted the man to speak in Fusha or Modern Standard, so that people throughout the Arab world would understand his objection. He responded with a frustrated wave of his hand, "I don't know Arabia, we speak Derija here!" Derija is a local dialect of Arabic shot through with French, Spanish, words from Imazighn dialects, and is spoken with shortened vowels. In fact, Derija is a different amalgam of languages in Oran, in Annaba, and in Algiers, further complicating any claim to linguistic hegemony.

Within minutes, the clip was shared thousands of times on social media, appreciated for the tenuous relationship its point about language illustrates between Algeria and the rest of the so-called Arab world—nearly sixty years after the War of Liberation, Algeria maintains its sense of singularity. The specificity of its long, intimate colonial relationship to France and the significance of its non-Arab, Muslim Berber minority in political discourse and cultural life are just two factors contributing to this exceptionalism. *Waiting for Omar Gatlato* takes this claim for Algeria's national exceptionalism seriously, in part because it is one of the factors in the country's exceptional imaginative obscurity. Without essentializing artists who live in Algeria or in its diaspora, the project takes its singularity as an important structuring condition of Algeria's effect on cultural production.

*

The exhibition began to take shape in the spring of 2016, long before the mass protests that started on February 22, 2019, filling every intersection of downtown Algiers. It is conceived in response to something I felt at that time: that there is a new, young, and profoundly transformed Algeria today that includes artists and filmmakers, graphic designers and photographers, living between Marseille and Mascara, Paris and Algiers. Fanny Gillet describes these people in her essay in this volume; in brief, they are a composite generation. Some lived through the Black Decade as children, and have emerged from it with an incredible will to see their country reanimated, its spaces of public discourse reactivated. Some were born into its aftermath and have reached adulthood without fear of the extremism that obstructed the energy and creativity of their elders. The previous generations studied in the USSR and the United States, choosing to live and study on one side or the other of a stark division of the world, but the emerging generation studies in London, Istanbul, Beirut, Aix-en-Provence, Brussels, Paris—or

they study in Algiers, while traveling to Hong Kong, Abu Dhabi, or Alicante for artist residencies. In other words, they breach any dyadic relationship to empire.

Nadira Laggoune-Aklouche, curator and director of the National Public Museum of Modern and Contemporary Art (MAMA) describes this generational notion as one that "provokes people's awareness, allowing society to take stock of its own potential, to situate itself in its own era and everyday context, connected to its origins, its reality, its present and future."[8] This is the Algeria of Picturie générale, three large-scale exhibitions of contemporary art, largely organized by Mourad Krinah and jointly initiated with Djamel Agagnia and Sofiane Zouggar in 2013 at Artissimo, in 2014 at La Bagnoire, and in 2016 at Volta, all in Algiers. Picturie générale is widely recognized as a phenomenon that made an artistic counter-current visible both in Algiers and internationally, one built by artists without asking for permission or official support.

Picturie générale is symptomatic of the broader claim for visibility and an appropriation of public space by artists that has been growing for years. It emerged from an artist's collective called Box24, founded in December 2008 and named after a room in the École supérieure des beaux-arts d'Alger that a group of students had taken over as a project space. Soon to open a new venue in downtown Algiers, Box24 is run today by Walid Aïdoud as a residency and project space. A strong pedagogical engagement and a commitment to working collectively runs through these kinds of initiatives in Algeria, which is partly the result of a society that has been governed by socialist principles for decades. Rather than stay in the center of Algiers among a small group of artists, for example, since 2009 Box24 has partnered with cultural organizations in the Western Sahara to create the ARTifariti festival, which has launched an open call to make work and teach art in the Western Sahara resettlement camps in solidarity with the Sahrawi people's struggle for sovereignty.[9]

Writing in 1961, in the essay "On National Culture," included in The Wretched of the Earth, Frantz Fanon argues that "the native intellectual who wishes to create an authentic work of art must realize that the truths of a nation are in the first place its realities. He must go on until he has found the seething pot out of which the learning of the future will emerge."[10] This generation of artists who belong to Algeria, like the characters depicted in Omar Gatlato, are ready to follow Fanon's injunction. They have let go of the astonishment and the indulgent joy that Algeria and its artists exist, in a basic sense.

*

When I asked curator Zahia Rahmani to consider contributing to this book on the basis of her own remarkable curatorial achievements in the field of Algerian histories of representation, she responded that perhaps the best thing would be to make an exhibition about the impossibility of Algerian art. Rahmani believed that this project's

8 Nadira Laggoune-Aklouche, "L'art, ici et maintenant," in the exhibition catalogue for Picturie générale II, held at La Bagnoire, Algiers, March 2014 (Algiers: Barzakh, 2014), n.p. Translation mine.

9 I am grateful to Walid Aïdoud for laying out the relationships between these structures, and though the collectivity of these endeavors is paramount to their impact, it must also be said that they exist because of his commitment to them.

10 Frantz Fanon, The Wretched of the Earth, trans. Constance Farrington (London: Penguin Classics, 2001), 224.

11 Glissant, *Poetics of Relation*, 151.

12 It has been pointed out to me, however, that in Algeria there is a concentration of artists in Algiers and that very little curatorial work has been done to date that reaches beyond the capital's networks. While I have made some effort to decentralize "Waiting for Omar Gatlato" in this respect, this effort should not be considered sufficient.

mandate, as I articulated it to her at the time, would inevitably lead to the symbolic recognition of a state system that should not be considered synonymous with the cultural production of the inhabitants of its territory, and even less that of its diaspora. Though I could not convince her to elaborate on this point, it has profoundly marked the shape both the exhibition and this accompanying book have taken since. I shared her unease at the thought of tethering artistic production to any single nation, and to Algerian nationalism in particular. Having spent a good deal of time in Algeria, and having debated this point at length with both the artists included in the show and those from an older generation, such as Denis Martinez, I acknowledge the difference between artwork made in Algeria by people who were trained and live there, and that produced in relation to Algeria by artists living and working in France. The formatting of artists, as Martinez would say, is different in each national context, as are the stakes of making art and even of identifying as an artist.

Yet those living in the diaspora are intimately connected to Algeria formally and culturally, so to exclude them would be to present a reductive and politically naive understanding of cultural legitimacy in relation to artistic practice. It is possible to be inhabited by a place to which one's belonging is unstable. Further still, "territory is the basis for conquest," as Glissant reminds. "Territory requires that filiation be planted and legitimated. Territory is defined by its limits, and they must be expanded. A land henceforth has no limits. That is the reason it is worth defending against every form of alienation."[11] The debate about what it means to be Algerian and to reflect on the impact of the histories of Algeria on aesthetic practices occurs in many places that are not, strictly speaking, in Algeria: Kader Attia and Zico Selloum's bar and event space in Paris, La Colonie, for example, or La Compagnie, an exhibition space and experimental arts programming center run by Paul-Emmanuel Odin in the Belsunce neighborhood of Marseille for over twenty years. For this reason, a guiding principle of the exhibition's curation has been to find an (almost) even balance in the list of artists between those based in France and those based in Algeria, with a slight bias toward those in Algeria.[12]

That said, there is a tension in the exhibition with regard to the diaspora that must be openly admitted. "Waiting for Omar Gatlato" excludes a number of established artists from the diaspora, such as Mohamed Bourouissa, Adel Abdessemed, and Neïl Beloufa, among others, whose work has done much for the visibility of Algeria and its artists beyond its borders. Placing the curatorial focus elsewhere is intentional here, and is largely the result of heated debates I have participated in and witnessed with artists in Algiers and in Paris. In these conversations, people spoke to me very directly about the difference between work that is commercially successful in Europe—high-production-value artwork made to circulate within the international art world—and work made in a country with relatively poor arts infrastructure. What I understood from these exchanges was that if the intention of the proposed exhibition was to create a

non-hierarchical surface of appearance, a level playing field between artists from the diaspora and those based in Algeria, I should exclude work made by those who are routinely called upon to represent *Algérienité* to a global audience. The conditions of production, in the Marxist sense, are not considered equivalent by some, and this non-equivalence would make it impossible for work by those based in Algeria to fully appear.[13] As a feminist with some ambivalence about the reduction of value to the material conditions of production, I nevertheless saw their point.

*

The first question I was asked in almost every studio visit I conducted in relation to this project was, why are you interested in Algeria? It is a fair question; I am a white woman in soft cotton button-down shirts and bright blue sneakers. The answer is complex: I am inhabited by Algeria, a place to which I am entirely exterior, by virtue of a personal history over which I have no control. I was born in Marseille to an American mother and a *pied-noir* father, a settler colonist who immigrated to France with his family after several generations in Algeria. I was very close to my paternal grandfather, and so my earliest relationship to Algeria was constructed through his experience of exile and conditioned by his nostalgia. This nostalgia was also complex: my grandfather's best friend and my father's godfather was Jean Sénac, a poet who was fiercely militant on behalf of Algerian Independence in word and action, and remains well-respected by the country's artistic and literary community. He was murdered in 1973 by his lover, though some claim he was assassinated by agents of the Algerian government for his unrepentant homosexuality. A painting by Mohammed Khadda, to whom Sénac was close, hung opposite my childhood place at the dining-room table in my grandfather's house. As he told the story, he had bought it directly from the artist in the early 1950s because Sénac chastised him for failing to support emerging artists in Algiers.

I began the research that would eventually result in this exhibition when my grandfather was dying, and living ever more firmly in the past, in an Algeria he left in the middle of his life. He grew Algerian jasmine from a pot so that it draped over the doorway to the kitchen, its scent the first thing he encountered in the morning as he stepped onto his small terrace deep in the heartland of France. He rolled couscous by hand in a giant wooden bowl made from a single olive tree, which he never washed for fear of losing the taste of olive oil left in the wood grain. I think there is no one who touched my grandfather more deeply than Sénac, and as the years between my grandfather's exile in 1967 and his present moment stretched out, his nostalgia for the country and his grief at Sénac's death became entangled.

Perhaps because of the research I had just embarked upon, perhaps because I had always been fascinated by the open, raw quality of his longing for the Algeria in which he and the poet were young, or perhaps because he sensed some similarity between

13 A number of people have pointed out that the reverse is also true: that it benefits artists with fewer resources to show with artists whose reputations are already international; it opens doors, creates more context for their work, and increases their visibility. I let the contradiction stand, hopefully to provoke a more engaged and rigorous debate on whether international visibility produces better artwork or better commodities, or something in between.

myself and Sénac, I became the one to whom he spoke about his loss. I am interested in Algeria first because I am astounded by that loss, by its force, and by its seeming non-relation to the historical record of brutal exploitation by colonial settlers of nearly everyone else in the country.

 Waiting for Omar Gatlato is then founded on a question first formulated in relation to my grandfather's perspective on Algeria: Did he and others in his position ever perceive the country they developed such elaborate nostalgia for and with which they thought themselves so intimately involved? This question has evolved into one concerned with the structure of decolonial perception: Can a viewer in New York City in 2019 perceive the effect Algeria has on art and on artists, and through this perception, encounter difference? I don't mean ethno-cultural difference, but rather a difference in the role of art and in an understanding of its function in a society that is, at least in part, structured according to an African horizon of experience and thought.

Natasha Marie Llorens
 Born in 1983 in Marseille.
 Lives and works between Marseille and New York.

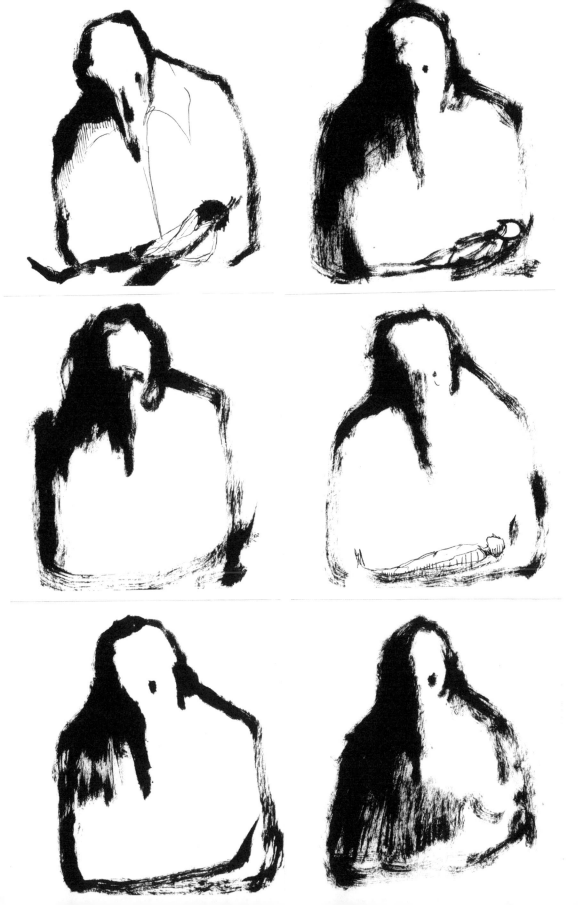

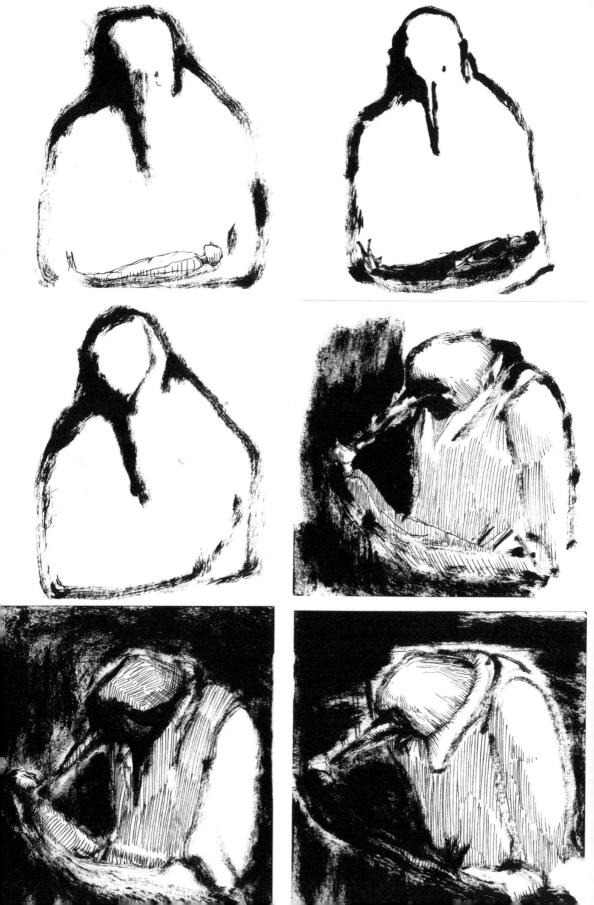

The Birth of a Cinematographer: Merzak Allouache's Omar Gatlato

Wassyla Tamzali

TRANSLATED BY OLIVIA CUSTER

We often wondered what we were waiting for as we paced back and forth in front of the cinematheque, or wandered through festivals abroad. As time went by, it seemed more and more as though cinema was slipping through our fingers.

Now we know. We were waiting for *Omar Gatlato*. Merzak Allouache clasps the old mummy that film had become, and plunges Algerian cinema into a pool of tenderness and rebellion. With this film, the "worthless old lady" suddenly realizes that she had remained, or was held, at a distance from life; rebelling against this, cinema dives into this life with true pleasure. To write his script, Allouache went to the streets of Algiers and, by dint of friendly curiosity, returned with a dark and tender portrait of the youth from the big housing estates, those who play at being men to keep their loneliness at bay.

Men's Loneliness

In the gang his nickname is "Omar Gatlato," the one who is killed by his own virility because his specialty is, so to say, being a man. He is the one to walk Cocomanie home at night, and it is he who refuses to back down in front of the Béni Hariens, the gang of tramps that pilfers the casbah at night. He is the one called on to chase away those who have come from other neighborhoods to pick up girls, prowling the grounds of the housing estate. Omar is the man of the group. He is already the man in his family; the war killed his father, leaving him no choice. This young man, who is barely a man, provides the food for his brothers and sisters, his mother and grandfather, and also for his elder sister, who has been "sent home" with all her children. He has little interaction with this family that is piled into a two-room apartment. The only sequence in the film that features a moment of family life shows a meal shared with the uncle, a former *moudjahed* who tries, in vain, to interest Omar in his exploits. The scene reveals the paucity of exchanges between members of this family.

Omar's refuge is his gang of friends and *chaabi* music. In the group he finds the emotional life he does not have elsewhere, and in music and poetry he finds an escape from boredom, from the overcrowding of kids in the room, their urine, the violence of people in the street as depicted in the masterful scene on the bus, where a passenger who has run out of arguments says "even dogs learn."

A mini tape recorder in hand, he goes to weddings, films, and shows and tapes the songs. Those cassettes, and the recorder that he never puts down, are his treasure, which he keeps locked up above his bed. This is what the Béni Hariens steal from him on the night of the fight, this loss adding to the despair of having had to surrender. The neighborhood is, however, extremely resourceful. Moh Smina, his friend from the EGA, who knows all the tricks, finds him a recorder on the black market, with a tape to boot. On the tape is the voice of a young woman confessing her loneliness. For the young man, her voice reveals a world of dreams and tenderness of which he has so far been deprived. From then on, he has only one desire—to see her. Football, sports betting, hanging out with friends—nothing

feels the same any more. Under the watchful, worried eyes of the group, he calls Moh Smina to get the name of the young woman who speaks of red flowers on her bedroom's wallpaper. When he manages to set a date for an evening with Selma, he hits all the bars in town. This is not a scene of banal drunkenness but rather a rite, an initiation. Unfortunately, he does not pass the final test. Encouraged by Moh he shows up wearing his best suit at the exit of the EGA offices. The young lady comes out and waits, anxious. It transpires that Omar is unable to cross the sidewalk; he cannot join her. Some form of impotence prevents him from crossing the street and putting out his hand. The rest of the group looks on, the boys yell at him to stay with them. On screen, the faces distorted by the lens figure this masculine society that feeds on its members and does not want to allow any of them to escape.

Omar was totally unprepared to go meet this woman. How could he have acquired a sentimental education in a society based on sexual segregation, where his superiority over women was instilled in him from an early age? In his cultural deprivation, in his poverty, he inflames these ideas and makes an ethic out of them. Men's loneliness is born of this contempt for women.

A Culture of Poverty

However *Omar Gatlato*, not simply a dramaturgy of the daily life of a boy in the casbah of 1970s Algiers, introduces us to richer and more complex facts than those born of the protagonists' psychological characteristics. The film goes beyond these particular circumstances to lead viewers to broader interpretations. With a great tenderness for his characters, Allouache depicts how, and why, they wander around alone in the city on a Sunday morning, waiting for Sunday afternoon, finding some release for their vitality only in football matches, our prosaic Roman circus.

One of the most important sequences in the film is the one in which the young men go to a show where a chaabi singer is expected. In the first part of the show, there is a play in which characters in period costume recite a text, in classical Arabic, about the loneliness of a king who wants to seduce a very young princess, under the envious eye of the vizier. It becomes ridiculous. The audience protests. A young man gets up and dances on the benches to the tune of an agrarian revolution song. Allouache goes further still: he does not settle for showing that popular culture is different from (opposed to) official culture. He brings in a mime, who starts his act with brio and sensitivity. Spectators quickly interrupt him with shouts of "Stop it, you tramp!," showing that popular culture is not only marginal to official culture, it is also the culture of poverty. The chaabi music acts more like a drug than a means of expression.

The Relation between Political Discourse and Social Practice

The second important insight the film provides is one into the relation between the dominant political discourse and social practice. The film was shot during the debate about the National Charter; at the office, the group are seen reading the sports pages of the

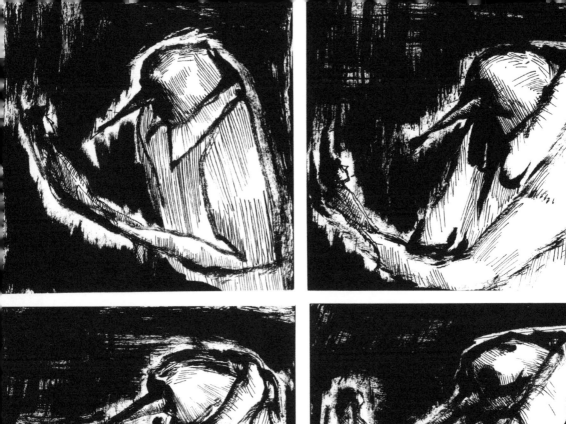

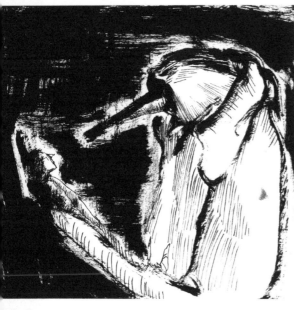

newspaper, turning their backs on this national debate. Their daily practice is a counter-discourse to the political discourse of power.

The film's other sociological concern is the relation between family and individuals. The family that Allouache describes are typical in those neighborhoods. We see them living in unbearable, crammed apartments. Omar shares a bed with his sister who is, as he puts it, "almost a woman now, it's not right," yet at the same time they exist in silent estrangement. None of the family members communicate with one another. The grandfather takes refuge in the dark, in the kitchen. "There are too many children here," he says to Omar, countering the affection grandfathers traditionally have for their grandchildren. The children wander alone, an empty bottle at their lips, a chamber pot in their hands. The three women of the house gather silently in front of the television, which, though a powerful grouping mechanism for the family, is devoid of any "sociability"; they stay there until they are overcome by sleep. They are together, on top of each other, some eating up others' lives (and not just figuratively, since the kids also eat Omar's tapes!) but no one talks, no one gets to really know any of the others. Incredibly, Omar moves through the house without ever running into anyone. It is clear why his friendship group is so important.

The Gang: A World with Its Moral and Honor Codes

The gang is a closed world that develops its own language, honor code, and morality outside of society's rules. Omar and his friends work to repress fraud, but buy their jeans on the black market. In fact, they do not seem very convinced by their "mission." We see Omar let a woman who was illegally selling jewelry go free. Does she realize she looks like his mother? And it is on the black market that he finds his tape recorder.

These young people also become aware of a sort of inevitability, of social determinism. Cocomanie, who manages his sound system so well, could have been an engineer, "if he had been lucky! But in fact... despite being so intelligent, he's a typist!" Of course, there is advancement, promotions, like the colleague who cannot pull himself away from his files—"poor guy," says Omar. It seems he is no role model. There might be a solution to change society, the debate on the National Charter that brushes by them could be one way, but one would have to believe in it, and look beyond one's daily problems. One would have to, for instance, stop watching that closed apartment in the hopes of being assigned it by the "vacant homes" authorities... And all that is easy to say when one already has a place to live.

Omar Gatlato is so important because it is the first Algerian film to paint a portrait of the popular culture that belongs to a significant part of the country's big city populations. Moving beyond the specificity of Algiers, its talk, its music, and so on, we find characteristic traits of the culture of poverty that predominates in underdeveloped countries. To wit, the absence of family traditions, the violence of interpersonal relations, the precariousness of life, the lack of integration into the rest of society.

Form and Content Are Intimately Linked

Form is closely linked to content and it is clear that, given its subject matter, this film is the first (after Mohamed Zinet's *Tahia ya Didou* [1971], to which it will often be compared) to get away from the elementary didacticism that characterizes almost all Algerian productions up until today. In *Omar Gatlato* there isn't a cursory staging of forces, some of which are held to be good, some bad. There is no triumphant ending, and Allouache intercedes at the end only very subtly. The morning after his failure, Omar looks at his mother and, for the first time, thinks she looks tired. "That's all I can do for him," explains the director, "I can't send him to the union." Consistent with this approach, and with a commendable rigor, Allouache chooses the monologue form. Before each scene, Omar addresses the audience and explains what they are about to see. For example, before the fight, he explains who the aggressors are. Again, Allouache refuses to use such an easy subject to attract and carry the viewers; instead, he prefers to invite his audience to try to understand what is going on, rather than be too taken in by the image of itself the screen reflects. I am thinking, of course, of those viewers who have been waiting for evening tickets to go on sale since eleven o'clock that morning, boys who resemble Omar Gatlato. This is also one of the reasons the director introduces some truly surreal, wacky moments—like the fish scene, or the scene in which a shopkeeper backs out of Omar's office, singing, "That is to show that this is cinema, not a documentary." At the same time, the film acts as research into popular thought, an attempt to visualize popular language. (Allouache first trialed this approach in his 1966 short film *Le Voleur* [The Thief].) It will call for new explanations. The director shows great tenderness for this youth, his youth, his city. In this, he reminds us of Zinet with *Tahia ya Didou*.

 Omar Gatlato is the first film to connect Algerian cinema to the history of cinema as it had been imagined by the Lumière brothers; that is, to film reality. It may open the way for a series of films that will address, with a critical eye, the environment in which we live.

Wassyla Tamzali
 Born in 1941 in Bejaïa, Algeria.
 Founding director of the Ateliers Sauvages,
 Center for Contemporary Art in Algiers.

Introduction: Daho Djerbal on Decolonizing Colonial History

Madeleine Dobie

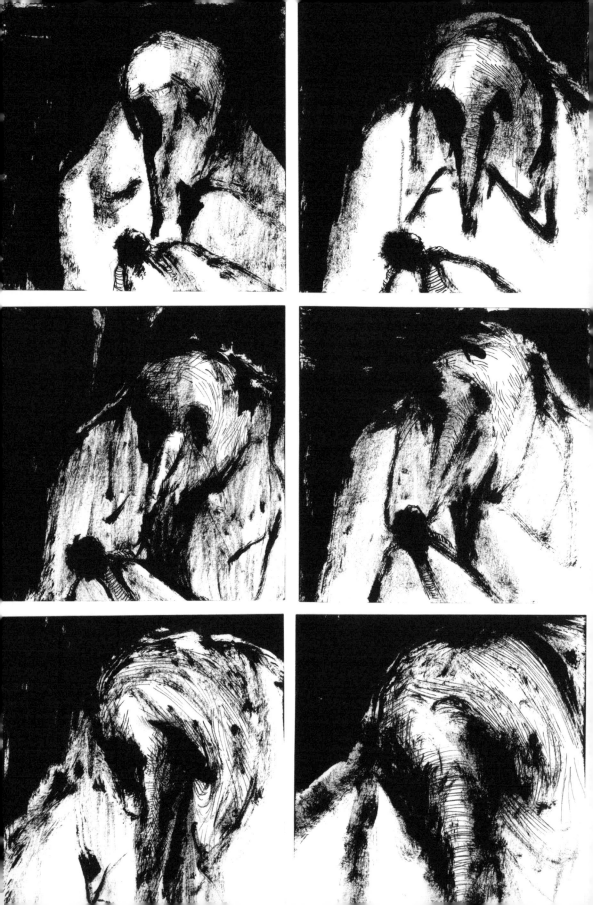

Daho Djerbal is one of Algeria's foremost historians. A member of the generation of intellectuals who came of age with Algeria's independence in 1962, Djerbal's body of work has evolved in tandem with his country's changing political realities and with the rise and fall of intellectual currents. His early work on colonial land appropriation, written against the backdrop of the socialist-inspired economic policies of President Houari Boumédiène (1965–78), was shaped by the anti-colonial and Marxist discourses of the period. But Algerian culture in the years after Independence was also still deeply marked by French influences. In an autobiographical essay, Djerbal recalls that until the 1970s, courses at the University of Algiers were largely taught by French faculty and organized around French history and literature.[1] This began to change in the 1970s, when the history and social science curricula were arabicized, and Djerbal, like other scholars who had been educated in French colonial schools, had to retrain so that he could lecture in the national language. Nonetheless, French concepts and theoretical models continued to play an important role in Algerian intellectual life. Much of Djerbal's later work has explored this intellectual hegemony and advocated for the decolonization of knowledge production. This is notably true of the bilingual and multidisciplinary journal *Naqd* (Critique), which he launched in 1991, and which has become one of the Maghreb's leading forums for new research in the social sciences. Over the past two decades, *Naqd* has gradually expanded its scope to encompass the breadth of questions and modes of thought produced in the Global South, understood, in Djerbal's words, "not as a geographical region but as a new field of thought."[2]

The short essay reproduced here grapples with the challenges involved in decolonizing colonial history.[3] It begins with the observation that writing the history of French colonialism in Algeria is not the same thing as writing the history of colonized Algerians, though historians have often conflated the two undertakings. Djerbal presents the challenge of writing the history of a (de)colonized society as a variant of the problem of colonial "alienation," or seeing oneself through the eyes of a more powerful other, described by Frantz Fanon.[4] To write Algerian history within the parameters established for French history, to operate exclusively within the "Western semantic field," Djerbal writes, is necessarily to ignore many dimensions of Algerian social, cultural, religious, and political experience. To avoid these distortions, Algerian intellectuals must work to decolonize epistemology and construct their own narratives.

1 He wryly observes: "Decolonized Algeria continued the work that colonial France had failed to undertake. Our training was organized around three axes: literary French, philosophical French and historical French."

2 Daho Djerbal, "Le défi démocratique," *Naqd*, vol. 1, no. 29 (2012): 31.

3 The essay was first published in French under the title "De la difficile histoire d'une société (dé)-colonisée: Interférences des niveaux d'historicité et d'individualité historique," in *Historein*, vol. 10 (2011): 153–60. Some of its arguments appear in preliminary form in a conversation between Djerbal and the philosopher Seloua Luste Boulbina published as "Critique de la subalternité," *Rue Descartes*, vol. 58 (April 2007): 84–101. The English translation published in this volume appeared as "History Writing as Cultural and Political Critique, or The Difficulty of Writing the History of a (De)colonized Society," *Thinking the Postcolonial in French, Romanic Review*, vol. 104, no. 3-4 (2013): 243–51.

4 The issue of colonial alienation is raised in different forms throughout Fanon's work, from *Peau noire, masques blancs* (*Black Skin, White Masks*, 1952) to *Les damnés de la terre* (*The Wretched of the Earth*, 1961). Djerbal cites specifically a passage in *L'an V de la revolution algérienne* (*A Dying Colonialism*, 1959), a collection of journalistic writings that Fanon published during the Algerian War of Liberation.

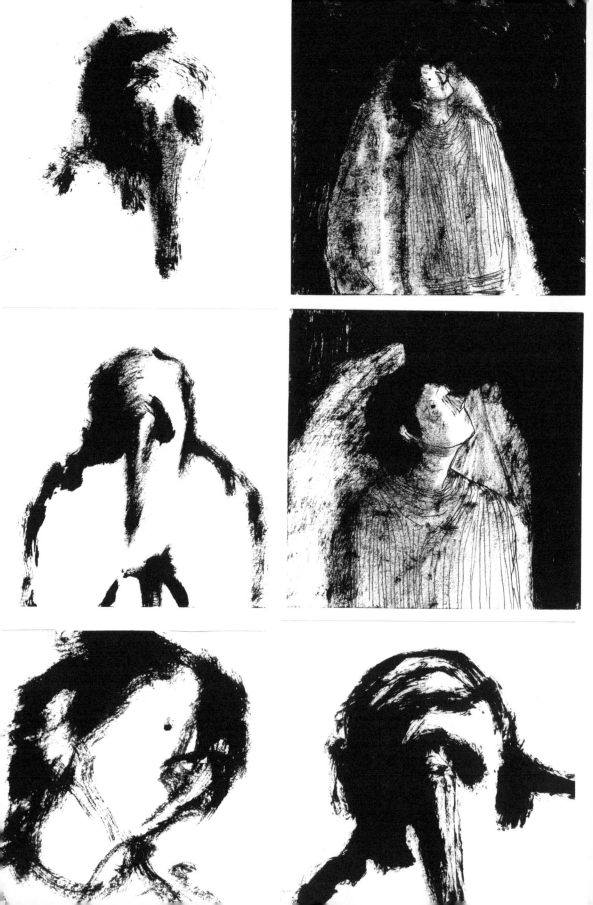

Djerbal's calls for the decolonization of history have inspired younger historians of the Maghreb to reimagine the framing of the region's history beyond the parameters furnished by French colonialism.[5] These ongoing efforts resonate with current initiatives by scholars and artists in other fields and from other world regions to decolonize the production of knowledge and culture.[6]

Madeleine Dobie
 Professor of French & Comparative Literature,
 Columbia University

5 Examples of this historiographical reframing include Isabelle Grangaud and M'hamed Oualdi, "Tout est-il colonial dans le Maghreb? Ce que les travaux des historiens modernistes peuvent apporter," *L'année du Maghreb*, vol. 10 (2014): 233–54, and Noureddine Amara, "1830. L'impossible frontière. Les écritures précaires de la possession française d'Alger. Le Djérid à l'épreuve de la nationalité algérienne," in *Penser le national au Maghreb et ailleurs*, ed. Fatma Ben Slimene and Hichem Abdessamad (Tunis: Arabesques, 2013), 89–105.

6 See for example the collective volume *Décolonisons les arts!*, ed. Leila Cukierman, Gerty Dambury, and Françoise Vergès (Paris: l'Arche, 2018).

History Writing as Cultural and Political Critique, or The Difficulty of Writing the History of a (De)Colonized Society

Daho Djerbal

TRANSLATED BY MADELEINE DOBIE

The Dividing Line of Historical Reason

At the start of my career as a researcher, I had the idea that contemporary French history was also, in a certain way, the history of colonial Algeria. With time, I realized that while there is in France a historiography of colonial France, there is no history of colonized Algeria. It cannot be said that the history of colonial conquest has created a common space if by that one means a space that is shared or divided.

A philosophical and practical dividing line bisects historical reason. This line is not merely a product of the unequal development of research. It is also a function of processes of differentiation and exclusion. To put it simply, there is just one subject who elaborates, defines, and activates the past, present, and future, who determines what must be said and preserved and what must be destroyed. This is the dominant/dominating subject. The dominated—the colonized or their heirs—remain in the shadows, in a "second college" of thought, the realm of memory. When the colonized attempt to become the subject of their own history, they become unbearable, inaudible, they terrorize. We block our ears.

Let us consider, as a point of departure, the case of the Harkis, who, in the wake of 1962, were corralled into camps in the south of France. It could be said that this was simply the physical materialization, or territorialization of what had always been, in the minds of the *Français de souche européenne* (French of European origin), and indeed of the "French of France." The Harkis were people who made a contribution to colonial France. They made sacrifices for France: they contributed to its "glorious" past. In 1962, when the *pieds-noirs* of Algeria retained their rights as French full citizens, the Harkis were classified as *Français de souche nord-africaine* (French of North African origin). The expression conveys the incomplete integration of this "auxiliary" population, in thought as well as political practice, as fully fledged French citizens.

What, then, can be said of those who fought for the independence of their country, for emancipation from colonial domination? In the best of cases, in the historiography "of the left," they are typically presented as petty local tyrants, leaders of factions, harbingers of the despotism that many formerly colonized countries—"postcolonies," to use the English terminology— experience today. If they were, at some point, subjects of their own history, then they were subjects of the history of despotism and tyranny, not of emancipation and freedom. For some French historians, the only true Algerian nationalists were the Algerian communists, European or Europeanized in their majority, for whom political "engagement" was not linked to community (the tribe) or the sacred (religion). They alone bore the standard of a supra-communitarian nation, a citizen-nation stripped of its religious sacraments, a secular and progressive or proletarian nation.

There are, I would contend, two histories: a history of colonial France with its institutions and people, and a history of Algeria with its institutions and its people. Rather than a common history and single ontological process, there are intersecting, concomitant

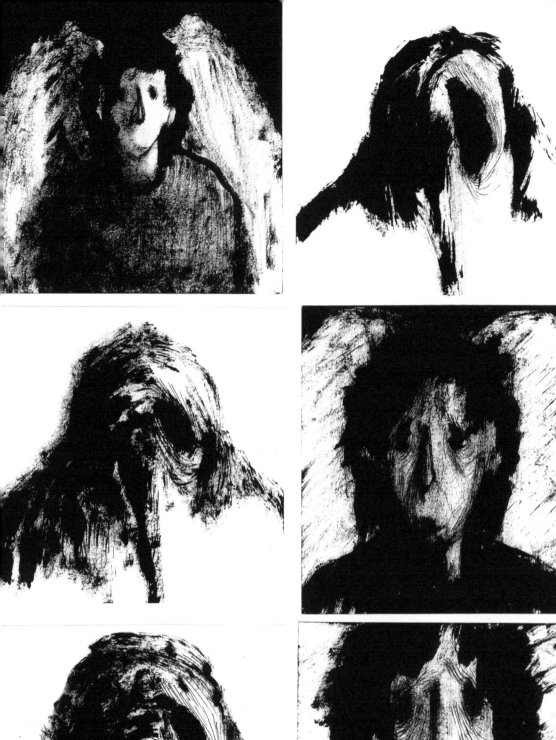
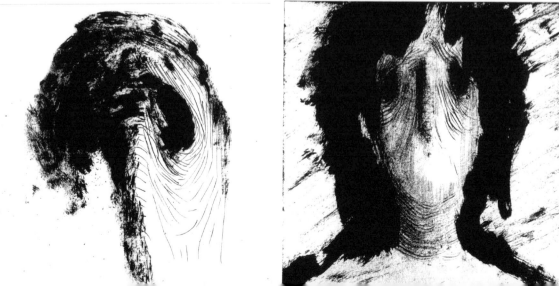

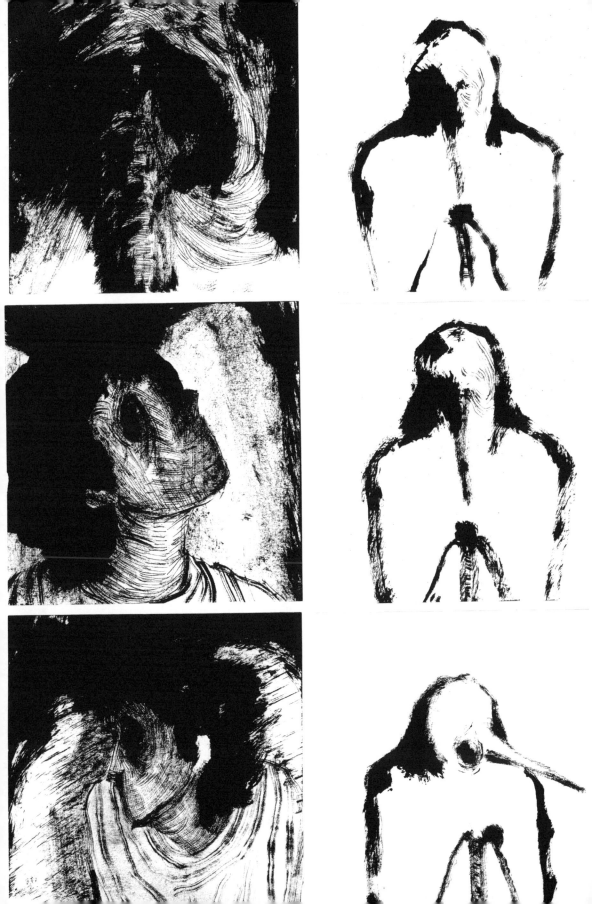

histories. Given this, what is necessary is not to decolonize history, as Mohamed Sahli proposes, but rather to enable Algerian historians to continue liberating their thought and forming their own paradigms.[1]

For Another Episteme

The colony inevitably generates confusion because it entails the maintenance, within the borders of the colonizing country—borders established by force—of a difference between national and foreigner, or rather between citizen and colonial subject, citizen and noncitizen, or citizen and second-class citizen. It might seem that the current generation of historians (those writing since the 1980s) are conscious of this dividing line, but actually they are not. Is this due to the conservative tendency of academic thought; the difficulty of contesting established theses and obtaining acceptance for new ideas? Or, is it a sign of the embattled status of critical theory? In either case, Algeria continues to occupy, in the French (and more broadly Western) historical and political sciences, the place of the repressed, the unthought, even the unthinkable. The malaise derives, in part, from a deep asymmetry in the accumulation of knowledge. The countries of the Global South suffer from a heavy handicap. Our reading is not up-to-date. We are in a subordinate position, always seeking recognition from our peers, looking for a chance to play in the major leagues. It takes us time to get up to speed, to learn to speak the same language, or at least to use the same vocabulary and to show that we master the same references. The philosopher Jean-Pierre Faye speaks of the "narrative effect": he writes that "to report a story is to give oneself the power of the report, the power to establish the meaning of a story and to put it into words."[2] We, however, are continuously faced with the ultimatum of mastering two narratives: the narrative that could enable us to give meaning to our own history, and the knowledge that would help us to enter into dialogue with others and give meaning to their history.

What is primarily at stake is making room for another episteme, a form of thought that recognizes the existence of the other as subject, that puts him/her at the center of the reflection and, correspondingly, allows him/her to produce his or her own categories. In order to think oneself as the subject of one's own history, it is first necessary to put this history into words, to put oneself into words. But, bringing a traumatic past into words is not easy. We have to assess the extent to which war neuroses, or neuroses arising from colonial domination, have been verbalized or silenced in our society, knowing that, in one way or another, we will confront the "encrypted" dead parts and the sites of repression.[3] As the psychoanalyst and one-time colleague of Frantz Fanon, Alice Cherki, notes, we are dealing with "catastrophes of the real, lived in horror and blankness, catastrophes which, in the years that followed the war, not only remained unexamined, but indeed were completely silenced, held in traumatic suspense by the impossibility of speech and the lack of access to representation."[4]

Algerian society continues to be shaken by compulsive movements because it has not been able to put its traumas into

1 Mohamed Chérif Sahli, *Décoloniser l'histoire: Introduction à l'histoire du Maghreb* (Paris: Maspéro, 1965).

2 Jean-Pierre Faye, *Langages totalitaires: Critique de l'économie narrative* (Paris: Hermann, 1972), 3–4.

3 Alice Cherki, "Retards de mémoires," *Psychologie clinique* 16 (2003): 147–58.

4 Alice Cherki, "Ni honte ni gloire," in *Actualités du trauma,* ed. Patrick Chemla (Toulouse: ERES, 2002), 101–10.

words or make its differences and internal contradictions an object of knowledge. There are, for example, many subjects that we have not studied enough. As Fanon explains, colonization, as a process of domination and submission, produces alienated subjects, witnesses to their own ruination, who are excluded from themselves, both literally and metaphorically. In *L'an V de la révolution algérienne*, he cites a powerful example of this state of affairs in a Front de Libération Nationale publication: "Le colonialisme français s'est installé au centre-même de l'individu algérien et y a entrepris un travail soutenu de ratissage, d'expulsion de soi-même, de mutilation rationnellement poursuivie."[5]

The liberation of a people or of an individual, the achievement of independence, does not necessarily constitute a foundational moment at which the gaping hole left by the departure of the colonizer is filled with feelings of self-rediscovery. The becoming-new (*devenir-nouveau*), born of an encounter with the self, may not translate into the capacity for freedom. As Karima Lazali writes:

> [Ce devenir-nouveau] comporte aussi le risque d'en appeler au même, par le prolongement d'une situation de domination, qui se veut rassurante car familière. Le dominant prend place dans ce cas à l'intérieur de soi et tisse le lien social en ré-ordonnant la poursuite identique de l'asservissement.[6]

Moved by the forces of validation and valorization we have neglected these issues. Thinking that they would be incomprehensible and inaudible, we have relegated them to an elsewhere that is hard to reach. Yet it is through the ways of thinking and acting of the indigenous population, the auxiliaries of the colonial administration, the communities and the individuals, that we can begin to understand the crises that we have lived through and continue to live through in Algeria. The history of Algeria is not only the history of the heroes and the saints, nor is it only that of French institutions or of those who have been acculturated to French (or Western) values. This is why I started working on "local elites," the so-called indigenous agents of the French colonial authorities. What interested me about this social group was its high rate of transfer of allegiance (to borrow an expression from Faye), that is to say, how people who were carefully selected for their honesty, fidelity, and long-standing subordination to French authority suddenly became dissidents, disputing French rule and emerging as political leaders of "the rebellion." I wanted to produce a kind of historical sociology of the actors of our history, whether inside or outside the colonial administration, inside or outside the nationalist party. This anthropology, this history, is not that of France in Algeria but that of Algeria leaving France; it is, in effect, the other side of the story. This side of the story asks how forms of legitimate representation, power, and authority have been constructed historically, without falling into the form of colonial overdetermination that would retain only the categories of French colonial history.

5 Résistance Algérienne, May 16, 1957, cited by Frantz Fanon in *L'an V de la révolution Algérienne* (Paris: La Découverte, 2001), 48.

6 Karima Lazali, "Plurilinguisme, pluriculture et identité," *La Lettre de l'enfance et de l'adolescence*, no. 79 (January 2010): 109–16.

7 This expression designates a dominant theoretical model which, in any given school or discipline, governs the types of explanation that can be offered and the kinds of facts that can be discovered.

8 Serge Berstein et al., eds., *Histoire de la France politique: Tome 3, L'invention de la démocratie (1789–1914)* (Paris: Seuil, 2002). Presentation made in 2003 to the Twentieth-Century History Section, Institut d'études politiques de Paris.

The Pronominal Paradigm[7]

When I was invited to France to participate in seminars and conferences, I encountered a kind of academic classicism that pervaded the famous faculties and schools. It was as though the impact of the Annales School and critical thinking in philosophy and the social sciences had reached a limit and evolved into a fixed body of knowledge that was being reproduced in erudite societies geared toward the training of new elites. I do not say this to contest the importance of the bibliographical resources, nor the intelligence and acuity of the approaches that specialists use to consider the various types of society that have been chosen as objects of knowledge. My criticism concerns, rather, what happens when these approaches solidify into a unique if not univocal referential system, relegating to the atypical whatever falls outside its paradigms.

In their presentation of the third volume of the *Histoire de la France au XXe siècle* at a lecture given in Paris in 2003, Serge Berstein and Nicolas Roussellier explored the "invention of democracy" in France. I learned a lot that evening from this impressive synthesis of the work of historians of contemporary France.[8] The authors laid out the architecture of the state, its modes of representation and action, the French political system and its relation to the successive stages of society, the progressive establishment of a political culture, and, finally, the stakes of political debate in relation to historical circumstances. What emerged was a description of a system organized around the capital concepts of the state (public powers), the nation (the group of adult individuals whose status as subjects evolved into that of political actors), and society, which has navigated an unstable compromise between national sovereignty and despotic authority, divine right and aristocratic liberalism, or between liberalism and Caesarism. From the interaction of these poles arose a national political space, an acculturation of the masses to political practice (their politicization), and a progressive replacement of violence by the vote (the losers accept the verdict of the ballot box). During the nineteenth century, and in the first part of the twentieth century, this parliamentary republic, with its republican culture, its public spaces, and its body of citizens, ripened. Thereby was established the power and promise of the French state, which serves the general interest through the work of its republican officers: its civil servants, teachers, and army. Correspondingly, in civil society, Catholic authority was replaced by lay authority, public meetings and a free press was born and diversified, and competitive elections replaced uncontested elections.

If I listened to their account with a certain malaise, it was because it evoked recollections of my own work on Algeria in the 1930s and 1940s, and in particular on how these same republican civil servants, the officers of the Third Republic, looked upon Algerian "natives." I thought, for example, of the administrator of the Mixed Commune of the Soummam, who noted the "inaptitude of Berber brains to move from the particular to the general" and explained that "individual interest remains the law." He continued:

Compromises among the various interests, the work of synthesis which we expect from a deliberative assembly, are out of reach for our peasants. Those who belong to these assemblies are the notables who, by their travels and contacts, are most open to new concepts. One judges the state of mind of the masses by that of this elite.[9]

When conducting my work on recent events in an Algeria in crisis, I started to classify as superficial or tangential anything that did not fit into the framework of the advance of modernity and the republican state (i.e., of a central logical regulating agent) in a society just emerging from a subsistence economy. Following, consciously or unconsciously, the model of analysis developed above, a model to which my generation of Algerians was acculturated, I classified the political fluctuations of my society, and in particular, instances of naked violence, as a series of jolts preparing the difficult birth of the French model of the republican state. Unfortunately, this "transition" appeared to be blocked in the compulsive movement of pre-political and in some cases somewhat barbaric forces. Instead of the administrative state embodying the general interest, with republican civil servants and a republican army, instead of the elected officials who were supposed to take the place of the traditional elites, we had a patrimonial, predatory state and the massive appropriation of revenue.

On the Principle of Subalternity

In my research and teaching, I have come to realize that nationalist political discourse, and in particular the discourse of independence, has in many ways been colonial (or neocolonial) discourse in reverse. It would not be much of a caricature to say that when the latter averred: "No, you have never been a nation! You are a barbarian country!" the nationalists answered, as if in echo: "Algeria was always there! We have always been a people that fought against the occupying power!" It is as if there were only one discourse marked by opposite signals.

The historiography of contemporary Algeria formed around political questions born in the bosom of France, as if all political culture emerged from a common matrix. Everything is grounded in the same categories of thought: the referents of the parliamentary republic, citizen democracy, or bolshevizing social movements. Whether they were of the right or of the left, the political language of Algerians during the twentieth century, and by extension their historiography, has been delimited by the French semantic field. The result is that we have many blind spots when we look at ourselves. In contemporary movements, whether political, social, or religious, there are currents of thought and modes of thinking and acting that belong to the East in general and the Muslim East in particular. For a long time, they were repressed, marginalized, minoritized, and ignored. They were driven back because of the domination of "modernist" discourse: the discourse that speaks about the formation of the modern state and the citizen-nation. These

9 Daho Djerbal,
"L'évolution de la propriété
foncière dans les plaines
intérieures de l'Oranie
(1850–1920)." Doctoral
thesis, Université de Paris
VII-Jussieu, 1979.

concepts had a long gestation in the French semantic field, yielding
the long duration of France's political referents. But the founding of
the Algerian state cannot flow from a simple renewal of the French
administrative, military, and legal systems.

The Return of the Repressed or the Inadequacy of Forms

It turns out that even when historically the real has been stifled,
repressed, kept in a vice, it always ends up making a brutal return.
The primary realities, the components of Algerian society in the field
of symbolic representation and political expression as well as in the
institutional field, have brought independent Algeria into crisis. And it
is a serious crisis, expressed in the emergence of violent movements,
forms of expression and counterpowers that seem to be, at the
very least, paradoxical, and in the worst-case scenario, irrational
and incomprehensible. In any event, no one saw them coming. Thus
arises the question of the components of the semantic field, or
of the episteme. To see this more clearly, we need to turn to facts
in their immediate manifestation, not to practice a kind of "event
history" in the classical sense, but to try to create tools of analysis
that are more adequate to their object. It is thus necessary to go
back to the starting point.

Colonization was, first and foremost, a brutal process of
expropriation. In my study of the history of land ownership and
property rights in the interior plains of the Oran region, I realized
that the long-term process of expropriation, the displacement and
confinement of populations, and generalized pauperization, created
within the Algerian farming community a technique of survival that
was also a form of resistance.[10] We can thus speak of a double
history: the installation of a colonial capitalist mode of production
and exchange, and, in parallel, the development of a system of
association and sharing, a technique of survival that aimed at
avoiding complete disintegration, poverty, and famine. The colonial
system produced new social agents: workmen and employees,
particular forms of individuation, but it also produced communal
and collective forms that were everything but a continuation of
tradition. Instead of repeating colonial French historiography and its
dualism of the modern and the traditional, I thus tried to show that
the forms known as traditional are in fact an outgrowth of modernity.
Confronted with dispossession and the shrinkage of the agricultural
land required for subsistence, peasants began to work together,
putting a collective system in place.

This perspective reveals two histories, that of the colonial
system and that of its counter-system. These new areas of research
no longer line up with colonial historiography and its semantic
field. Here, transversal and transdisciplinary approaches become
essential, since it is necessary to seek in the fields of anthropology,
philosophy, and sociology what traditional historiography does
not give or perverts in its language and vocabulary and its
academic specialization.

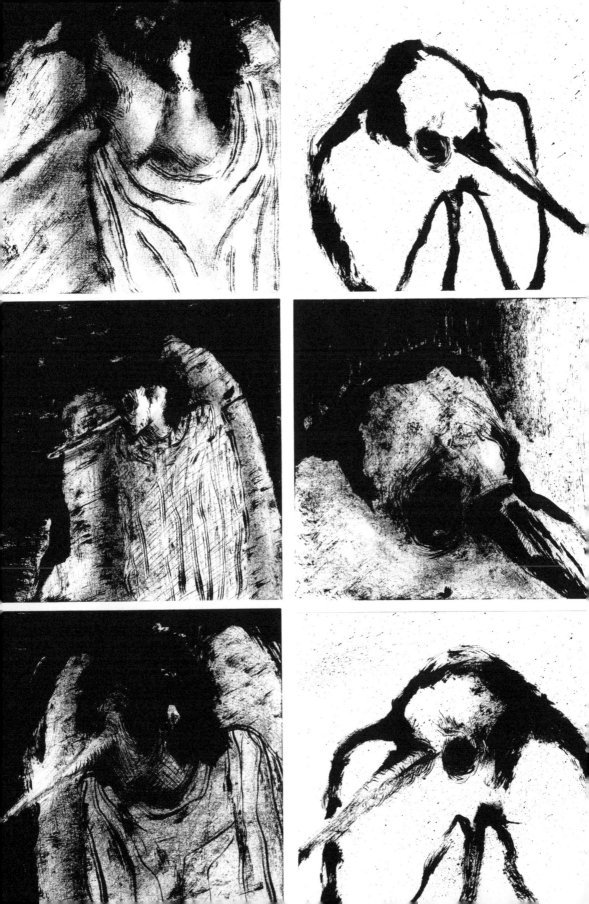

10 "Algérie, du soulèvement d'octobre 1988 aux contestations sociales des travailleurs," in Mouvement social et modernité, Hommage à Saïd Chikhi (Algiers: Editions Naqd/SARP, 2001).

11 See La Quête de la rigueur: Hommage à Djillali Liabès (Algiers: Casbah Editions, 2006).

12 See Ouverture, in Naqd: Revue d'études et de critique sociale, nos. 19–20 (2004): 7–10.

Current Questions

The last few decades, in particular the 1990s, have been tragic. Algeria has been rocked by social and political tremors so powerful that at times it seemed as though the dearly bought edifice of the sovereign nation-state would collapse. Saïd Chikhi, a philosopher and sociologist of social movements, was among the first to grasp the extent of the crisis that first began to unfold in October 1988: "When the uprising of October 1988 broke out, the whole country fell apart. Society had no compass, social relations broke down, the discourses of professional politicians and the administration were hollow and the field of social movements was empty."[11] In the knot of these lines, written in the heart of the storm, we feel the force of interpellation by our own society. How can a society weaken in this way, watching its substance discharge like liquid spilling from a broken vase? How can organized social forces weaken to the point that they can no longer lead historical change? Is the repression of all organized opposition by the political system and the refusal to address social conflict through institutional channels sufficient to account for this collapse?

To answer these questions, it is necessary to revisit the question of the subject, since the abstraction that underlies the opposition between the collective and the individual always emerges when we try to define collective consciousness. Does the fiction of a society-subject (or of a people-subject) possessing, if not an identity, then at least a consciousness independent of the individual subjects that compose it, need to be reexamined? It is in the occult fields of the social and the subjective that we perceive a shift in relation to the symbolic. This rupture of the social bond, this negation of subjectivity, makes it possible to measure the extent of the damage caused and of the damage still to come.

For several years, the question of "unfinished primitive accumulation" or "blocked transition" seems to have been abandoned in favor of a reading that acknowledges the telescoping or interweaving of levels of practice and social conscience. Sociologists were the first to point out the apparent aberration of forms, followed by historians, then political scientists and other anthropologists. Djilali Liabès was at the forefront of this way of thinking.[12] The notion of coexistence, of the forms of interlacing specific to "a composite society," led him to hypothesize that each facet of society, each aspect of the behavior of social agents, was organized according to its own temporality, a logic that entered into a relation of "exteriority" with other logics.

Starting from the same point of departure, political scientists took up this analytic thread a few years ago. With Mohammed Hachemaoui at the fore, they tried to show that *political play* is contained in *social play*, that state and society are structurally embedded in clientelisms, apparatuses, and interposed groups.[13] They asked whether, in the end, we were moving toward the *subject* leading the change (*sujet agent de changement*). They posited not the fiction of a society-subject (or of a people-subject) as discussed earlier, but a model in which all of these powers are embedded in

society and the state. This, briefly, is what I meant when I spoke earlier of creating a space for the reinterpretation of social facts in conjunction with a critical approach to established knowledge.

Daho Djerbal
 Born in Oran, Algeria, in 1945. Lives in Algiers.
 Professor in Contemporary History at the University of Algiers 2.

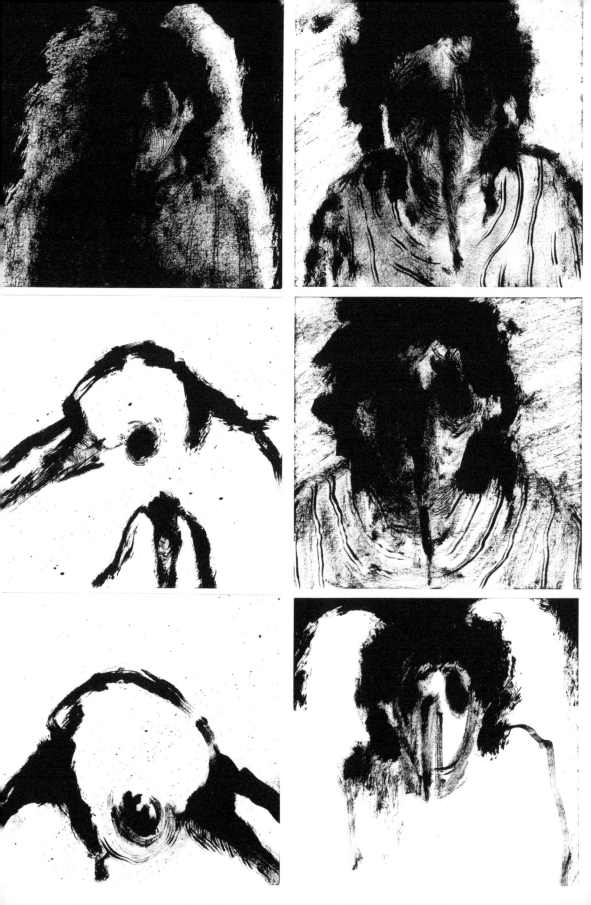

Structures of Reappropria-tion

Nadira Laggoune-Aklouche

TRANSLATED BY OLIVIA CUSTER

Forty-five years after Independence, and forty-three years after the Union nationale des arts plastiques (UNAP), which has since become the Union nationale des arts culturels (UNAC), an exhibition was organized to honor the founders of this Union, which was so important for the development of the arts at the moment of Independence.

For many, the show, which opened on July 19, 2007 at the Racim Gallery, headquarters and gallery of the UNAC, was a chance to discover not only the real list of UNAP founders,[1] but also their work and what it meant, at the time, for a country whose concern was to establish itself in the concert of nations.

The invitation to the vernissage, which included a photograph of each of the founders, is therefore now much more than a mere announcement to be discarded once the show has opened: it is a precious archival document.

The photographs of the twelve founding artists, mostly photographed in their youth, put faces to names that have become mythical. These pictures also raise questions: How did they live through this period during which freedom was reclaimed in incomparable ways? What dreams did those beautiful faces nurture? How did they shoulder their status as artists, exceptional as it was at the time? How did they carry this responsibility in the face of history? Looking at these moving portraits, our perception of the artists' work changes a little. These portraits, landscapes, or still lifes, which seem almost dated, carry not only the charm of the first productions of an art that was yet to be discovered, but also the enshrining aura of the things from the past they represent.

In 1964, Algeria, having barely reclaimed its independence, began the task of founding its culture anew. The aim was to restore the importance of national culture by embedding it, as firmly as possible, in society, and, importantly, to make it accessible to all. This aim came out of the momentum produced by the War of Liberation. It called for the participation of as many people as possible, and for social and political commitment from intellectuals. It was transmitted in revolutionary terms by the idea that art must not only be addressed to the entire population, but also be within reach of the people, to constitute a mode of expression for all those who want it.

To pursue this aim, a structure that would serve it needed to be found. It was in this way that in independent Algeria in the 1960s, a group of painters gathered to establish an organization that would defend their interests by promoting the arts, while also paying tribute to the heroes of the revolution, as was being done at the time by all means of expression—be this writing, documentary image-making, or painting.

The big idea was to forge the kind of art that would be, in its very essence, for the people, and whose destiny would be to serve the social. It would aim for symbiosis with workers and peasants, since its main interest was to communicate with the people. This form of artistic expression therefore called upon the rehabilitation of

[1] The founding members of the UNAP were Mohamed Louail, Ahmed Kara-Ahmed, Mohamed Ranem, Mohamed Bouzid, Mohamed Zmilri, Mohammed Khadda, M'hamed Issiakhem, Mohamed Temmam, Choukri Mesli, and Ali Ali-Khodja.

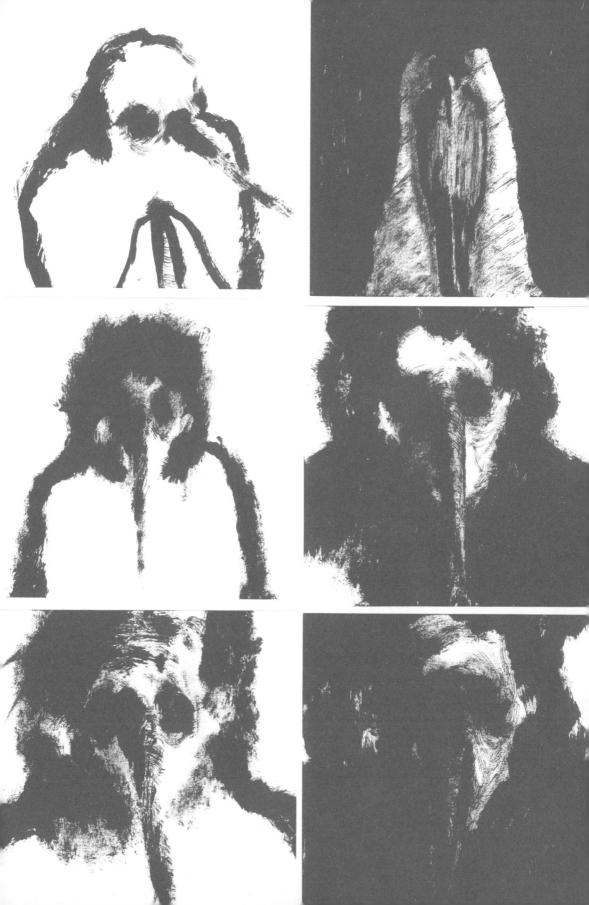

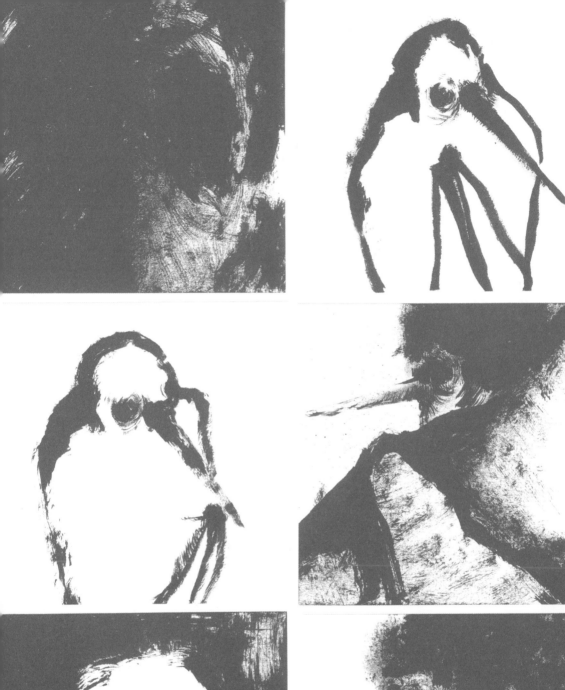

2 Ramon Tio Bellido,
*Le XXe siècle dans l'art
algérien* (Paris: Aica Press/
AFAA, 2003).

the past, hero worship, Arab-Berber identity, self-determination, and so on, as popular motifs.

Beyond these rallying cries, the original motivation for creating the UNAP was in order to set up professional tools (workshops, exhibitions, commissions, etc.), and as a means of professional recognition for artists.

Consider the importance of iconographic representation for a society that, as it entered the postcolonial era, needed both to be recognized as an equal partner on the international scene and to convince its own people of the scope of the new social project it intended to build. Every type of discourse that could transmit this project had to be mobilized.

Since colonization, Algerians had appropriated the images and representations imported by the colonizers. As in other African countries, the new mediums and modes of expression introduced by the colonizers, in particular painting, became the favored mediums of Algerian artists, serving to depict the colonizers and to challenge their schemas of modernization. The appropriation of imported notions and their transformation into weapons and means of expression is a genius move on the part of peoples. It is also a classic acculturation phenomenon.

In a society where, as everywhere in Africa, the production of traditional works was anonymous, painting, which came to stand as an "index of modernity," served as a referent for recognizing the profession and the figure of the artist. The UNAP thus became the place *par excellence* for the production of this recognition. In his work *Le XXe siècle dans l'art algérien* (The 20th Century in Algerian Art), art critic Ramon Tio Bellido describes this move as a double revolution:

"—The acceptance of painting and its recognition as an integrated mode of expression;

—the distribution and acquisition of paintings as an intelligible sign of a singular and artistic form of writing."[2]

The great question of the time was: "What art for Algeria?"

While from an artistic perspective, images were understood to be "memory catalysts," easel painting came to be inscribed in the particular context of modernity, or, at least, in the idea of modernity implied by Independence. As in many other young countries at that time, the idea put forward was to break with the domination of a Western art that was, to a greater or lesser degree, associated with colonization.

Various debates and positions formed around this sensitive issue: Should one paint simply according to the pictorial tradition that had been acquired? Or should one instead push for a form of art different from that inherited from the culture of the colonizers? What was clear was that art was expected to fulfill a primary need—the need for communication, which involved collective effort, participating in the dynamics driving the people, and participating in such historical moments.

Nevertheless, the wish to gather was not new, perhaps due to an instinct for self-preservation and to feel stronger through unity. This desire was latent among Algerian artists, and, as the painter Mesli recounts, had already been apparent in 1951, when he "founded Groupe 51 with Ghermoul, the trade unionist, Issiakhem and Louail, the painters, and Kateb Yacine, the writer. What effervescence: we used to meet every Friday evening in the marina neighborhood, in the Moorish café run by Amar Ouzegane. Those were the evenings of Groupe 51. Meanwhile, Amar Ouzegane had founded the Association des Amis du Theatre Algérien."[3]

The first show of Algerian painters and miniaturists during colonial rule did not take place until December 7, 1944. Organized by Mohammed Racim at the Cercle Franco-Musulman d'Algérie in Algiers, it brought together thirteen artists,[4] mostly self-taught, or students of the Racim brothers. Several of them would be among the founders of the UNAP at the time of Independence.

Bachir Yellès, who took part in this show, recounts that "the quality of the work on view surprised the Europeans, who had a monopoly in this domain. They expected to find minor works. At the time, the press expressed much praise for this show, which was the point of departure for a specifically Algerian painting."[5] It took a while, however, for the number of Algerian painters to increase, and given how difficult it was for them to live from their art, some left for Europe, returning just after Independence to champion cultural decolonization.

In March 1962, as soon as Independence was proclaimed, the Comité pour l'Algérie Nouvelle, an organization of Algerian and European intellectuals created in order to fight the right-wing paramilitary organization the OAS (Organisation de l'Armée Secrète) set up the Premier Salon de l'Indépendance in the Ibn Khaldoun space in Algiers on July 13, 1962. Social and political commitment was spontaneous, and the artists took part in multiple initiatives to demonstrate this, through auctions and exhibitions to benefit war orphans.

The initial approach, which involved creating "groups" in order to face adversity, and also to affirm the existence of the self in relation to the other, to speak to the other in his own language, established itself through the appropriation or reappropriation of existing structures framing artistic activity. As early as December 1962, the École nationale des beaux-arts d'Alger, restored after having been bombed by the OAS, became the École nationale d'architecture et des beaux-arts, and was opened to Algerians. This was also the case, in the same period, for the art schools in Oran and Constantine. Art schools being taken over by Algerian artists was one of the early objectives, harnessing the postcolonial collective thrust of enthusiasm, which was being manifested in all areas of social life: Algerian doctors replacing Europeans in the hospitals, farm workers "self-managing" farms, and so on. New discourses drove these actions, linked to art's commitment to the "efforts for national development," and they gave rise to

3 Françoise Liassine, *Choukri Mesli* (Algiers: Éditions ENAG, 2002), 39.

4 They were A. Hemche, M. Temmam, N. Benamira, M. Zmirli, A. Besliman, B. Yellès, A. Ali-Khoja, M. Boutaleb, A. Belhassol, M. Ramen, A. Absi, M. Ferhat, and A. Farrah. Cited in *L'Union Nationale des Arts Plastiques* by Bachir Yellès, text to accompany the exhibition on July 19, 2007, in Algiers.

5 Ibid.

6 Ibid.

confrontations that led to a need for a structured framework for national art, so that art could work in line with this commitment.

Bachir Yellès, the first director of the École nationale des beaux-arts d'Alger, noting the "scale on which artistic education was developing," then a novel thing for Algerians, considered on the one hand that it was necessary to "develop public awareness of this activity that was traditionally restricted to Europeans," and on the other hand that "existing artists felt the need to organize and to make themselves known to the public."[6] He decided to invite a group of artists interested in the project to his office at the École des beaux-arts, where he submitted the statutes he had drawn up for their approval; then these twelve founding members set up a board of directors and an executive committee. The Union nationale des arts plastiques was born.

This union oversaw the development of the arts by orienting them (as the European artists had done previously) toward the decoration of official buildings and the organization of national and international events. At least at the beginning, it brought together the big names of Algerian painting (Khadda, Issiakhem, Mesli, Yellès, Temmam, Ranem, Bouzid, Ali-Khodja, and so on) and an important collective of artists of different inclinations, since the idea was to present participants in artistic production with all the contradictions of this kind of production.

The Premier Salon des Arts Plastiques in June 1964 was effectively an inaugural show for the UNAP, under the patronage of the President of the Republic, Ahmed Ben Bella. It was received by the press as a sketch for sovereignty over a culture that presented itself as heterogeneous and composite, comprising references to the old (illuminated manusctipts, miniatures) as well as the use of foreign modes (figurative or abstract painting). This culture-in-the-making already heralded the debate that was to unfold around the legitimacy of these various forms. The UNAP's twelve founding members participated in the salon, as did Algerian artists of European origin, and invited foreign artists.

Mourad Bourboune speaks movingly of these burgeoning themes in the exhibition catalogue: "This exhibition is less the gathering of a few paintbrush professionals than it is a vigorous lyrical flight, which has been repressed for many years, and which establishes itself through these poems on easels, woven in the shadows and against the shadows."

This salon marked the founding of artistic sovereignty in independent Algeria. This is true for several reasons. Firstly, it was the first exhibition of Algerian artists post-1962 to be organized by an artistic body that claimed to represent the people. Secondly, a significant number of the works presented in the show then entered the Musée National des Beaux-Arts in Algiers, contributing to the reappropriation of the sites where artistic heritage is preserved.

Finally, this is where Khadda's name first appeared—the Khadda who, a few years later, would publish the first work on a new Algerian art. In *Éléments pour un art nouveau*, a theoretical work of analysis

and reflection, the painter situated this new Algerian art in relation to a wider network of meanings and models.[7] He also underlined Islam's contribution to the graphic arts, and its relevance for non-figurative forms, thus emphasizing Berber-Arab roots over all the other sources of the new Algerian art.

Indeed, the diversity of writing styles, visions, feelings, and tools that would later come to be clearly established was already perceptible in this "art nouveau." In an interview for *Révolution africaine*, in connection with the exhibition "Reflets et promesses" in February 1966, the painter Issiakhem declared: "From the start, the Union des arts plastiques aimed to bring together all Algerian painters, regardless of their different tendencies ... to group painters of various tendencies into a single organization, to pluck them out of their isolation in order to mobilize them with a common task that was entirely geared toward the flourishing of our national culture. It aimed to elicit vocations, involve the public in our work and our research, and, finally, to provide the outside world with an image of our realities and possibilities. This was our common aspiration."[8] It was an ambitious program, difficult to execute, and soon had to contend with the varying sensibilities of its members. Divergences surfaced concerning the principles and forms that this "popular art" should take. In fact, the narrow and complex connection between art and power characteristic of the first years of Independence forced artists to respond to a prosaic question: What is the use of art in periods of revolutionary transformation?

Yet the particular nature of art is that in order to act, it needs distance; it needs delay, which is at odds with direct effects. And while the influence of traditional culture was recognized, the culture associated with foreign modes had to overcome a latent suspicion, whereby the public did not immediately acknowledge it as its own. Such was the case for orientalist painting, which for a long time was criticized by both artists and the press.

The controversies characteristic of modern art came next: between figurative and abstract, art as witness to history or pure abstraction, specificities and traditions or universality, and so on. These debates were supported by an explosion of different styles, bolstered by the development of research that had been carried out in Paris by the painters known as "the thirties generation." Kateb Yacine spoke of them in these terms: "These necessary precursors opened up, and marked, so many paths ... They come, sharp mirrors, to restitute shards of their own memories to the tribe."

It is true that the question of identity had been confused and distended by history, and by the colonial period in particular, and that it was difficult to assemble the components of a new national identity into a homogeneous whole that would not shatter at the slightest conflict. As Issiakhem underlines, from this perspective, the UNAP's ambition to bring together all Algerian painters, irrespective of their "different tendencies," and to make art accessible to all, "should have, ordinarily, created a flow of exchanges and salutary emulation." Instead, the union fell into the trap of the contradictions inherent in its own objectives.

7 Mohammed Khadda, *Éléments pour un art nouveau* (Algiers: SNED, 1972).

8 M'hamed Issiakhem, *Révolution africaine*, February 1966.

Between 1963 and 1964, the assertion that art must appeal to the whole population, and become a means of expression for whoever wanted to embrace it, seemed to be shared by all of the artistic currents and artists who had worked with both traditional artistic forms and modern painting. However this early assertion quickly led to controversies and (occasionally violent) conflicts regarding the aesthetic forms likely to deliver on the aims of progressive painting. These aims were typical, and legitimate, in recently decolonized countries. Of course, these conflicts attest to the UNAP's vitality—producing exhibitions, with command over public commissions and cultural policy programs in Algeria and abroad. But they are also the result of a certain confusion in the approach of politically engaged art, which many would like to have limited to representing the battles and military exploits of the War of Liberation. As a consequence, this approach then excluded those who were seen as having an "elitist vision and behavior"; that is to say, those who did not speak directly about the revolution, and so were not addressing the people directly.

At a roundtable on the pictorial question, organized by the journal *Révolution africaine* in May 1966 in Algiers, which brought together the best-known painters of the time (among them Issiakhem, Mesli, Farès, Martinez, Bouzid, Ouis, Boumehdi, Benmiloud, Ali-Khodja) as well as amateurs, Yellès, President of the UNAP, declared that "the fault lies with the artists who can never agree as soon as one draws up a cultural or political program; nevertheless, the UNAP brings together the majority of painters and pursues its efforts, despite the absentees."[9]

Dissent took on concrete forms as the union split internally into several groups. These included Jeune Peinture (Young Painting); the Groupe 54, started by Sénac and de Maisonseul; and, in 1967, the Aouchem Group. These did not last long, but their formation and splintering signified the crisis of meaning characteristic of the need to define art anew in a society in which aesthetic reference points not only had to be rediscovered, but also reconstructed, insofar as identity must be constantly reworked. In his tenacious activism for this attempt to define Algerian art, Khadda, who was the union's secretary general from 1968 to 1973, "defended the modern art that was furiously challenged at a time when many painters, 'privileging the political slogan over artistic work,' and driven by motivations ranging from sincerity to trauma or guilt, stuck to the more or less naive illustration of patriotic scenes."[10]

As such, Khadda masterfully summarized the oppositions connected to the reading (or rather readability) of artistic work, its accessibility for the masses, the practice of painting, the introduction of new ideals to painting, and so on. The union's role increasingly came to resemble the role of mass organizations: namely, to serve the revolution, to privilege those who participated in the War of Liberation and its representations, and to "decentralize" access to art by creating offices of the union in the smallest *wilayas* (provinces) in the country, allowing artists in these now accessible regions to exhibit their work. Nevertheless, several of the founding artists,

9 Bachir Yellès, *Révolution africaine*, May 1966.

10 M. G. Bernard, *Khadda* (Algiers: Éditions ENAG, 2002), 190.

11 Yellès in conversation with Tio Bellido, *Le XXe siècle dans l'art algérien*.

or artists who joined as soon as they returned from Europe after Independence, found that their artistic research was moving away from the popular "commemorative" illustrative painting, away from a writing of history that sought to affirm a realistic truth, the truth of the workers and peasants.

By this logic, the UNAC opened up to all those who considered themselves artists, and to this day it has never imposed precise criteria for membership, or for access for painters to participate in the salons and exhibitions it regularly organizes to commemorate significant dates (Independence, Revolution, May 1, May 8, etc.). Similarly, the armies of painters who join its ranks every year are not subjected to any selection procedure. Today it fulfills the role of a public institution charged with connecting cultural and municipal services, in order to set up national artistic projects around the country and abroad, and to organize collective exhibitions related to major political events.

The UNAC's role was straightforward just after Independence, when mass communication, revolutionary energy, and enthusiasm were all directed toward a single aim: to overcome historical backwardness, construct modernity, and provide equal opportunities. Today, this role cannot remain the same. The turmoil of current events and the ideals of a contemporary society in transformation in the era of globalization increasingly impose their rhythm and conditions on the union, and, once again, accentuate its lack of alignment with the concerns of international contemporary art. Unless there is some shift, the union will have to be satisfied with the place it now occupies, which involves channeling the overflowing activity of a great number of artists, requiring only that their production be driven by a faith in art; its purpose upheld by a sometimes extremely simplified discourse, which, because "accessible," is considered to represent the expression of the people.

The UNAP was conceived as an association that would defend artists' interests but in the end, Yellès admits, "It did not know how, or was not able, to institute a social system that would defend artists' activity."[11] Today, it still tries to spearhead the struggle for the rights and social protection of artists. Nevertheless, it must reconsider its function, given the complexities of its collective actions and of contemporary political uncertainties.

Nadira Laggoune-Aklouche
 Born in 1954 in Algeria.
 She has always lived and worked in Algeria.

View of the Fine Arts: Interview with Nadira Laggoune-Aklouche

Zahia Rahmani

TRANSLATED BY OLIVIA CUSTER

Zahia Rahmani: You teach the history of images at the École supérieure des beaux-arts d'Alger. You are in contact with young people who have inherited a tumultuous contemporary history since the War of Liberation, the end of colonialism, and the coming into existence of the Algerian state. Before considering the way that youth, and your students in particular, approach this history through art, I would like to ask a few questions about your own trajectory. You remember the moment of Independence, socialism and years spent in the Soviet Union, the disillusionment of the 1980s, and terrorism. Before we get to the moment of global insecurity we live in now, and to our common contemporary aesthetic sensibility, could you remind us what Algerian Independence meant for your generation?

Nadira Laggoune-Aklouche: For my generation, Algerian Independence was a time of jubilation, a time when everything seemed possible. Suddenly many things that we had not had, or known, were within reach: higher education, free circulation throughout a country that was "home," which we rediscovered. For most of us, who came from families of very modest origins (farmers, workers, etc.), Independence promised, and provided, better living conditions. It was a dream come true.

Access to higher education and training played an essential role in our lives. It was our springboard toward a great future! All social classes had access to education, and especially to universities, beginning in the early 1970s. At that time, socialism was one of the great utopian ideals and, from the early years of Independence, it embodied an idea of social, economic, and cultural justice. In that context, there was massive support, especially in universities, for this form of economic structure. In the same spirit of idealism that socialism represented, going to the Soviet Union to train was something everyone wanted to experience, both for the art and for the lifestyle. As far as we knew, the academic system of Soviet art (classical dance, fine art, and cinema at the Gerasimov Institute of Cinematography—the VGIK) was at least as good as that of other

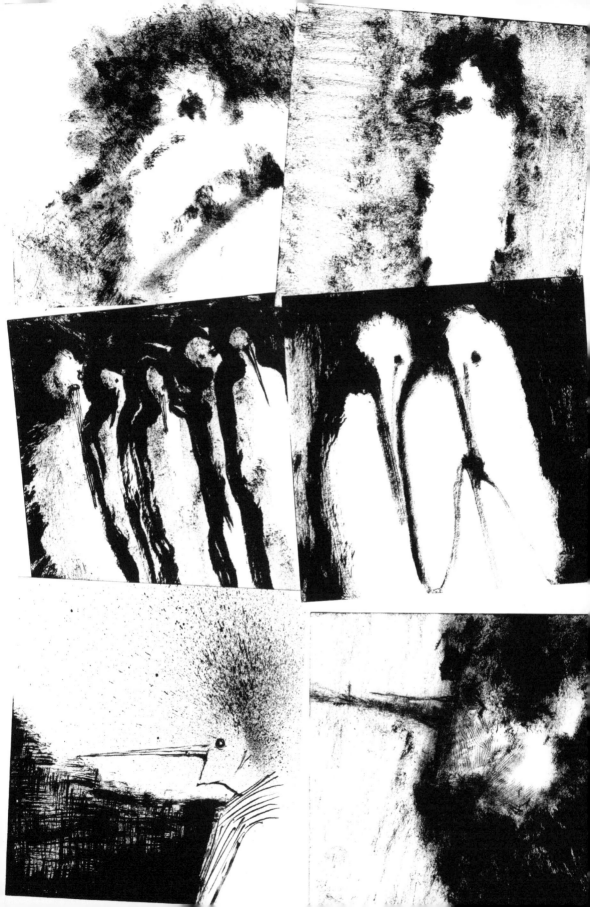

European countries, and many Algerian art students went off with an Algerian-Soviet cooperation grant and returned six years later with a master's in art (in audiovisual critique, in my case).

With the momentum of Independence, and given all the possibilities opening up for us, women began to enter public space and professional training programs. The status of women changed because they had access to jobs, which was encouraged by economic development policy. Public authority was a recognized and accepted force, and radical Islamism did not yet exist: women did not suffer as much as they do today from attacks or hate speech. The Union des femmes algériennes was created immediately after Independence, although it was quickly taken over by partisan politics. There were women's marches in the 1980s, against the Family Code for example, but this code remained very conservative with regard to personal status.

ZR: What was art's place at the time, in that society?

NLA: In the 1960s, and even more so in the seventies, cultural life was imbued with the revolutionary atmospheres of resistance and independence movements in African countries, Latin America, and Asia. Many of these movements had offices in Algiers. These included South Africa's African National Congress (the ANC), the Mozambique Liberation Front (FRELIMO), the Black Panthers, Salvador Allende's Chile, all the Palestinian fronts…. At the same time, May '68, the Vietnam War, and the hippie movement influenced our attitudes and provided inspiration. Our culture was partly made up of what had happened elsewhere, transmitted through shows and concerts organized by public institutions. You could go see the Bolshoi, go to listen to Joan Baez, Nina Simone, Archie Shepp, Miriam Makeba, or Marcel Khalife, and politically engaged music and songs were readily available: Ángel Parra ("¡Venceremos!"), Jean Ferrat, Boris Vian ("Le déserteur"), Bob Dylan ("Blowin' in the Wind"), Léo Ferré…. You could see films by the great directors from Europe and beyond (Henri Langlois, Joseph Losey, Youssef Chahine, Andrei Konchalovsky) who would come for debates at the cinematheque in Algiers, famous throughout the Arab and African worlds. The same period saw the development of "local" modern art (with painters such as Mohammed Khadda, M'hamed Issiakhem, Denis

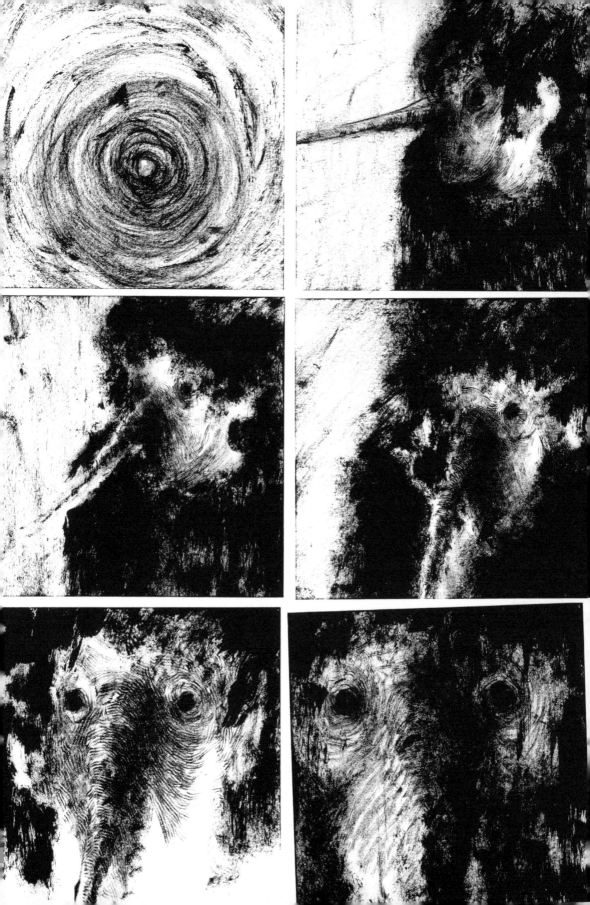

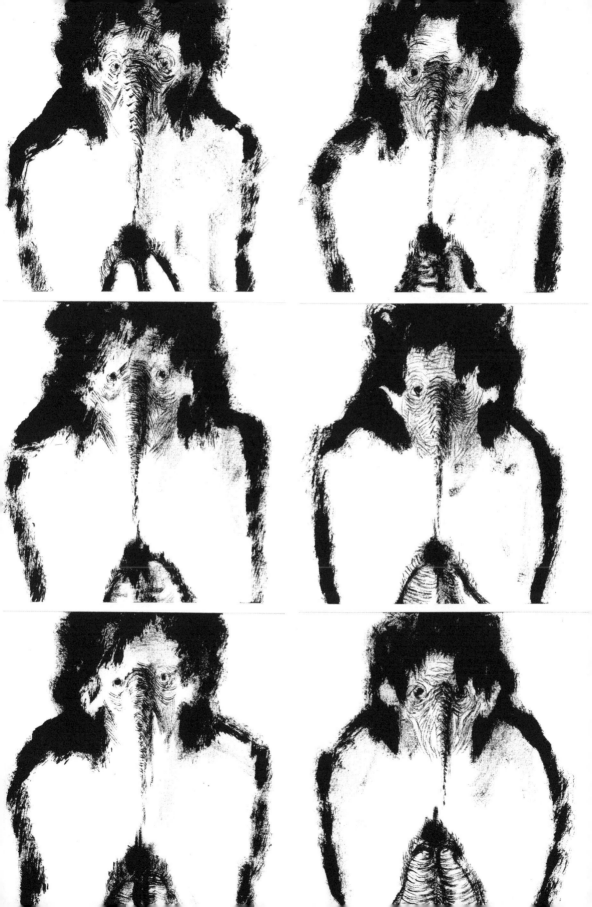

Martinez, and Choukri Mesli), and *djedid* cinema, which is not unlike Cinema Novo in Brazil. *Djedid* is a realist cinema that, for the first time, stopped representing the War of Liberation and addressed social realities. It was carried by a whole generation of directors, notably Farouk Beloufa, Mohamed Lamine Merbah, and Merzak Allouache. At the same time, Kateb Yacine, Rachid Boudjedra, and Abdelhamid ben Hedouga were publishing novels that shaped generations of readers and writers.

The political and ideological discourse of the time advocated anti-imperialism, support for the Third World and peoples' struggles for independence, against apartheid, racism, and the Vietnam War. In the same vein, a discourse promoting the struggle against the large landowners and local reactionaries lent support to the "great tasks of national construction": the agrarian, industrial, and cultural revolutions. Whatever one may think of it today, we had a political conscience. It was reinforced by our studies since, at university, we discovered the ideas of Marxism, class struggle, and political economy.

ZR: When does this Algerian seduction end and disillusion take over?

NLA: Houari Boumédiène insisted on development and "economic self-reliance." Part of the left, notably the PAGS (Parti de l'avant-garde socialiste) supported him, with some reservations. Yet Boumédiène also set up a strong repression of leftist movements and the Muslim Brotherhood, in the name of constructing a developed and independent state. For Boumédiène, this construction was embodied in slogans such as "Bread for All," "School for All Children," "Free Healthcare for Everyone," and "Exploiting the Natural Resources of the Soil and the Subsoil for the Sole Benefit of the Children of This Country." Officially, President Boumédiène said Algeria was not a communist system but rather a model "inspired by socialism," that is to say, a system adapted to local specificities, which drew on socialist ideologies concerning the workings of the "non-capitalist development path" he was laying out.

The seduction of Algeria started to wane toward the end of the 1980s, when the single party was imposed, while the economy was being opened to the private sector in an anarchic

way, based on unbridled imports and the dismantling of the large state economic structures. This accelerated pauperization and accentuated social differences, leading to the economic crisis of 1984–85, and the related popular uprisings, which then continued until 1990. All that created a favorable context for Islamist ideology, which rests, among other things, on social problems.

ZR: At what moment did terrorism really emerge? What was your reaction? How do you see the Algerian situation today?

NLA: Terrorism really emerged starting in 1990, with the first bombs and assassinations. At the time, we still held protest marches. That was no longer the case two years later: terrorism had corrupted Algeria entirely. We lived in terror of hearing of the death of a relative, friend, or neighbor. We were afraid to be killed one fine morning walking out of our homes, or in an explosion…. I kept living, working at the École des beaux-arts, but I felt a constant weight, latent anxiety, always present, haunting us. I was afraid for my loved ones, afraid for my friends and family. We were waiting. We had more or less suspended our lives. We fell back on ourselves, looking inward. We did not go out in the evening, or only rarely; we took precautions and cultural life was, therefore, much less intense. Many cultural spaces closed. Many people left the country at that point. Some had been threatened, others had not, but anyone could become a victim. How could one know? We all felt in danger, threatened. Of course, one cannot criticize those who left, for having done so. Nor can one criticize those who stayed, for not having been threatened, or having stayed.
In 1991, we thought it was a strictly Algerian problem, that the armed Islamists were attacking the army. But in 1992 the situation deteriorated, and civilians began to be assassinated, notably political figures, intellectuals, artists, journalists…. Then, with bombs in public spaces, everyone was targeted. Despite everything, we were aware that this was also connected to something coming from the outside. We were astounded to discover that these terrorists were returning from Afghanistan, that some were not Algerian. And even if they were, why and how were Algerians suddenly killing other Algerians? At the

beginning we had a hard time realizing what we were up against and taking it seriously. We were stupefied and did not understand. We thought it must be a few crazies and that they would rapidly run out of steam.

In March 1993, the director of the École des beaux-arts and his son, a student, were assassinated inside the school, as the director was walking to his office. As often happened, the perpetrators took advantage of the surprise effect to flee. They were two youths who easily passed as students at the school. At that point, we realized what was going on was something we had never seen before, and never even imagined. It was a terrible shock. I arrived at the school moments later and the bodies had already been taken away in an ambulance. It was like a nightmare. Something you live through only half-conscious. It's too huge to be believed, it's impossible. We had heard about the assassination of public figures but, in spite of everything, you never expect these things to happen so close to home, to reach those close to you. Even less, that they could happen in front of your very eyes. It was at this moment that we understood that terrorists were trying to destroy everything that could signify progress, or thought.

I think we lived through the worst, and that the period of terrorism taught us a lot. For instance, we learned to mistrust rhetoric. Today, there are fewer Algerians among those who join the jihadists in Syria than people from other Arab countries or Europe. Of course, that doesn't mean that all is well socially and economically in Algeria. There is social unrest and our economy is not shining. But safety to move around, go out, study, work, have fun—these are important, irreplaceable things. Everyone in Algeria will tell you: "Islam, yes; terrorism, no! We don't want to live that again!" Yet the danger is still there.

ZR: Do you think that there was an end to that kind of terrorism? Why should one think this situation changed, giving way to an internationalization linked to the idea of Muslim transnationalism?

NLA: There was an end to terrorism insofar as the assassinations and massacres stopped and security was reestablished. Today, one can drive from one end of the country to the other.

VIEW OF THE FINE ARTS

ZAHIA RAHMANI AND NADIRA LAGGOUNE-AKLOUCHE

Cultural and social life has taken up again, and the artistic scene is being renewed in Algeria. We have found a dynamic we had lost during the years of massacres. It is not a surprise that terrorism became international. When terrorism was decimating families and destroying the entire structure of society, we were isolated from the world. We were not welcome anywhere, we were considered criminals. Yet we already knew that these attacks were partly organized from the outside, that there were calls for crimes and support that came openly from foreigners, notably from London and Berlin, from Islamist leaders. The internationalization of terrorism can, therefore, also be ascribed to the laxity of those countries that harbored, and harbor, radical Islamists. I do not think, however, that it is a matter of Islamic transnationalism. It is rather an international political phenomenon (or strategy?) which goes beyond the question of Islam.

It is possible that Algerian patriotism will be our bulwark against global insecurity. Algerian nationalism played an important part in the War of Liberation because the people had to be brought together and mobilized, around that aim, but today I would rather speak of patriotism. To love one's country is to defend it and not betray it. Nationalism can lead to ostracism, to inward-looking attitudes, and even to racism. Unfortunately, nationalism and patriotism are often confused. Economic development, knowledge and culture, democracy, tolerance—these are also elements of the bulwark.

ZR: What can be said about the transmission of those values in your school today?

NLA: The École supérieure des beaux-arts d'Alger, which never closed even in the darkest days of terrorism, has, like other institutions, gone through difficult periods. The number of students diminished at that time and has only begun to slightly increase in recent years. Pioneering teachers of Algerian art left, and the school's life was suspended for as long as terrorism went on. Today, there are 300 students altogether, in all fields (design, fine arts, Islamic arts). The teaching is mostly academic and it cannot be said that contemporary art really has a place. However, under the pressure of a generation of hyper-connected students, who are very aware of what is

happening in new media, there is a new tendency in new work, in particular the work produced for final degree shows. Recently, practices and mediums are no longer as separate, as more and more students often "move" between one genre and another to produce work attuned to the present and unabashedly inspired by lived experience and contemporary events. This contemporary practice of art is, however, still linked to the specific possibilities and visions of some of the students; it is not a pedagogical strategy encouraged by the school. The school remains in the background. The artistic scene is increasingly inscribed in contemporary approaches, and is nourished by artists whose production attempts to give an account of life in the here and now. I know that formalism is what distinguishes artistic forms. But what we are interested in is always which questions are politically urgent, and how we can respond to them. We also view societies from that perspective, which means the question of form often becomes secondary. Some quality work escapes the system's selection process.

Algiers, September 2015

Zahia Rahmani
Born in 1962 in Algeria.
Lives in Paris and works at the Institut national d'histoire de l'art.

The Impact of the Arab Revolutions on Artistic Production in Algeria: Between Saving the Local Model and Denouncing Foreign Interference[1]

Fanny Gillet

TRANSLATED BY OLIVIA CUSTER

Algeria occupies a particular place in the dynamics of the revolts that have animated the Arab world since the spring of 2011. Foreign observers have constantly asked, "When are the Algerians going to revolt?" But to think in such terms is to forget the sociohistorical specificity of a country that, just twenty years earlier, in October 1988, went through a popular revolution and then a decade of civil war.[2] Furthermore, it should be noted that the same media sources that raised this question did not see fit to cover the "1001 riots" (émeutes)[3] that took place in Algeria in recent years, ignoring the fact that the echo of the "Arab Spring" there was less spectacular than in neighboring countries. Saturated with an abstract logic of linear causality, the dominant discourse in the media turns out to be incapable of accounting for the complexity of these revolutionary moments. In the face of profusion, the literature tries to explain the specificity of the phenomenon by appealing to ethnographic analyses.[4] The fact that Algeria is rarely considered an exemplary case is due, in part, to the symptomatic state of French research on the period after independence. Research on the arts is, of course, no different.[5]

1. Grasping the "Event" of the Arab Uprisings

Different fields in the social sciences have shown us that artistic production, considered as the symbolic construction of a society in a given context, can legitimately serve as the basis for understanding the constitution of social orders and relations, the orientation of collective behavior, and the transformation of the social world.[6] The arts seem to be the preeminent place where the interactions of the symbolic with lived reality are reflected. Given the work that artists do in creating meaning, their role is all the more instructive in protest situations.[7] Whereas academic research has, in general, paid scant attention to artists' political engagement, we have seen to what extent artists have reclaimed this ground in the settings of the Arab revolutions. This has, in turn, driven a new interest in the arts in the academic world.[8] Legitimizing the critical appropriation of the "event" by researchers in the field, these recent studies make it possible to understand the ethical and practical stakes connected to the impact of the Arab uprisings on artistic production, beyond teleological models.[9] I will not attempt to develop a comparative study with other countries in which such social movements have been present. Rather, I will insist on the specificity of the Algerian context in the moment of Arab uprisings.

In line with Layla Baamara's observations about the student protests in Algiers in 2011,[10] my aim here is to evaluate the role of artists in these movements and to offer a survey of iconographic production from 2011 to 2012. This was a period marked by the spontaneous spread of protests and the deterioration of the conflict in Syria, and it corresponds with the period in which the cited artists constructed the event through their practices. In her analysis, Baamara details the complexity of the disposition to political

expression in a population that is young, educated, and informed, as is the case with the artists I am writing about, in an authoritarian context where the terms of public advocacy are restricted by an official security apparatus. The social function of the artist as opposed to that of the student determined the conditions and specificity of the modes of action used (demonstrations, sit-ins in the case of the students); though we will also see there is some overlap between them. Different questions emerge from these experiences, linked to the positions artists took during the Arab revolutions. Many studies have investigated the relation between art and progressive political engagement, understood as aspiring to defend an ideal of democratic freedom.[11] In the case of Algeria, the idea of political engagement assumes a quasi-proverbial attachment to the anti-colonial and anti-imperialist struggles inherited from 130 years of popular resistance to French colonization.[12] The correlate of this nationalist imaginary, sustained by the "glorious history," is an impetus for artists to work for emancipation through engaging with the social.[13] This ethics of responsibility for the collective grows out of the very constitution of a dominant political culture based, as James McDougall sees it, on the "surplus of the 'social' and the lack of space for individual self-expression."[14] As Nadira Laggoune-Aklouche emphasizes, this disposition to political engagement must necessarily remain outside official frameworks. The consequence of this is that, on the one hand, it reduces the heterogeneity of the opposition's registers, while on the other hand it dismisses the reality of what is at stake in seeking recognition, given the challenges to visibility that artists' work faces in the Algerian context.

The generation of artists for whom the problems raised in this article are relevant is characterized not only by age (they are on average between twenty-five and thirty-five years old), but also by the variety of mediums they use (graphic design, video, installation) and by the challenges the system poses to their professional identity.[15] Laying claim to an ethical responsibility that impels them to denounce forms of domination, the registers in which the artists formulate their opposition unfold through various forms of action. Graduates of the École supérieure des beaux-arts d'Alger, they participate in local and international exhibitions, and are invested in autonomous and collaborative projects such as the alternative space Box24 and the artist-run series of exhibitions Picturie générale.[16] Over the course of several research trips to Algiers, I developed connections with the artists participating in these initiatives, maintaining relations with the help of the modes of sociability the internet enables, such as Facebook and Skype. In general, I favored a chrono-biographical approach to the work, based on intensive interviews, where I could learn about things that were sometimes far from the subjects of concern, but which turned out to be important, in order to understand artists' social logic, and to measure what was at stake in the political context.[17] Because this investigation required a flexible approach, informal exchanges played an important part in the way I collected information over a relatively long time period (2011–14). It was an exceptional period on a symbolic level: 2011

saw the beginning of the Arab uprisings; 2012 marked the fiftieth anniversary of Independence; 2013 saw the French intervention in Mali and the recent evolution of the Syrian crisis. All of these events raised anew questions about foreign intervention and the specter of radical Islam, which are particularly sensitive questions, given Algeria's recent history. In these significant contexts, my status as a foreign researcher, moreover a French one, and my involvement with the group of artists, both as a friend and a professional, made it possible to assess, on a local level, the disputes that derived from an imbalanced relationship between West and East, or between the former colonial power and the former colony. Still relatively unexplored terrain, these issues call into question the researcher's legitimacy in a radical way.[18]

The body of work discussed in this article comprises a selection of visual sources of different natures, with aims that are either documentary (photographs, videos of performances, testimonies) or artistic (drawing, painting, comics, photography, video, installation). The work is distributed in various spaces, depending on the degree to which the artists are involved emotionally and professionally. Collected mostly on social networks (Facebook, YouTube), these spontaneous works are freely accessible. They are not copyright-protected or signed, but the artists often consider them legitimate parts of their practice, despite the fact that these works were not necessarily designed to be exhibited. This material is the only accessible visual trace of the artistic activity in this particular context. It does, however, sometimes manage to move out of virtual space—to be printed, published, or exhibited in public space. In those cases, these "professional" outputs are created in response to requests to participate in exhibitions in Algeria or abroad. These works thus constitute a source where a symbolic surplus is elaborated, determined by stakes connected to visibility and to local and international recognition, which dictate different strategies. The way these artworks are inscribed in the Algerian sociopolitical reality can thus provide the basis for analyzing the ways in which the political is expressed in a context of crisis, beyond determinist logics.[19] Using examples that illustrate militant commitment (Western Sahara) and the collective emancipation project (Autonomous Student Committee of the art school in Algiers, known as the Comité autonome des étudiants de l'Ecole des beaux-arts d'Alger), or the critical positions individuals adopted, I will try to evaluate the complexity of dispositions to artistic expression in what Paul Ardenne calls a "political moment" constituted by the Arab uprisings.[20]

2. "The Western Sahara: Here Begins the Arab Spring"

To introduce this analysis, I would like to return to comments made by the philosopher and linguist Noam Chomsky, on February 17, 2011, on *Democracy Now!*,[21] a program that aims to cover stories that its producers consider to have been ignored, or insufficiently covered, by mass media.[22] According to Chomsky the true cradle of the Arab Spring was Western Sahara. In November 2010, police forces violently repressed a peaceful initiative that had begun a month earlier, leaving dozens dead among both the Moroccan police and Saharan civilians, as well as hundreds injured in the Gdeim Izik camp near the city of Laâyoune in territories controlled by Morocco.[23] Chomsky pointed to the event as a trigger, a month before Mohamed Bouazizi set himself on fire. In doing so he claims to identify the beginning of the revolutions that took place in a region with a long and complex history.

Despite its problematic nature, this assertion, which privileges labeling at the cost of investigation, provided the militant association in Seville (the Asociación de Amistad con el Pueblo Saharaui de Sevilla, or AAPSS) with a chance to launch an artistic initiative at the sixth edition of the ARTifariti festival in October 2012.[24] Mohammed Walad made a series of interventions in a number of sites inside the Tidouf refugee camp in Algeria, using a template designed by Javier Mariscal, which includes the inscription *Comienzo primavera árabe* (Here Begins the Arab Spring). The organizers invited "artists and militants from the whole world to participate in this action painting" by posting photographs of stencils made in public on a blog created for the event.[25] The fact that there have been no uploads to the site since it was created would suggest that this participatory project failed to bring artists together. Nevertheless, the administrative and material opportunities granted by the Ministry of Culture provided a most unexpected opportunity to put forward artistic projects in support of the Saharan people. Although the official position of Algeria, a historical bastion of anti-colonialism and anti-imperialism, is a non-negligible factor in the social legitimation of the cause, the apparent lack of interest in this participatory action should without doubt be ascribed to the limitations of ARTIfariti, which is an event existing in a limited framework, rather than to content calling for unity around the "Arab Spring" label. Beyond the festival, given the constraints on artists' daily lives, it is likely that a hierarchy of needs exists; an extract from my field log notes that in Algeria "creating is already a political engagement."

The example of "Western Sahara" shows some of the consequences of the desire to force the label "Arab Spring," rather than attend to the issues in a situation in which the sociopolitical stakes have to be understood within specific histories. This desire produces incoherence.[26] Furthermore, the apparatus of a participatory blog constitutes a special case: its driving force depends on the extent to which the organizers can maintain commitment, individual or collective, beyond the limits of the festival. The little impact this proposal had on artistic dynamics leads one

to wonder whether the Arab uprisings provoked the emergence of new modes of contestation, and new formulas for production in the Algerian art world.

3. The Autonomous Student Committee of the École des Beaux-Arts in Algiers: An Ephemeral Attempt at a Political Expression of Resistance

A brief recap of recent sociopolitical history will help us to better understand how Algerian artists positioned themselves with respect to the Arab Spring. To justify Algerians' wariness, or even fear, of political change, the media points to the suppression of revolts by the army in October 1988. This was followed by the beginning of a multiparty system, freedom of the press, victory of the FIS (Front Islamic du Salut), and the collapse of the electoral process, which led to the civil war in the 1990s. It should be noted, however, that the consequences of this trauma have been skillfully maintained by Abdelaziz Bouteflika's government in order to hold on to the legitimacy he acquired largely through national reconciliation.[27] Thus, although the wariness of the governing powers and the socio-economic situation may have had a similar impact on the eruption of demonstrations in 2011 as they did in neighboring countries, the explicit targets of contention reveal a mode of governing which makes Algeria an "exception" or "counter example" to these others.[28] Demonstrations, not in themselves a new fact, were undoubtedly influenced by the context of the Arab Spring, in their frequency, size, and, to some extent, in the claims made. However, contrary to what happened in neighboring countries, in Algeria the protests were less the direct expression of a desire for regime change than a demand for salary increases in different professions, rights to housing, rights to dignity, and against oppression by the State (*hogra*). The absence of explicit and formal political demands characterizes all those movements that, in general, take abstract aim at the "system," the "regime," or "power," while taking up the "Get Out" slogan made popular by different demonstrations in the Arab world.

Expressing a resistance that is anchored in a project for society has little to do with militant support for an identifiable cause like Western Sahara. It is on such a corporatist model that the art students mobilized in the *polis* to lay claim to their rights. On April 16, 2011, the École supérieure des beaux-arts d'Alger (ESBA) officially joined the Coordination national autonome des étudiants (CNAE) by a declaration of support for the Algerian autonomous student movement. The art school is considered by artists of different generations to have been a place of reference for progressive protest since the independence of the country. Under the impetus of a small number of "bozartistes"[29] attuned to the political views of the revolutionary left Parti socialiste des travailleurs (PST), the activity of the Comité autonome des étudiants (CAE) was unofficially restarted during the riots in the working-class neighborhood of Bab El Oued in January 2011.[30] In a first show of support for these protests, the students rapidly

mobilized around a collaborative studio, producing work that was exhibited on the outside walls of the ESBA, before being removed by law enforcement, which claimed the work was disruptive.[31]

Nevertheless, advocating for the role of constructive and reflective action in the face of social injustice, they devised a distinctive ethic of modes of spontaneous street protest denouncing the abuse of public space, in particular destruction of common resources.[32] The meetings of the CAE were thus held according to an "illegal and anti-hierarchical" model; they included a log of actions,[33] and the staging of performative non-violent scenes between the ESBA and the Cité universitaire de Zéralda: "Opération *bidoun*" denounced the lack of water, transportation, and space,[34] while "Opération suicide collectif" (Operation Collective Suicide) railed against the morass of an unchanging curriculum. "Scènes de crime" (Crime Scenes) more specifically addressed the existential condition of designers and creative workers.

Although their content was inscribed in a general climate of protests over organization and pedagogy, the forms their mobilization took involved "emotional formulas" whose excess somehow belongs to the register of artistic production, even if it can be considered a little juvenile.[35] The difficulty in expressing open political contestation appeared in a tangible manner when the group formed by the committee decided to move beyond these installation-performances, created in a limited space, in order to "recreate a common dynamic" with the universities. It demonstrated that sharing performative experiences of protest remains localized in a community that is both physical and sociological. A call put out on April 15, 2011, and published on the CAE's Facebook page, bears witness to this:

> Students must become aware of their responsibilities. We intervene at the level of images, the visuals of a movement that transcends personal, political, and regional conflicts. It is up to us to mark the event by providing an image for it. Get to your cameras, crayons, computers, etc. All together for the same ideal! Put aside personal matters and egos, let's wield the creative baton and act! Posters, caricatures, photos, this will snowball on a national level! ... So let's act and beat that out everywhere. It is time for the École des beaux-arts to reclaim its place and its status. This is an accomplishment, and the return will be for us all.

The CAE's different propositions attempt to "generate debate and raise consciousness" by projecting a documentary film about 1968 and distributing images comprising a stylized black bludgeon on a red background with a series of explicit protest slogans: "In the streets!", "Aware and responsible," "From the University to the Streets," "Join the Movement," "Students calling," "We're not scared anymore," "I fight, therefore I am." However, during general assemblies some members of the university made clear that they disapproved of these actions.[36]

According to the members of the CAE, the École des beaux-arts "is not an isolated milieu disconnected from society."[37] Situating their movement as a continuation of the critical tradition developed in Europe, not unrelated to the teaching at the ESBA, they posit that "history has shown that artists and avant-garde arts have been the motor of all the struggles that have aimed to change society."[38] The members of the CAE draw their rhetoric from revolutionary ideals but it is impossible to grasp this dialectic logic without contextualizing it within an understanding of political engagement that cannot be distinguished from a progressive struggle, which, incidentally, is marginalized.[39] Given that it refers directly to the coercive force exercised by power against the population, it is clear that the reappropriation of a political imaginary inspired by the French experience does not resonate in a context in which mobilization happens on terms that submit to euphemized manners of laying claim. Thus, the CAE's dynamic had trouble coalescing around a specific social project. Even within the École des beaux-arts itself, the committee was in the minority and did not manage to rally students who were wary, fearful, or uninterested in these projects for change because they deemed them too radical.

The organized, spontaneous, and autonomous attempt at political expression of protest, of which the CAE is an example, does not share strategies with the festival in Western Sahara. While it is possible to create structured forms of autonomous resistance, this always remains dependent on logics in which normative behavior is interiorized. It is possible too that the inability to move beyond the localizing effect depends only on a form, perhaps a legitimate form, of "discontinuity" between the artist's ethos and logos. More fundamentally, however, it would seem to be connected to the "ongoing nature of the political game in Algeria."[40] Might the latter be the explanation for the semantic "slippage" that Algerian artists effect in relation to the Arab uprisings? Regarding Western Sahara, we saw how important the inscription in the media is for a political struggle, especially when it is relayed by an intellectual authority. The example also teaches us something about choice in processing information and its impact. On such grounds, the role of the media is more than ever considered critically by Algerian artists who read the unequal coverage of Arab uprisings—citing the fact that the protests in Bahrein received little coverage—as a sign of the way foreign powers impose their hegemony. As they see it, this hegemony is clear, both in the United Nations' intervention in Libya, and in the stalemate in the Syrian conflict.

4. Manipulated Arab Uprisings: Algerian Artists and the Media

Contemporary Algerian creatives target both the media's overexploitation of the Arab Spring and the way information is processed. Algeria's isolation during the years of civil war, and the image deficit maintained by the dominant media, especially the French media, have maintained this feeling of isolation.[41] These historical facts ground the argument about the "Algerian experience"

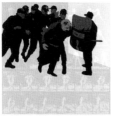

Mourad Krinah, *La Valse du Samedi*, 2011–12. Digital prints, 100 x 100 cm.

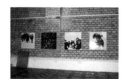

Mourad Krinah, installation view of *La Valse du Samedi* at the Mediterranean Biennial for Contemporary Art, Oran, March 2012. (c) Mourad Krinah.

in relation to the upheavals in neighboring countries. This is not, however, simply a matter of circumstantial positioning. For this generation of artists, most of whom were adolescents during the civil war, the memory of past events also constitutes an active connection with the present.

This work often circulates in part via social networks before reaching public exhibition spaces (galleries or museums). One of its characteristics is emotional reactiveness. The analysis of this work can tell us something about the modalities of symbolic inscription in society in the context of a crisis. The social uses of information and communication technologies also reveal artists' conception of political engagement, as well as the conditions of visibility of their work.[42]

Like autonomous student movements, attempts by other professions to assemble in public were rapidly checked by law enforcement agencies. The "1001" protests throughout Algeria in 2011 inspired *La Valse du Samedi* (The Saturday Waltz) by artist Mourad Krinah.

Practicing a misappropriation of photojournalism in order to question the meaning of the mediatized image, the artist isolated the dramaturgy of the repressive mechanism that oversees severely constrained public expression. The piece was initially titled *Pigs*, a reference to the English term for the police. The artist was denouncing the police violence that took place in the protests. The discourse shifts from targeted denunciations of the ways authorities exercise power to a more abstract denunciation of the ritual, and convulsive, "game" into which the media and protesters were drawn, the impression being that "no one was going all the way to avoid the excessive violence of our neighbors."[43]

The artist's critique would seem to suggest a certain reading of modes of action, and a conception of resistance that is far from the voluntary utopian project of the CAE students. According to the artist, dissent is expressed in a diffuse, individual, and "anonymous" way, outside an institutional framework, although that does not prevent his engagement from being tied to a collective social cause. This distancing is a response to the routine nature of the protests that denounce the consensus imposed by the Algerian system around freedom of expression and the occupation of public space. Nevertheless, the proposition according to which "there was not even real repression, a sort of well-orchestrated waltz," reveals as much about the complexity of the artist's experience inside a system that knows as well how to handle democratic discord as it does the isolation of a country from upheaval in neighboring countries.

Indeed, although the artist admitted some surprise at his work being selected for the second Mediterranean Biennial for Contemporary Art in Oran in March 2012, the register he used to voice opposition did not overstep the limits of what is tolerated in criticism of the leadership. Later, part of *The Saturday Waltz* and another piece, *(They) Occupy Algiers*, were also chosen to illustrate the exhibition "Newsfeed: Anonymity and Social Media in African

Revolution and Beyond" at the Museum for Contemporary African Diaspora Arts (MoCADA) in New York at the end of 2012.[44]

According to the exhibition's curators, the appropriation of information and communication technologies, by artists mainly from the African continent, was the new paradigm for the expression of social and political struggle against systems that threaten freedom. In Algeria, specifically in the capital, the significant increase of law enforcement was legitimized by the military victory in the anti-terrorism struggle of the 1990s. Indeed, the Arab Spring brought about a reinforcement of security forces that dissuaded, or broke up, attempts to gather in public.

Mourad Krinah, *(They) Occupy Algiers*, 2013. Digital prints, dimensions variable.

In *(They) Occupy Algiers*, Krinah cites the resistance of the activist collective Anonymous and of the Occupy movements and reverses the symbolic significance of anonymity: the omnipresence of the police becomes an "anonymous" threat. Exhibited as wallpaper in Picturie générale, a group exhibition organized in Algiers in January 2013 at the private art school Artissimo, this work was belatedly added to the MoCADA exhibition catalogue. It can be seen that the use of different participatory online platforms creates the circulation and re-appropriation of a store of symbols of popular resistance linked to different protest movements, from the economic crisis to the Arab revolts. This clarifies both the social uses of these images and the processes of professional interaction.

Mourad Krinah, installation view of *(They) Occupy Algiers* at Picture générale. (c) Mourad Krinah.

These artists believe that "the real wars start when the war of images begins to manipulate us." They denounce the way the media can be instrumentalized and defend the right to self-determination for all those dominated by forces of influence and control. Aiming to deconstruct the models used to understand the Arab uprisings, Sofiane Zouggar's *R-Evolution* and *Arab Spring Fashion Show* and Walid Bouchouchi's *Prêt à voir* illustrate "the reality of media that, from a consumerist view, favors shocking or sensational messages in the race for ratings." A complex phenomenon, "the Arab Springs [became] a fashion. The media and foreign countries select models from a few countries, despite the fact that the situation is different in each country" and "portray the majority of the population as revolutionaries," resembling the Libyan or Syrian uprisings. Appearing at the same pace as the events that prompt them, these images suppose an efficient reading, notably because they fix stereotypes of an Arab revolutionary (*Prêt à voir*) and use well-known iconographic reference points, like the raised fist or the Guy Fawkes mask (*R-Evolution* and *(They) Occupy Algiers*). It seems that these elements of popular resistance do not lead the artist toward a politicized discourse, but rather toward a universalist perception of popular resistance.

Sofiane Zouggar, *R-Evolution*, July 2011.

Sofiane Zouggar, *Arab Spring Fashion Show*, December 2012.

The flood of images disseminated by international television channels, by Al Jazeera in particular, the scope of the coverage of the conflicts, and the way in which they are treated as spectacle, provides the material for *Noise*, Sofiane Zouggar's installation that presented a montage of images of protest from the Arab uprisings and the crisis in Europe "as they were presented in the media."

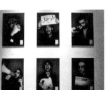

Walid Bouchouchi, *Prêt a voir*, installation: photos and found materials, 2012. (c) Mourad Krinah.

Sofiane Zouggar, *Noise*, video projection of still photos, 2012

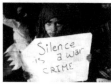

Walid Bouchouchi, installation view of *Prêt à voir* at Picture générale, 2013. (c) Mourad Krinah.

Thanks to an acoustic sensor activated by software, the artist allows the public to interact and control the selection of what "should be interesting as an event."[45] Just like *Prêt à voir*, this video was shown at the first edition of Picturie générale although it was produced in the context of a show for the festival World Event Young Artists in Nottingham, UK, in September 2012. Under the title "Disorder," that show was tasked with reflecting upon society's capacity for transformation and change. Although the description of the event contains no explicit mention of the Arab revolts, the organizers did underline the importance of having artists from the Maghreb and the Middle East.

Denouncing the media's control of information is not a new phenomenon in the history of art, although it is more trenchant when reenacted in the context of a crisis. This shows that political and social engagement is not necessarily articulated with conceptual finesse. Furthermore, one might be surprised at the critical distance of work that addresses the geostrategic role of mass media. References to Arab-Muslim identity, the revolutionary history of Algeria, or their own ethos as artists might have moved these artists to manifest explicit support for the cause of neighboring peoples. Note, however, that although this process of empathy is not to be seen in the images that circulate, it does emerge in discourses. What is deemed threatening is not the popular desire for political change, but rather the way this change might come about. In this sense, the position these artists adopt is not so different from the position of public opinion, which pleads for regime change in their country, as long as this comes about through political reform. Indeed, when an "Algerian Spring" is mentioned as a possible outcome, the memories of the 1988 revolts and of the civil war resurface. These do not trap public opinion in a fear of change, so much as cast doubt on the very idea that change is possible.[46]

Contrary to their "bozartistes" friends, professional artists did not actively participate in the dynamic of the CAE. Among other reasons, that is because it was connected to student preoccupations that no longer concerned them. Nevertheless, it is not impossible that certain experiences were shared by different generations, as attested by InfidjArt, the last big protest movement, which began at the ESBA in March 2015.[47] Thus, the stakes for these artists would seem to be outside the framework of information that is perceived as manipulated by the strategies of those powers on which the future of Algeria, and the Arab region in general, is seen to depend. More fundamentally, the position they take—distanced, and tinged with disillusioned humor—allows Algerians, even those aware of the system's limitations, to comfort themselves with a model of political stability in their country; this is reassuring after Mohamed Morsi's overthrow and the reinstating of military power in Egypt, and in the face of the dramatic situations in Libya and Syria. The media constantly invokes the decade of civil war in Algeria as a warning.

5. Contesting with Images from the Margins: The Limits on Modes of Being and Acting

Although it may be the case that, to quote Bourdieu, "the only truth is that truth is a stake in struggles,"[48] the way the protagonists reflect on their actions betrays a certain malaise, and ways of thinking and acting that are sensitive to conspiracy theories passed on by journalists, researchers, and political figures. By putting the role of information at the heart of their narrative, they also show that the decentralized, network-based structure facilitates conspiracy theories.[49] The work of these artists thus reaches its limits through an apparent disengagement, one that sacrifices the possibility of taking a stand against conservative protectionism. Pointing to the ways in which the elites in power have diverted "real" history, popular sentiment tends, at the same time, to reproduce its anxiety-provoking mechanisms.[50] Yet, surely, this need for transparency brings us back to the daily experience of a resistance that attempts to speak against the opacity of the political system.[51]

Thus, it would seem that ultimately what drives the political engagement of a generation of artists who are concerned with the inscription of art in the public sphere, is the need to achieve "social visibility." Characterized by the audience they reach, as much as by their transitory nature, new artworks, often created reactively, follow one another as fast as the socio-political events that solicit them. These examples illustrate the difficult emergence of a counter-center at the margins of power, revealing that representation of public space, as a space for meetings and multiple perspectives, is in crisis. Artists' projections concerning public space underline the fact that the conditions of visibility of art depend on the state apparatus' production in the cultural domain, and that the way the works are integrated into public space is related to the way power is exercised. The stands artists take flow from a commitment to challenge iniquitous situations, but their use of social networks also depends on the structural limits set on modes of expression. Positions are voiced through collective and autonomous arrangements; the sharing of information remains, however, restricted to a community. Moving from virtual to physical space, these objects acquire a visibility that is determined by the symbolic stakes connected to the Arab Spring as well as the wider context. The role of social networks should not, however, be overestimated. They do not provide answers either to the demands for visibility specific to artistic work, or to the structuring of social mobilization in public space.[52] Within the space of social networks, there is no coordination, nor even any politically structured discourse, because, with a few exceptions, as we saw in the CAE, the artists do not identify their positions as having an explicitly political, or even democratic dimension. Symptomatically, those terms rarely appeared in our interviews, contrary to references to ideas of commitment and responsibility.[53] Nevertheless, the fact that they interiorize depoliticized language does not mean that the actors consider their actions to be apolitical; rather it shows that they act *as if* that were the case.[54] This is illustrated, for example, by

the way that, in our exchanges, the artists offered colorful evocations of the defect in the system that helps bring it down.

Understood as an event that induces the emergence of specific new narratives, the impact of the Arab uprisings makes it possible to show the complexity of the shapes and trajectories of artistic creation in a political moment. Without dismissing the specificities proper to the context, my study suggests that we look at the relation between art and political engagement in historical perspective, wherein the function of artists has a necessarily social, and even demagogic, dimension, determined by anti-colonialist and anti-imperialist ideals present since independence. Analysis makes it possible to detect a certain permanence of orientations in discourse and representations of actors in the art world. However, in order to think about ways of expressing resistance and its consequences, this generation invokes the imagery of the October 1988 protests and the civil war, rather than the imagery of the War of Independence. Furthermore, although the types of production developed during the Arab uprisings are not very different from the usual habits of artistic creation (video, installation, graphic design), the ways experiences are shared within the artistic community take on new meaning in these times of protest. Indeed, these moments authorized a reformulation of the social identity of the artist, grounding it in an ethics of responsibility, and the defense of art's autonomy in the face of the coercive power of the state.

Thus, contrary to other Arab political scenes, where revolts against regimes targeted their figureheads, the attempts at mobilization in Algeria contested the "system" or "power," whose opacity seems to contribute to the mobilization of infra-political registers.[55] The geopolitical strategies of Western countries, Qatar, or Saudi Arabia are, unsurprisingly, driving a renewal of neocolonial critique that is itself inscribed in the context of a wider denunciation of hegemony. In this framework, the Arab uprisings are perceived as the means these powers use to destabilize the region, and, although they do not refuse the idea of change, Algerian artists hope it will be sovereign, and serene. Furthermore, the images produced in connection with the Arab uprisings only reached the public insofar as the artists had a chance to make themselves visible at the local level (private initiatives) or at the international level (applications, recommendations). At the local level, the production of politicized images that take aim at the system can lead to the rules being reshuffled through censorship and self-censorship, even if the rules of the game remain undefined. At the international level, although the repercussions of the Arab uprisings have played a part in the increasing number of artistic events, interest in a country where there were no spectacular upheavals remains low. The reception of these works is made difficult by the fact that they do not participate in a Manichean denouncement of evil (political authoritarianism or religious extremism), or strengthen a romantic imagery of revolution, or explicitly defend the democratic values through which foreign actors recognize their projections of the Arab world. In any case, the action of Algerian artists who produced artworks related to the Arab

Spring cannot be understood as simply strategic. The constraints they face locally today remain the same, unaltered, as obstacles to their visibility.

Special thanks go to the artists Samir Abchiche, Walid Aïdoud, Maya Benschikh El Fegoun, Walid Bouchouchi, Mehdi Djelil, Mourad Krinah, Fares Yessad, and Sofiane Zouggar.

Fanny Gillet

Born in 1979 in France. Lives and works in Paris, founding member of Research Group on Visual Art and Maghreb and the Middle East (ARVIMM), and a doctoral candidate at the University of Geneva.

1 This work was first presented in May 2013 during the workshop organized by Annabelle Boissier and Anahi Alviso-Marino under the title "Effets du cycle des révoltes arabes sur les mondes de l'art: De l'inspiration à l'opportunité" (Effects of the Cycle of Arab Revolts on the Art World: From Inspiration to Opportunity). I am grateful to the participants for their comments, which helped me develop my thoughts. Thanks also to Annabelle Boissier, Marine Branland, and Alain Messaoudi for feedback on this article.

2 In order to avoid a partisan reading of the conflict, I use this term, borrowed from Luis Martinez, *La Guerre civile en Algérie, 1990–1998* (Paris: Éditions Karthala, 1988).

3 Cherif Bennadji, "Algérie 2010: L'année des mille et une émeutes," *L'année du Maghreb*, vol. 7 (2011): 263–69.

4 For an analysis of the mobilizations in the Arab-Muslim area before and after the Arab uprisings, see the publications of Mounia Bennani-Chraïbi and Olivier Fillieule, *Résistance et protestations dans les sociétés musulmanes* (Paris: Presses de Sciences Po, 2003) and "Retour sur les situations révolutionnaires arabes," *Revue française de Science Politique*, vol. 62 (2012), and "S'opposer au Maghreb," *L'année du Maghreb*, vol. 5 (2009). The collection edited by Amin Allal and Thomas Pierret makes the case for field research: *Au cœur des révoltes arabes: Devenir révolutionnaires* (Paris: Armand Colin, 2013).

5 Pierre Vermeren, *Misère de l'historiographie du "Maghreb" post-colonial (1962–2012)* (Paris: Publications de la Sorbonne, 2012). On art in Algeria, two dissertations should be mentioned: Chaïb Hammouda, "La peinture algérienne depuis l'indépendance: Precedents et situation de 1962 à 1988," History of Art dissertation, Université Paris VIII Saint-Denis, 1992, and Farid Saâdi-Leray, "L'auteur de génie et l'artiste créateur en Algérie: Modèles importés, renversés,

repositionnés puis singularisés," Sociology of Art dissertation, Université Paris VIII Saint-Denis, 2011.

6 As Pierre Bourdieu's analyses suggest, the symbolic, in the widest sense, makes it possible to grasp the processes through which social phenomena become visible in the eyes of those who live through them and observe them.

7 In their introduction, "La contestation dans l'art, l'art dans la contestation," Justine Balasinsky and Lilian Mathieu use the term "symbolic struggles" (*luttes symboliques*) to define the social and political struggles in which artists are led to take leading roles. *Art et contestation* (Rennes: Presses Universitaires de Rennes, 2006), 9–27.

8 See Annabelle Boissier, "La négociation entre art et politique: Les artistes contemporains et la bureaucratie Tunisienne," in *Les ondes de choc des révolutions arabes*, ed. M'hamed Oualdi, Delphine Pagès-El Karoui, and Chantal Verdeil (Beirut: Presses de l'Ifpo, 2014), 199–217; Anahi Alviso-Marino, "Soutenir la mobilization politique par l'image. Photographie contestataire au Yémen," *Participations*, vol. 3, no. 7 (2013): 47–71; Cécile Boëx, "Mobilisations d'artistes dans le movement de révolte en Syrie: Modes d'action et limites de l'engagement," in *Au cœur des révoltes arabes. Devenir révolutionnaires*, ed. Amin Allal and Thomas Pierret (Paris: Armand Colin, 2013), 87–107, and Cécile Boëx, "Montrer, dire et lutter par l'image: Les usages de la vidéo dans la révolution en Syrie," *Vacarme*, no. 61 (2012): 118–31; Cassie Findlay, "Witness and Trace: January 25 Graffiti and Public Art as Archive," *Interface*, no. 4 (2012): 178–82; Amanda Rogers, "Warding Off Terrorism and Revolution: Moroccan Religious Pluralism, National Identity and the Politics of Visual Culture," *Journal of North African Studies*, vol. 17, no. 3 (2012): 455–74.

9 Alban Bensa and Éric Fassin, "Les sciences sociales face à l'événement," *Terrain*, no. 38 (2002): 5–20.

10 Layla Baamara, "Quand les protestataires d'autolimites. Le cas des mobilisations étudiantes de 2011 en Algérie," in *Au cœur des révoltes arabes*, Allal and Pierret, 137–60.

11 As well as the studies cited in footnote 8 on European art, see the clarification of Maria Stravrinaki and Maddalena Carli in their introduction to *Artistes et partis: Esthétique et politique (1900–1945)* (Dijon: Les presses du réel, 2012), 5–25.

12 Mostefa Lacherag, *L'Algérie: nation et société* (Paris: Maspéro, 1969). From the perspective of the arts, see Fanny Gillet, "Les artistes algériens pendant la guerre d'Algérie: Entre quête de reconnaissance et construction d'un discours esthétique modern," *Textuel*, no. 63 (2010); "Pratique artistique et régime de l'image dans l'Algérie post-coloniale: 1962–1965," *Quaderns de la Mediterrània*, no. 15 (2011), http://www.iemed.org/publicacions/quaderns/15, and with Annabelle Boissier, "Ruptures, renaissances et continuités: Modes de construction de l'histoire de l'art maghrébin," *L'année du Maghreb*, vol. 10 (2014): 207–32.

13 See Nadira Laggoune-Aklouche, "Art et crise sociale en Algérie," in *Art et engagement: Actes du colloque en hommage à Abdelhamid Benzine* (Algiers: Éditions Les Amis de Abdelhamid Benzine, 2008), 37–42.

14 James McDougall, "Social Memories 'in the Flesh': War and Exile in Algeria," *Alif: Journal of Contemporary Poetics*, 30 (2010): 5.

15 It is only recently that the Ministry of Culture has authorized artists and authors to be covered, and have access to social services with the same benefits as workers (Executive Order nos. 14–69, February 9, 2014). Although one should not overestimate the consequences for not on artistic dynamics,

active artists constantly denounce the conditions for professional artists, limited by lack of exhibition spaces and means for creation. The denunciation is also driven by the fact that artists are subjected to a cultural policy that is often judged to be opaque, and subject to cronyism by those who are excluded from it.

16 The first was an apartment that occasionally served as a place for exchanges and exhibitions, the second is an annual exhibition devoted to young Algerian artists' work, the first edition of which took place in January 2013 (http://issuu.com/mourad-krinah/docs/picturie_generale_catalogue_web), the second in March 2014 (https://issuu.com/mourad-krinah/docs/catalogue_picturie_2_web), and the third in April 2016. In both cases, the exhibitions were held outside institutions (museums, galleries), in private spaces (apartments, an art school, offices, or industrial wasteland) and were free and open to the public. The website Annaba Art Scene was also created in June 2013 to increase the visibility of artists from this region of Algeria.

17 Because I prefer to let the term "political" emerge through the actors, I chose not to use the term during our interviews. It seemed too narrowly associated with a model of exercise of power "from above," rather than with the constructive relationships that dominated actors can build within their society. See Anahi Alviso-Marino and Mariane Poirier, "Revenir sur le choix du terrain: Réflexions sur la temporalité et l'engagement dans la recherché au Yémen," talk at CESSP, "Pour une objectivation de la recherche en pratique," 2011. On the benefits of intensive interviews, see Stéphane Beaud, "L'Usage de l'entretien en sciences sociales. Plaidoyer pour l'entretien ethnographique," Politix, vol. 9, no. 5 (1996): 226–57.

18 The knowledge and power stakes that determine relationships of latent conflict are indeed expressed in a

restricted context in which the terms of competition are exacerbated by the fact that the actors on the ground, both in France and in Algeria, often seek a monopoly. Protectionist reactions from those who produce knowledge, whether institutions or private individuals, might thus be understood in relation to strategies for auto-determination, when faced with a researcher laden with methodological tools and knowledge geared to elaborating a critique in an art world that struggles for recognition. On this subject, see Natacha Gagné, "Le Savoir comme enjeu de pouvoir. L'ethnologue critiquée par les autochtones," Les Politiques de l'enquête, ed. Alban Bensa and Didier Fassin (Paris: La Découverte, 2008), 277–98.

19 See James C. Scott, "La prise de parole sous la domination: les arts de la dissimulation politique," in La domination et les arts de la résistance: fragments du discours subalterne (Paris: Éditions Amsterdam, 2008), 153–98.

20 In L'Art dans son moment politique: écrits de circonstance, Paul Ardenne proposes a notion of politics that is deliberately wide: "All at once the relation to the polis, the public and opaque organization of common usages in the social body, and its systems (including, in particular, the art system), but also the matter of legitimacy, of domination, and of the activist logic of competitions" (Brussels: La Lettre volée, 2000).

21 See https://www.youtube.com/watch?v=JTjOt0Pz0BQ.

22 Since its annexation by Morocco in 1975, there have been recurring insurrections in Western Sahara, which has been a bone of contention between Morocco and Algeria for almost forty-five years.

23 Although there is some identity component to the demands made by Saharans, they are more specifically oriented toward a socioeconomic plan. For an analysis of this situation, see Carmen Gómez Martín,

"Sahara Occidental: quel scénario après Gdeim Izik?," L'année du Maghreb, vol. 7 (2011): 259–76.

24 Since 2007, the group has organized the "Rencontres internationales des arts en territoires libérés du Sahara Occidental à Tifariti," a militant festival in support of Saharan rights, commonly referred to as ARTIfariti.

25 http://comienzoprimaveraarabe.blogspot.fr/. The images that will be discussed are available on the site.

26 For a clarification of the terms: miliantisme (militant activity) and engagement (political engagement), see Nicole Brenez, "Édouard de Laurot: L'engagement comme prolepse," talk at Bétonsalon, Paris, Les voies de la révolte: Cinéma, images et révolutions dans les années 1960–1970 (2011), https://archive.org/details/TheMilitantImage.ACine-geography.N.brenez.EdouardDeLaurot.

27 It began with the law on Concorde civile (Civil Peace) in 1999, the year of his election. Then, in 2005, the adoption of the Charte pour la paix et la reconciliation nationale (Charter for peace and national reconciliation) officially ended the civil war.

28 See Mohamed Rezzik, Le Printemps arabe et l'exception algérienne (Algiers: Self-published, 2013); Hocine Belalloufi, La Démocratie en Algérie, Réforme ou révolution? Sur la crise algérienne et les moyens d'en sortir (Algiers: Apic-Lazhari Labter, 2012); Lahouari Addi, "Le régime Algérien après les révoltes arabes," Mouvements, no. 66 (2011–12): 89–97; Louisa Dris Aït Hamadouche and Chérif Dris, "De la résilience des régimes autoritaires: La complexité Algérienne," L'année du Maghreb, vol. 7 (2011): 279–301.

29 Or "beaux-artistes," the name commonly given to fine arts students in Algiers.

30 The ESBA student committee's activities seemed stalled at the time when the February 23, 2011 Decree 10-315 was repealed. That decree devalued the diplomas given under the old educational system. Encouraged by the context of the Arab Spring, this decree is what sparked the student protest on April 12, 2011, organized by the Comité national autonome des étudiants (CNAE). It was the largest student protest since 1987.

31 This account relies on my field logbook and conversations with people involved who will remain anonymous. Below I also use the texts that accompany the works as sources.

32 According to one of the actors, passersby showed such curiosity for the drawings that it provoked traffic jams in the street. This is why the drawings were removed. The action is documented in a video by Walid Bouchouchi, http://www.youtube.com/watch?v=uBGBNaiWOwk.

33 Some documents are reproduced on the committee's Facebook page, https://www.facebook.com/cae.esba. Spelled out in the report of March 8, 2011, the CAE's demands were then repeated in letters sent to the head of the École des beaux-arts in April 2011. They involve the revalorization of the school's diploma after the LMD reform, the possibility for ESBA students to register with the ONOU (Organisation nationale des œuvres universitaires) to obtain a permanent resident status in the university housing, a request for a room and computer equipment, as well as the possibility of communicating the committee's activities through a local bulletin board, and the opening of spaces for socialization on the school premises. Images of the installation-performances are available on CAE's Facebook page.

34 *Bidoun* is a complex term literally meaning "without" but also "stateless, without a country."

35 Aby Warburg's concept of *Pathosformel* refers to the expression of elementary drives that come from Western pagan iconography. Reinterpreted as a "mnemonic code" throughout the ages, the crudeness of this vocabulary can prove to be socially inadmissible (*The Renewal of Pagan Antiquity*, Los Angeles: Getty Research Institute, 1999), cited in Carlo Ginzburg, *Fear, Reverence, Terror: Five Essays in Political Iconography* (London: Seagull Books, 2017). The situated anthropological value of this term might be examined in the light of phenomena linked to the adaptation of modernity in extra-Occidental settings. Here it is adopted for its literal signification.

36 These images were produced by a small group of art students in Algiers. They were circulated via Facebook and reproduced on leaflets distributed during student protests in several cities (see the CAE Facebook page).

37 As one example, there is the film club that, as its director explained, made a special place in its program for the question of the relation between art and politics.

38 These quotations come from the notice published on the CAE Facebook page, April 16, 2011.

39 See Annabelle Boissier and Fanny Gillet, "Ruptures, renaissances et continuités."

40 Mohammed Hachemaoui, "Permanence du jeu politique en Algérie," *Politique étrangère*, no. 2 (2009): 309–21. See also by this author *Clientélisme et patronage dans l'Algérie contemporaine* (Paris: Karthala-Iremam, 2013).

41 Published in 1981, Edward Said's *Covering Islam* provided a critical analysis of the portrayal of Muslim countries in Western media. It was (belatedly) translated into French as *L'Islam dans les médias* (Arles: Actes Sud, 2011).

42 Yves Gonzalez-Quijano has worked on the role of social networks in the dynamics of the Arab uprisings; see *Arabités numériques, le printemps du web arabe* (Arles: Sinbad, 2012).

43 The extracts in this section are drawn from my field logbook and the texts in the catalogue for the Picturie générale show.

44 "Newsfeed: Anonymity and Social Media in African Revolutions and Beyond," MoCADA, New York 2012. This exhibition was a critical exploration of the role of social networks in relation to "traditional" activism. It originated in a collaborative platform that aimed to put into dialogue visual expressions of support for various movements from the Arab uprisings to the Occupy movement, or the destruction of mausoleums in Timbuktu, Mali.

45 See also Atef Berredjem's video *Living with the Aliens* (2012), which refers to *baltagisme*, a phenomenon whereby the authorities use groups of young unemployed men to fight against demonstrators. This became widespread during the Arab uprisings.

46 See Edward McAllister, "Immunity to the Arab Spring? Fear, Fatigue, and Fragmentation in Algeria," *New Middle Eastern Studies*, 3 (2013): 1–19.

47 Wordplay with the Arab term *infidjar*, which means "explosion." This movement officially began on March 15, 2015 and lasted about three months. It rose up against "the submission, suffering and obscurantism felt in the institution [the ESBA] in the last years." Facebook page: https://www.facebook.com/IfidjArt-1566624000290291/ and Youtube: https://www.youtube.com/channel/UCb2pSuqX8EOMN2gALeajOyA.

48 This phrase introduces the conclusion of Bourdieu's *Science of Science and Reflexivity*, trans. Richard Nice (Cambridge, UK: Polity, 2004).

49 See the analysis of conspiracy theories applied to the context of post–civil war Algeria in Paul A. Silverstein, "An Excess

of Truth: Violence, Conspiracy Theorizing and the Algerian Civil War," *Anthropological Quarterly*, vol. 75, no. 4 (2002). The author takes issue with an approach that links conspiracy theories to a form of "monolithic" resistance to the dominant power by invoking the fact that these types of "vernacular" productions contribute just as much to reproducing the domination mechanisms they criticize. My analysis of the artists' representations converges with his hypotheses.

50 McAllister, "Immunity to the Arab Spring?," 5–6.

51 On the elaboration of a theory of public speaking under domination, see James C. Scott, "La prise de parole...."

52 For a synthetic approach to the connections between media and protests, see Erik Neveu, "Médias, mouvements sociaux, espaces publics," *Réseaux*, vol. 17, no. 98 (1999): 17–85; and on the role of information and communication technologies, see Dominique Cardon and Fabien Granjon, *Les médiactivistes* (Paris: Presses de Sciences Po, 2010) and Fathallah Daghmi, Farid Toumi, and Abderrahmane Amsidder, eds., *Les médias font-ils les révolutions? Regards critiques sur les soulèvements arabes* (Paris: L'Harmattan, 2013). On the role of the internet in the Arab world, see Yves Gonzalez-Quijano, "À la recherche d'un Internet arabe: démocratisation numérique ou démocratisation du numérique?," *Maghreb-Machrek*, no. 178 (2003): 22–35.

53 As an example, I cite this sentence, which an artist uttered in jest when I tried to bring up the student protests of 2011: "Tu parles beaucoup de politique" (You talk about politics a lot).

54 Lisa Wedeen, "Acting 'As If': Symbolic Politics and Social Control in Syria," *Comparative Studies in Society and History*, vol. 40, no. 3 (1988): 503–23.

55 On the forms of claims during the Arab revolts, see Michel Camau, "La Disgrâce du chef: Mobilisations populaires arabes et crise du leadership," *Movements*, no. 66 (2011–12): 22–29. It is however necessary to bring this analysis back to observations on the ground, insofar as, as Layla Baâmara shows, protesters establish evasive strategies through which to be heard, and in these strategies, "power" or "the system" cannot be important targets. Mahfoud Amara's study, "Football Sub-Culture and Youth Politics in Algeria," *Mediterranean Politics*, vol. 17, no. 1 (2012): 41–58, provides additional analysis of the modes of public contestations in Algeria.

Frantz Fanon, an Icon? Thoughts to See: Fanon's Algeria in the Visual Arts

Émilie Goudal

TRANSLATED BY OLIVIA CUSTER

"We will have to bind up for years to come the many, sometimes ineffaceable, wounds that the colonialist onslaught has inflicted on our people."
— Frantz Fanon, 1961[1]

Frantz Fanon's presence in Algeria, and the singular account he gave of the problems underlying the relevance of decolonization, resonate in his analysis of social and racial discriminations as this was already formulated in his first publication, *Black Skin, White Masks* (1952).[2] Considering the Algerian situation, he bolstered his analysis by denouncing assigned identities—in terms of class, race, and gender—to identify, and reject, the construction of an essentializing perception of the Other. He writes: "It is the white man who creates the Negro. But it is the Negro who creates negritude. To the colonialist offensive against the veil, the colonized opposes the cult of the veil."[3] Although in the anamnesis of the racist mechanics he formulates Fanon distinguishes, and overturns, the racist assignation of "Negro" in his text, the experience of racialization, and the hope that African insurrection would prevail, led him to identify with the oppressed and colonized class, and to name himself among the Algerians, transcending these categories. Thus he refers to "We, Algerians" throughout *L'an V de la révolution algérienne* (*A Dying Colonialism*, 1959), and in the one who speaks for the silent minorities in *The Wretched of the Earth* (1961). Agent, witness, and theorist of decolonization, Fanon is linked to the Algerian territory by his psychiatric practice (he was head of department at the mental health hospital in Blida from 1953 onward), then through his political and intellectual investment in Algerian Independence. At the time of his premature death in 1961, he left, in *The Wretched of the Earth*, a precious testament to his presence in a colonized territory fighting for its emancipation and an emphatic denunciation of the colonial system. In recent decades, artists have offered visual accounts of the work and figure of Fanon, articulated in relation to a contemporary representation of Algeria. They interrogate the possibility of displacing the projected and constructed gaze on a country that is marked, both visually and historically, by colonial denial.[4] The idea of visuality, which is at the heart of a number of epistemological debates since the 1990s, makes it possible to consider how social, historical, and aesthetic values intermingle in the study of the visual domain, and helps us apprehend the mechanisms through which construction, but also deconstruction, through and by images, occurs.[5] The political value attributed to the notion of visuality, notably as it is defined by Nicholas Mirzoeff, makes it possible to cast doubt on the arrangements from which representations emerge to face the seeing subject and, with that subject, create both an ambiguity, and the possibility of an alternative writing, a *counter-visuality*, within a dominant visual narrative.[6] Could thinking the visual representation of Algeria through the prism of the Fanonian icon—not in its sacred dimension, but insofar as it embodies a certain foothold, and a possible historical authority and alternative

epistemology—open toward a displacement in the direction of decolonizing the gaze on a visual space that is haunted by a colonial denial? In other words, could invoking Fanon in the visual arts today provide the conceptual means for thinking about visuality in Algeria through the prism of an *aesthesis* of emancipation?[7]

Return of the Figure of Fanon: The Visual Construction of an Icon?

It is a good idea to reread Fanon today: he illuminates the contemporary period, particularly because he pushes us to rethink the construction of assigned identities, and to consider how to overcome a certain racialization, or ethnicization, of representations and culture. Even if, as Azzedine Haddour observes, "Fanon remains a relatively minor figure in France and in Algeria,"[8] he has received much critical attention in the anglophone world, where Fanon's work has been one of the major sources for the critical theories formulated in postcolonial, decolonial, and cultural studies. Through percolation, Fanon then interacts with the space of artistic representation, whether as a central figure in artworks or metaphorically through visual productions that reference, or are inspired by, his writings. In the spring of 1995, the exhibition "Mirages: Enigma of Race, Difference and Desire" in London brought together a number of intellectuals and contemporary artists around the tutelary figure of Frantz Fanon.[9] The exhibition culminated in a conference, the proceedings of which were published as *The Fact of Blackness: Frantz Fanon and Visual Representation*. Formulated essentially around the question of race and sex, this volume suggests we think about visual representation from a decolonial perspective, around the notion of blackness.[10] Indeed, the title of the publication refers to the English translation of the first chapter of *Black Skin, White Masks*. Between the original phrase, "l'expérience vécue du noir" (the lived experience of blackness), and the English translation, "the fact of being black," the existentialist dimension, which emphasized the construction of the self through lived experience, seems to have been lost. Respected by posterity for his foundational work on systemic racism, as well as for his thought forged in the context of a decolonial war, Fanon is one the major figures of emancipation in Algeria. This exhibition and its publication seem to avoid these facts as they concentrate on Fanon's contribution to the construction of critical thinking subsequently developed by colonial studies and cultural studies.

In the wake of these events around the figure of Fanon, Isaac Julien, founder of the Sankofa Film and Video Collective, shot the feature-length film *Frantz Fanon: Black Skin White Mask*.[11] This docu-fiction traces Fanon's path, combining an analysis of the reception of his work by contemporary theorists with acoustic and visual archive material, reconstitutions of scenes from his life, and extracts from his publications, to "render on screen the poetic dimension of the Fanonian text."[12] Fanon is played by actor Colin Salmon, who depicts key moments in the psychiatrist's biography, broken up by readings of texts chosen by Julien. Although *Black Skin, White Masks* provides

the framework and title for this poetic docu-fiction, the writing and reflections on systemic racism developed in *The Wretched of the Earth* and *A Dying Colonialism* are also present, in particular through the diagnosis they make of a colonial system that reproduces this *color line*,[13] or this blackness, against the colonized subject. This filmed transposition of the racist social separation understood by Fanon resonates closely with the political claims of black artists in the UK.[14] The events connected to the representation of Algeria in Julien's film seem to appear implicitly throughout the documentary. Algeria is present in the scenes related to Fanon's clinical activity, through the patients expressing litanies in Arabic, the appearance of women dressed in haik on whom photographs of unveiled women by Marc Garanger from 1960 are projected, and, further, in the image of the floating flag, brandished by Fanon at arm's length, in the desert.[15] This representation of the desert, which evokes the limbo the country experienced at the time of the struggle for Independence, also echoes the deadly attacks that were tearing the nation apart at the time the documentary was being filmed. It was 1995, and filming could not take place in Algeria because of the violence of the Black Decade. The work acts as a sort of memorial to the martyrs of Algerian Independence, as well as to the victims of the "fratricide war" that was raging at the time.[16] The narrative thread of Julien's film weaves connections between Fanon's biography and the period in which the film was made, in the middle of the Black Decade, thus reducing the ellipsis of the thirty years that stand between them. This temporal connection is supported by the words of Fanon's son who, at the film's end, reminds us:

> I am forty years old, I am the son of a martyr of the revolution, as we speak of son of a 'shahid.' There are a few thousand of us, a few million in Algeria ... whose parents died so that the country could stand. Today, thirty years later, this country is on its knees, not to say sitting down. Fanon is a theorist of the revolution, Fanon would never have accepted this situation. Fanon disrupts.[17]

Between hope and disillusion, the film uses an epanadiplosis: Julien's visual narration opens and closes with the same final quote from *Black Skin, White Masks*, to frame the quasi body of the documentary with its prayer: "O my body, make of me always a man who questions!"[18] Julien employs the figure of Fanon in an attempt to sketch the complexity of the notion of the identity (or identities) of the "post-decolonial subject" as it tries to extricate itself from the "colonial self." Through this biopic, which restitutes Fanonian poetics, Julien seems to resurrect the influence of an existentialist perception of a *being-in-the-world*.[19] Homi K. Bhabha, interviewed in the film, confirms Fanon's iconic status: "At the bottom of an abandoned suitcase is a bag full of books about heroes, icons of bygone times. The covers are flags, launching revolutions, announcing the prophets that are fetish symbols of an era."[20] By offering this temporal journey, Julien evokes the theme of identity while updating the historicity of a mode of thought that seems relevant to him, to suggest this

Fanonian path. One might say that he looks from this icon toward the future, because the director does not only want to "return to Fanon, but to realize his ideas. To understand this past in order to give meaning to the future."[21]

All artists do not imagine reading Fanon from the same perspective. Depending on how historically involved they are, they sometimes opt for a more essentialized approach. Is it, then, because of a connection with the colonial history of France that video artist Eija-Liisa Ahtila calls on Fanon for a work created in Paris?

For a retrospective of her work at the Jeu de Paume in Paris in 2008, Eija-Liisa Ahtila made a new film installation, *Where is Where?*, which focused on a passage from *The Wretched of the Earth*.[22] The work articulates a fictional narrative around a short extract from Fanon's text, describing the "murder by two young Algerians, thirteen and fourteen years old respectively, of their European playmate."[23] The installation comprises six projection screens, multiplying the points of view, each of which direct the viewer's gaze to the act, reconstructed and heightened by Ahtila. This reference to a historical subject is unique in the artist's work, and she uses the example to develop her visual and poetic interpretation, focusing on the themes of violence, death, and childhood. Her encounter with Fanon is essential to understanding the piece. In an interview published in the exhibition catalogue, she says that she "stumbled on *The Wretched of the Earth* by chance, and read it with great interest. I knew who Frantz Fanon was, but I had not yet read any of his writings. At the time, in the fall of 2005, I was trying to document a theme that was still abstract, refugees and the passage between two cultures, which raises the question of identity, and notably national identity."[24] This transposition of questions around the themes of "national identity" and "refugees" is then made visible through her choice of actors, which she also discusses in this conversation. When interviewer Doris Krystof underlines the duality of the choice of a white woman poet facing two "black boys," she responds: "In the book, the boys are Algerian. These roles are played by two Finnish boys, one whose parents are Moroccan, the other whose parents are Palestinian."[25] For these roles, Ahtila deliberately chose "black" and "white" actors whose distinct origins (Palestine, Morocco) meet around the common denominator of Finnish citizenship and the Finnish language. Yet Ahtila makes a slippage in signification when she quotes the English edition of *The Wretched of the Earth*. When the artist reuses the narrative device of the psychiatrist's interview with one of the young boys after the murder, she substitutes the term "Arabs" for "Algerians," as per the English translation of the text: "because the Europeans want to kill all the Arabs," and films the young man repeating this, word for word.[26] However, the short testimony of this case, number 1, in Fanon's original French version, reports that, "One day we decided to kill him, because the Europeans want to kill all the Algerians."[27] This semantic slippage, the tension produced by the translation, bears witness to an essentialization of Algerian identity, and obscures the decolonial perspective which is, in fact, being played out in the context of the War of Liberation.

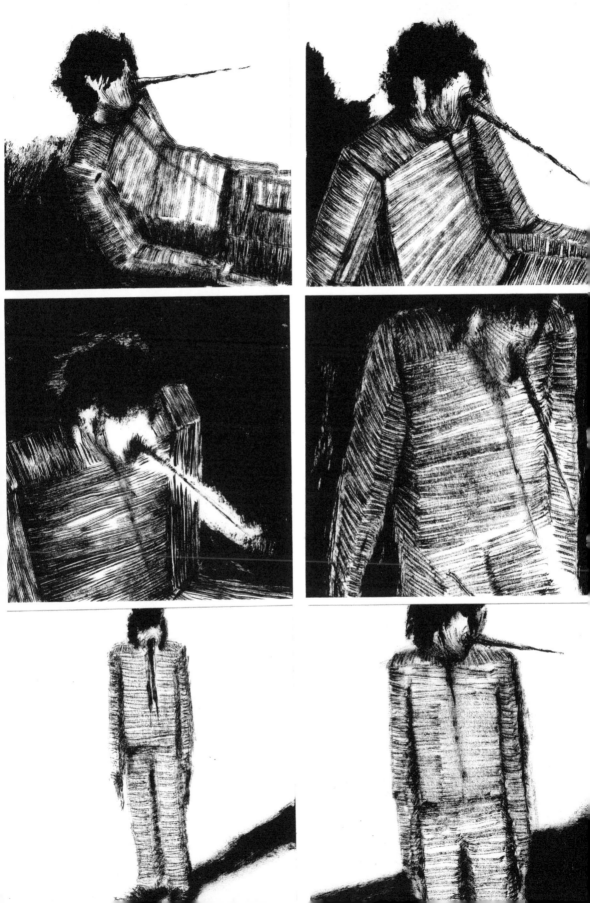

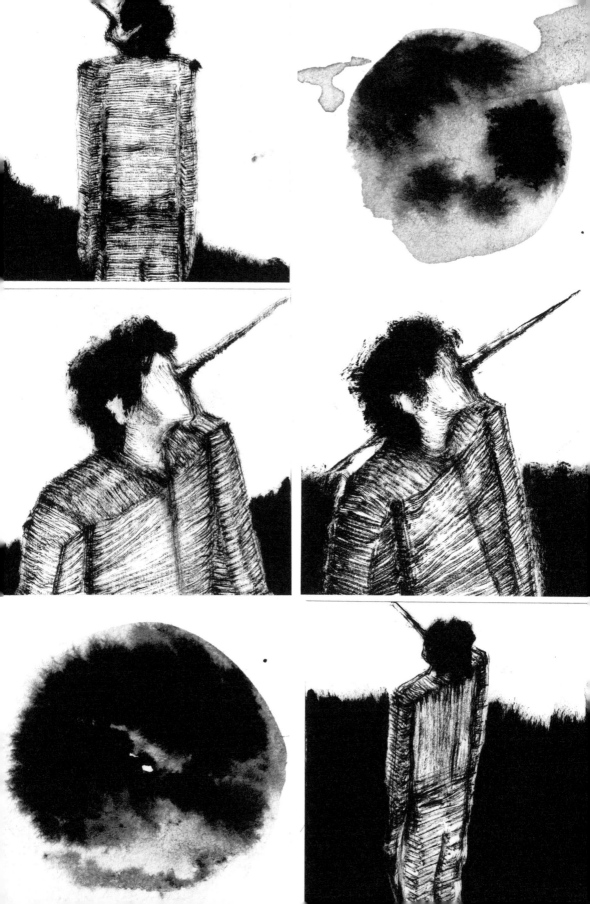

This substitution, which corresponds to a racialization of the term "Algerian," denotes an interpretation of historical fact that is at odds with Fanonian thought, from a "We, Algerians" in which he, a black man, from the Antilles and of French nationality, recognized himself and identified as a brother, damned. Ahtila, via this English translation, concentrates on the tenacity of facts, and not on the dialectics of emancipation and the deconstruction of assigned identities, which Fanon develops throughout his work. As a result, several interpretations of *Where is Where* note the subjective character of her reading.

Around this case, which shows the impact of the violence of war and colonialism,[28] here especially on adolescents, the artist develops a variation focused on a meeting between death and poetry, in the context of a "confrontation between two cultures,"[29] illustrated by the murder committed by the two young boys. As if to respond to the vision of murder, Ahtila confronts the reconstitution of the crime narrated by Fanon with the representation of archival images relating to the massacre in Rivet, perpetrated by French militias in 1956, cited by Fanon as one of the triggering events for the killing. The climax of the installation remains, however, the realistic reconstitution, in natural settings, of the murder of the young European friend. The dramatic tension is accentuated by the scene being projected simultaneously on all six screens. Ahtila's interest in the relationship to childhood likely determined the choice of this scene: How do the adult wars and discriminations of the colonial system impact the younger generations? These children, like those one could see "playing war" in Agustí Centelles's chilling photographs from the Spanish Civil War, are here directed by the artist to "replay" a crime, which carries the charge and violence of a war against a discriminating colonial system. The entire installation rests its conclusion on the question of its title, voiced at the end of the film by "the elder of the young Arabs [Algerians]." The latter appears in front of her and asks, "Is death always something intimate? When one is dead, where is one? And where is where?"[30] This work investigates the space of limbo between life and death, a space-time that the artist both transcends and puts into tension, but without picking up on the theoretical principles of the tutelary author she summons. Ultimately, she replays a sort of "civilizational" shock. From this dimension, left suspended, from this question left open for reflection, there emerges an unease, generated by the reproduction of the assignation of an ethnicized identity to these two Algerians, here essentialized as "young Arabs," which inevitably reminds one of the weight of stereotyped collective imaginations. In an approach contrary to Ahtila's, in a text published on the occasion of the London exhibition of Bruno Boudjelal's series of photographs following in Fanon's footsteps, writer Salima Ghezali asserts that "to pay tribute to Fanon today may involve picking up on the theme of violence where he begins, entrenches himself, weaves, and disguises domination as civilization."[31]

Transcending Colonial Denial, Toward an Aesthesis of Emancipation?

Summoned again by contemporary artists from the French mainland, Fanon's specter today seems to be embodied in visual representations of the Algerian territory. Beyond a vision inherited from a prevailing colonial denial, these works suggest reading the visuality of a place, both imaginary and real, with, and after, Fanon. In 2012, on the fiftieth anniversary of Algerian Independence, at the Nicéphore Niépce museum in Chalon-sur-Saône, photographer Bruno Boudjelal showed the Algerian part of series of black-and-white photographs titled "Frantz Fanon."[32] This series picks up the traces of the writer's transnational path, and immortalizes, in the present, the sites crossed and inhabited by the decolonial thinker. The artist, who had already produced the remarkable work *Jours Intranquilles – Chroniques algériennes d'un retour (1993–2003)*,[33] questions his familiar connection, his intimacy, with this place: "There, I was upset by something a little like a feeling of proximity with locations, landscapes, places I had never been. The question came up, and upset me enormously—and this, independent to the connection of the filiation of the father, the family recovered, this verticality—was it possible for me to have a connection with what might be the territory, the country?"[34] Boudjelal left this question open until 2009, when, by chance, his wife's family's itinerary led him to Martinique, Fanon's birthplace. At his wife's suggestion, when he returned from that trip, of which he has few pictures, he began to read *The Wretched of the Earth*, while pursuing photographic projects, in collaboration with his photographer friend, Nii Obodai, that investigate the notion of Pan-Africanism and the identity of the African continent today. He covered and photographed Africa from north to south, from Tangiers to Cape Town, from east to west, and, in Ghana and Tunisia, again found himself confronting Fanon's ghost. With the financial support of the British organization Autograph and the Nicéphore Niépce museum, Boudjelal decided to bring together the photographs he had already collected of Fanon's presence, and to add to this first collection a search for the places in Algeria that bear his presence and memory. The Algerian psychiatrist's itinerancy is transcribed in blurred photographs, taken in movement (as is Boudjelal's signature), as well as through the plurality of sites crossed, which would be unrecognizable without signposts, and which effectively transcend geopolitical and temporal borders. Through a personal genealogy, Boudjelal meets Fanon's spectral presence; he registers in snapshots the historicity of these places, inhabited as memorial and historical sites to be reoccupied. From this cartography of an investigation into his own subjectivation of the place, traces of Fanon emerge and take hold, rendered in archives of the present. Through this creative process, the photographer also points to an inhabited blank in an active image, echoing Hans Belting's analysis of an *iconic presence* that itself transposes a *visible absence*.[35] The way the images of inhabited places are

processed by a decolonial thinker passing-through pertains to an "unframed, blurry, in motion" aesthesis, and bears witness to the "impossibility of taking photographs there,"[36] in an Algeria scarred by the trauma of the 1990s, where photographing in public space, unless permission is granted in advance, provokes suspicion from the authorities.

The trauma of the Black Decade is also evoked in Katia Kameli's work *Le roman algérien* (*The Algerian Novel*). Here it is evoked by a noticeable visual absence, as Samir Toumi underlines: "You have a temporal break in this wall of images ... this sort of black-out of the Black Decade, where, indeed, there are no photographs."[37] This piece, which was made for the exhibition "Made in Algeria: Généalogie d'un territoire" at MUCEM in Marseille in 2016, interrogates the representation of Algeria *in situ*.[38] Setting up her video camera in Larbi Ben M'hidi street in Algiers, in front of a kiosk where one can buy postcards that show designated representations of the place, Kameli tries to capture Algerians' relationship to this iconography. The artist chose this kiosk because it embodies an "eclectic collection [that] echoes colonial and postcolonial iconography. It seems to be haphazardly organized, but it allows for many associations, like a sort of Algerian Mnemosyne Atlas."[39] Representations of fantasia; odalisques inherited from orientalist subjects; shots of the colonial architecture of Algiers; and portraits of revolutionary icons from the Emir Abdelkader, Djamila Bouhired, and Zohra Drif to Che Guevara and Fidel Castro, and even the current president Abdelaziz Bouteflika. One of the preparatory documents for *The Algerian Novel* is reproduced in the exhibition catalogue and on the artist's website, with the Fanonian subtitle *L'Œil se noie* (The Drowning Eye). This composite image, present in the film and the only figurative occurrence of the decolonial author, shows a photographic portrait of Fanon against the background of a national flag, and next to an image archive of the colonial era.[40] The profusion of temporalities and iconography deployed by the reproductions "exhibited" in this kiosk align with the title of Fanon's first play, unpublished during his lifetime.[41] According to Jean Khalfa and Robert Young, this play asks "the central question of the relation of the eye to external reality,"[42] and already prefigures the rejection of the conception of the self by the Other that will later be developed in *Black Skin, White Masks*. This national narrative in images questions the plurality of gazes implicated in the visual construction of a country, which one tries to grasp, and "own," through the image. The "drowning eye" among this multitude of images, which coexist anachronistically as so many pieces of evidence, evokes the need to extract oneself from a standard representation that is constructed by the gaze of the Other. The video subjects this iconography to a critical examination through the filmed reactions of inhabitants viewing the kiosk, and the audio commentary of Algerian intellectuals on the soundtrack,[43] as each consider these external representations. Through these interactions, the video work allows other definitions, other subjectivities of the place, in order to decenter, in the present and *in situ*, the vision projected on Algeria.

These *thoughts to see* formed under Fanon's tutelage, rendered through visual and poetic narration and spelled out in the present, express a plurality of readings of the writer's work, and open up the possibility of a gaze disoriented from the standard vision of Algeria. Reading, rereading, and articulating Fanon's thought, as one constructs and analyzes the visual representation of spaces haunted by a colonial denial, is one path toward revealing the historicity of the present. This is close to what Karima Lazali proposes when she invites us to accept the "agent's role of the subject facing his or her heritage":

> Fanon, a clinician, invites each and every one of us to take part [in] a gigantic construction project which would be to continue his place in writing, rewriting a collective History, so as to come out in the position of an author and not subjugated. Refusing a unique version of History in favor of an ambiguous plurality open to interpretation, interlocution, in other words to an incessant dialogue between Self and Other.[44]

These authors' reactivations of a figure who has become iconic,[45] whether through echoing his words in contemporary critical space, or via topical artistic stagings of his thought, encourage us to consider the value of writings that have, curiously, been marginalized in France.[46] These (re)readings of Fanon may then open on to a third zone, a zone in which a historicity, whose legacy we carry, might be articulated, in a space aware of an "indexed present"[47]; a zone in which one could gain "awareness of one's alienation."[48] What we must do now is reclaim this thought, through the original text, and hold this author of decolonization among the major theoretical figures, in order to think Algeria's visuality.

Thanks to Elvan Zabunyan for our stimulating exchanges concerning this article, and to DFK Paris – German Center for Art History for making it possible for me to write it in the best possible conditions.

Émilie Goudal
> Born in 1982 in Paris. Lives and works in Paris, PhD in art history and researcher associated with the Norbert Elias Center (EHESS/CNRS).

1 Frantz Fanon, *The Wretched of the Earth*, trans. Constance Farrington (New York: Grove Press, 1963), 249.

2 Frantz Fanon, *Black Skin, White Masks*, trans. Charles Lam Markmann (London: Pluto Press, 1986 [translation: New York: Grove Press, 1967]).

3 Frantz Fanon, "Algeria Unveiled," in *A Dying Colonialism*, trans. Haakon Chevalier (New York: Grove Press, 1965), 47.

4 "L'impensé colonial désigne la persistance, la résurgence ou la reformulation de schémas imaginaires qui avaient été institués pour légitimer l'ordre colonial et qui survivent dans la pensée républicaine moderne." Mathieu Rigouste, "L'impensé colonial dans les institutions françaises: La race des insoumis," in *Ruptures postcoloniales: Les nouveaux visages de la société postcoloniales*, ed. Ahmed Boubeker, Françoise Vergès, Florence Bernault, Achille Mbembe, Nicolas Bancel, and Pascal Blanchard (Paris: La Découverte, 2010), 196. On the colonial *impensé* (translated here as denial) and the French reception of Fanon and Edward Said, see Sonia Dayan-Herzbrun, "De Frantz Fanon à Edward Saïd: l'impensé colonial," *Journal of French and Francophone Philosophy – Revue de la philosophie française et de langue française*, vol. 19, no. 1 (2011): 71–81.

5 On the historiography and recent studies of the notion of "visuality," see, among others, Keith Moxey, "Les études visuelles et le tournant iconique," *Intermédialités* (2008): 149–68; Emmanuel Alloa, "Changer de sens: Quelques effets du 'tournant iconique,'" *Critique*, vol. 8, nos. 759–60 (2010): 647–58; Veerle Thielemans, "Au-delà de la visualité: retours critiques sur la materialité et l'affect," *Perspective: Actualité en histoire de l'art*, no. 2 (2015): 141–47, http://journals.openedition.org/perspective/6171; Gil Bartholeyns, "Un bien étrange cousin, les visual studies," in *Politiques visuelles*, ed. Gil Bartholeyns (Dijon: Les presses du réel, 2016), 5–28.

6 Nicholas Mirzoeff, "The Right to Look," *Critical Inquiry*, vol. 37, no. 2 (Spring 2011): 473–96 and Nicholas Mirzoeff, *The Right to Look: A Counterhistory of Visuality* (Durham: Duke University Press, 2011).

7 Refers to the concept of "decolonial aesthesis" developed by Walter Mignolo, which Rolando Vasquez explains in the following terms: "Eurocentric modernity established esthetics in order to control subjectivities and forms of perception of the world. … we prefer to speak of *aesthesis*, rather than aesthetics, in order to emphasize the idea that the senses, and the ways of perceiving the world, are liberated as they face a system of regulation." For a more detailed definition of this distinction, see Miriam Barrera, "Entretien avec Rolando Vasquez: Aesthesis décoloniales et temps relationnels," in *La Désobeissance épistémique. Rhétorique de la modernité, logique de la colonialité et grammaire de la décolonialité*, ed. Walter D. Mignolo (Paris: PIE-Peter Lang, 2015), 175–85, 176.

8 Azzedine Haddour, "Fanon dans la théorie postcoloniale," *Les Temps Modernes*, nos. 635–36 (January 2006): 136–58, 137. Note, however, that art historian Laurence Bertrand Dorléac rightly invokes *The Wretched of the Earth* when she picks up on Fanon's title for chapter 5 of her work *L'Ordre sauvage: Violence, dépense et sacré dans l'art des années 1950–1960* (Paris: Gallimard, 2004). Here she refers to Fanon's writings to broach the question of the Algerian War, in this work on violence and conflict through art in Europe from 1950 to 1960.

9 "'Mirage: Enigmas of Race, Difference and Desire' is an interdisciplinary project inspired by the writing of Frantz Fanon, and in particular his influential text *Black Skin, White Masks* … which contributes so crucially to contemporary interpretations of race and sexuality." *Mirage: Enigmas of Race, Difference and Desire*, exhibition catalogue, ed. Kobena Mercer and David A. Bailey (London: ICA/Iniva, 1995), 13.

10 "Following the model of writers of blackness (such as Aimé Césaire and Léopold Senghor), a new notion arises: the blackness that allows a claiming of different cultural belonging from a white society, which takes the function of an antidote to racial segregation." Elvan Zabunyan, *Black Is A Color: A History of African American Art* (Paris: Dis Voir, 2004), 14.

11 Isaac Julien, *Frantz Fanon: Black Skin White Mask*, 1996. Documentary, 35mm, color, 70 min. Note the plural, "white masks," is dropped in the title's transposition from the book to the film.

12 "Interview with Isaac Julien," in *Frantz Fanon, Peau noire, masque blanc, scenario du film d'Isaac Julien et Mark Nash*, ed. Klaus-Jürgen Gerke (Paris: K Films Éditions, 1998), 30–33, 31.

13 Frederick Douglass, "The Color Line," *North American Review*, vol. 132, no. 295 (1881): 567–77.

14 On this subject, see Sophie Orlando, *British Black Art: Debates on Western Art History* (Paris: Dis Voir, 2016).

15 Julien here makes a direct allusion to Fanon's text "Algeria Unveiled," as well as to Marc Garanger's book *Femmes algériennes 1960* (Paris: Contrejour, 1982).

16 "A fratricidal war in which we are our own enemies." Nadira Laggoune-Aklouche, "Le mutisme des peintres ou l'indulgence du silence," *Naqd*, special edition, *L'esthétique de la crise*, no. 17 (2003): 27–37, 30.

17 Gerke, *Frantz Fanon*, 70–71.

18 Fanon, *Black Skin*, 181.

19 *Dasein*, as it is formulated by Martin Heidegger in *Being and Time* (New York: Harper, 2008 [1927]).

20 Gerke, *Frantz Fanon*, 35–36.

21 "Interview with Isaac Julien," in Gerke, *Frantz Fanon*, 30.

22 "Case No. 1: The murder by two young Algerians, thirteen and fourteen years old respectively, of their European playmate." *The Wretched of the Earth*, 270.

23 Ibid.

24 Doris Krystof, "Interview avec Eija-Liisa Ahtila," in *Eija-Liisa Ahtila: une retrospective*, exhibition catalogue (Paris: Galerie nationale du Jeu de Paume, 2008), 14–18, 14.

25 "A poetess rather, since she is a woman, and she is white, whereas the boys are black." Ibid., 15.

26 "[B]ecause the Europeans want to kill all the Arabs …" *The Wretched of the Earth*, 271.

27 Ibid.

28 Fanon writes, "Ici, c'est la guerre, c'est cette guerre coloniale qui très souvent prend l'allure d'un authentique génocide, cette guerre enfin qui bouleverse et casse le monde, qui est l'événement déclenchant" (Here it is the war, it is this colonial war which very often begins to look like a genuine genocide, this war which shatters and breaks the world, which is the triggering event). This sentence is omitted, absent, from the Farrington translation of *Wretched of the Earth*. See Kathryn Batchelor, "Fanon in English: Irish Connections," in *Translating Frantz Fanon across Continents and Languages*, ed. Kathryn Batchelor and Sue-Ann Harding (New York: Routledge, 2017).

29 "The theme of *Where is Where?* is colonialism and the clash of two cultures," Steve Anker and Bérénice Reynaud, introduction to the film *Where is Where?* at REDCAT, Los Angeles (April 18, 2011).

30 *Eija-Liisa Ahtila: Une retrospective*, 13.

31 Salima Ghezali, "Rendez-vous avec Frantz Fanon," in *Frantz Fanon 1925–1961*, exhibition booklet (London: Autograph, Rivington Place, 2015), n.p.

32 *Bruno Boudjelal – Algérie: Clos comme on ferme un livre?*, exhibition catalogue, ed. François Cheval (Châlon-sur-Saône: Musée Nicéphore Niépce, 2012); Marseille, 2015; Prix Nadar 2015.

33 A series of photographs from his first discovery of the land of his father, whom he accompanied on his return to Algeria, after a several-decades-long absence.

34 Conversation between the author and Bruno Boudjelal, Paris, March 2017.

35 "Images traditionally live from the *body's absence*, which is either temporary (that is, spatial) or, in the case of death, final. This absence does not mean that images revoke absent bodies and make them return. Rather, they replace the body's absence with a different kind of presence. *Iconic presence* still maintains a body's absence and turns it into what must be called *visible absence*." Hans Belting, "Image, Medium, Body: A New Approach to Iconology," *Critical Inquiry*, vol. 31, no. 2 (Winter 2005): 312.

36 Bruno Boudjelal, interview for the exhibition "Algérie: Clos comme on refme un livre?," 2012, http://www.museeniepce.com/index.php?/exposition/exposition-passee/bruno-boudjelal.

37 Samir Toumi in Katia Kameli, *Le roman algérien (Chapitre un)*, 2016. Video, color, 16:00 min.; 5:45.

38 Zahia Rahmani and Jean-Yves Sarrazin, ed., *Made in Algeria: Généalogie d'un territoire*, exhibition catalogue (Marseille: MUCEM, 2016).

39 Katia Kameli on *Le roman algérien* on the artist's website, http://katiakameli.com/videos/le-roman-algerien-chapitre-un/.

40 Portrait by Mohamed Kouaci, Algerian photographer for the GPRA during the War of Liberation.

41 Frantz Fanon, "The Drowning Eye" (1949), in *Alienation and Freedom*, ed. Jean Khalfa and Robert J. C. Young, trans. Steven Corcoran (London: Bloomsbury, 2018), 81–112.

42 Young, "Fanon, revolutionary playwright," in *Alienation and Freedom*, 44.

43 In order of appearance in the credits: Djalila Kadi Hanifi, Samir Toumi, Wassila Tamzali, Nassim Labri, Farouk Azzoug, Mahdia Gheffag, and Daho Djerbal.

44 Karima Lazali, "Plurilinguisme, pluriculture et identité," *La lettre de l'enfance et de l'adolescence*, no. 79 (2010/1): 109–16, 112.

45 Almost all the publications and new editions of Fanon's work have covers comprised of his full-page portrait.

46 See notably Dayan-Herzbrun, "De Frantz Fanon à Edward Saïd," and the introduction to Matthieu Renault's dissertation, which analyzes the critical reception of Fanonian theory, "Frantz Fanon et les languages décoloniaux. Contribution à une généalogie de la critique postcoloniale," doctoral dissertation (Université Paris 8, 2011), 11–34.

47 Notion borrowed from Adrian Piper, "Xenophobia and the Indexical Present," oral comments published in *Place, Position, Presentation, Public*, conference proceedings, ed. Ine Gevers (Maastricht, Jan Van Eyck Academy, 1992), 136–56. On this subject, see Elvan Zabunyan, "Did You Hear What They Said? Historicity and the present in the works by Adrian Piper and Renée Green," in *Perspective: actualité en histoire de l'art*, special edition *Les États-Unis*, no. 2 (2015), http://perspective.revues.org/6012.

48 "He cannot go forward resolutely unless he first realizes the extent of his estrangement from them." *The Wretched of the Earth*, 226.

SEVEN LITTLE JASMINE MONOLOGUES
Samira Negrouche

light shot up its way
like an angel fallen in love
with green colored
leaves
......
Shadows as black as the walls' whiteness
cover the infinite depth of the
body

Etel Adnan,
"A lime tree and then another"

TUNIS

He's gone that man and I no longer know
what I'm waiting for. Surfaces covered over passed
by along the blank wall or even surfaces torn to
shreds during the night, laid out along the avenues
and even within interior walls, faces and surfaces
of our dreams the man. He arrives, nascent morning
shadows, dead lanes and alleyways resonating,
breathing like a bottle on the ground. It happens
that his hand grasps worries my shoulder with its
sharp fingers. My back under the man's hand and the
alley whistles and the bottle turns over. I am not
waiting, the man has flown off with I don't know
what in his pockets I don't know what in his eyes
of a man with cutting fingers I don't know what in
his ears, silent within his head which dictates
the vertical movement from below to above, I don't
know what the man who does not look at a man and
gives orders and loses his patience. The surface has
gone, has left the blank walls the inner walls and
the summer palaces. I am not waiting for the abyss
of years abandoned by the January man on the cold
tarmac, years now gone.

TRIPOLI

Green a certain shade of green dilates
my eyes and eases my breath slows down the erratic
stampede hammering on the walls of my thorax but
green even that green doesn't go with my complexion
and however silken it might be my skin refuses
it who knows why! The only green that pleases me
is wide infinite spaces panoramic landscapes that
the field of vision cannot inhabit alone. I still
move forward, black triangle I'm not afraid of
the desert, like the dunes like the sand I enter
everywhere and continue moving forward and the
weight of the black tent does not stop me from

crawling and the minuscule openings in the black
cone do not keep me from seeing beyond I move
forward under cover and no one sees anything but
a black tent among other black triangles in the
landscape of blinded and blinding sun. Through
indirect tunnels and on streets from which I'm kept
away from houses where I'm confined I advance and
I see and I deflect the green to my own use. In my
black dune I flow to the shore and offer my *djilbab*
string to the sea.

CAIRO

The alarm clock went off late and Marseille
that morning bitter coffee on the rue de Rome
deflected along all its length the s lives in the e
and the street could not care less about propriety
spirit misted over that morning head raised a sheet
is hanging from a balcony "Beethoven is a Manouche"
we are all Roms and Beethoven is a revolution.
The air burns me in Tahrir Square and we are all
acrobats comedians minorities the crowd of one man
and a woman alone in the crowd. Come forward with
your pharaoh's old clogs and scrub the mud off your
head. Oum Kalthoum is a Manouche and Naguib and
Shahin and all those whom you no longer hear are
the revolution. The Colossus rakes the square and
sweeps away as insignificant detritus the vaginas
broken and entered the eyes gouged out in precaution
the prayers shared mingled the words chanted
stolen. Crowd of all dangers, freedom is a chiseled
symphony. The Colossus persists, with his huge hands
he sweeps up the guitar on the ground; on the guitar
case dozens of stickers: No to military trials
of civilians!

SANAA

Two hundred and sixty-four kilometers on
dusty roads, caravan of withered legs skimpy soles
that move forward becoming denser as if weighed down
with oversized bags as if liberated from unloaded
cargo Aden the sea breeze becomes more distant with
each step I offer you my back and the ivory of my
skin burned a hundred times by the day-laboring
sun crossing clambering in the crowd of passersby
placing the grain a hundred times on others'
thresholds. Surging onto the road faces determined
or resigned this road that seems to lead only to the
center of the metaphor but still cuts the illusion
short.

Two hundred and sixty-four kilometers to
set fire to my shaven head let it catch fire let it

thin out the horizon and change the weather above
the close-ranked columns of men and slogans to each
step taken let it add one more and let the city
roads never arrive from the ancient heights.

DAMASCUS

Holy Man of fertile valleys of sculpted
columns of the fine-carved lute they live in your
dwelling place and claim to have your wisdom they
pretend to your inheritance but taste only its
colored spices they kiss your tomb read your verses
and agree to the offering they stand tall and speak
of dignity they speak fraternally and claim to be
gods. Holy man in your land souls left the wall's
shadow and surged up as One their burgeoning shadows
were arrested and they remained One their eyelashes
were broken their gaze smothered and they remained
One. The One who persists and comes forward and
finally speaks and reveals the deception. On your
lands and on the land of the One, Holy Man, the
brothers have come from the four corners of the
ancient kingdom of the Maghreb the Mashreq the
Hidjaz they have come the brothers who embrace your
wisdom and on the threshold of your doorway they
closed the windows of their eyelashes and at the
hearth of the One they veiled their senses and spoke
in the name of the son. Holy man of the fertile
valleys a bicycle rolls across the heart of your
wisdom and now the Heights are merely firing ranges.

RABAT

I have my Toubkal cousins' precise and
deadly way of talking impenetrable skin and the
gaze of Thanina elusive eagle. On my unattainable
mountain the song of the red wellspring comes to me
the echo of the Atlantic the coastal islands and
defeated hooves fleeing the almond trees. I have
my Toubkal cousins' attentive silence about the
Folklore squares, the fire-eaters, the choreographed
marriages, the rented arses, and the two-dirham
hrira. At my Toubkal cousins' home the luxury of the
destitute puts an end to Andalusia and the pauper
poses, his leg extended toward the show shiner. And
when at the height of virtuous feelings small-time
monarchs of a cobbled-together celebration a mother
on holiday sipping orange juice at nearly midnight a
mother finds the smile of the plucky child beautiful
the smile of the little girl who on the square at
nearly midnight is selling a packet of tissues to
the mother whose children are already asleep already

dreaming when the mother admires that smile Granada
is lost forever.

 ALGIERS
 On this morning cracked with
disappointments when blue has left the sea to invade
the hill in a uniformed chain tightening on the
diminishing crowds. Midnight aborts the day leaving
the casbah to its rubbish and fragments.
I appeal to the memory of Algiers from its seaside
bars to the tanks of the occupation, I appeal to
Hassiba to Djamila to Didouche and to Boudiaf to
the ancestors and to the amnesiacs to the rapists
of dreams and to the perpetual traitors I appeal
to every drop spilled to every humiliation let the
bay gush forth at last and let it inhabit us let
it open our senseless eyelids let El Anka and the
besieged diwans awaken let the doorways of our
houses open and let a new song arise. Let the TGV
Express awaken, let it bring back the breeze from
Tangier and let it start a new route from Tunis to
Alexandria and from Beirut to Istanbul. Let a new
day open and let midnight be fragrant with jasmine.

 translated by
Marilyn Hacker

Six makeshift trees around my bathtub
Samira Negrouche

> "Man part animal part flower part metal part
> human"
> *The Approximate Man*, Tristan Tzara

*

above our heads a vertical shadow
 vibrates
a shadow that flaps above our heads
a clandestine whistling
on the arid plain above our overloaded
 heads

and while there's that whistling that unanticipated whistling
as our buzzing skulls
a cement roof accommodates our moods
 on the makeshift platform
 the constellation set adrift
in the fog of the senses

you have not abandoned the dusty wreckage

vertical shadows race at the dunes' edge
your eyes bandaged behind concave ice
anti-UV protection not guaranteed

a piano's black keys at the dunes' edge
a scale that makes no sound

you have not abandoned the dusty wreckage

a vertical shadow planted on the arid plain
that you water with promises
the metallic organ that vibrates
 at the edge of a lung
on the cement platform
where the musics clash
protection not guaranteed
for a makeshift totem.

**

in the rock garden
a mute man dances
we don't know what funeral oration

they say a deaf man
sows steps of abundance
and solar circles

he was not born to hear
the world exploding

is there a place washed up
on a forgotten ridge
where the news wouldn't arrive
where the news wouldn't be implied
where the news wouldn't be felt
is there a breech in time
that isn't waiting
to fix our gaze
on suffocated screens?

are there eyes in this world
ears in this world
that were born
to welcome
into their souls
obscenity
obscenity
obscenity
obscenity
obscenity
and turn away
and not turn away?

* * *

what I like about Jesus
are his faded feet
and those of his companions
- thirteen haloes -
on the abandoned icons
of the small Bulgarian Mount Athos
I'm not talking about the fig tree
- the fig tree Jesus illuminates -
nor of the cascade of rocks
- more like the Grand Canyon than Galilee -
Jesus's delicately faded feet
made me think of the rock paintings
of Tassili
there is no foot as finely
traced on Hoggar's boulders
they are long slender figures
suspended
exactly like the Christ
suspended fixed and dynamic at once
it's a lightning bolt
an allusion stripped of logic
or so it seems
you find what you find
above all when it's different from what you see
what I like about the astrophysicist
are his premonitions
when he says perhaps
when he says that statistics
have altered physics
fixed it in place
emptied
disembodied
when he says that matter
isn't matter
that time and space
are heresy
that we humans
take ourselves too seriously
thinking ourselves fragile
inventing ourselves powerful
that we invent landmarks
that we forget having invented them
that we must relinquish control
when he says perhaps
give your doubt back its soul

```
**
**

it seems like
a cartoon
tchouri                 comet              under surveillance
for the good of humanity   welcome life
matter          organic        welcome
                    non-hallucinogenic mushrooms
                    preferably
                    Japanese
                    that seems more serious
                    as far as cartoons are concerned
                                and micro-tchouri
everything is in fact
a game of marbles
marbles of varied size
on a cloth of varied textures
on an infra-silent language
no protection guaranteed
from bubbles              and scattered micro-lakes
around which chairs are overturned
that can be read as cuneiforms
depending on the branches

network of aquatic bubbles
a solid form
        gaseous              visible      under
my bowl of water seemingly              isolated
the cradle
of a wireless
network
```

* * *

* *

it seems unlikely to me
that a keyword
would open anything whatever
worth the bother
 words don't open anything
actually
function paralyzes words
I acknowledge the statistic
paralyzes
all the software
 by saturation

* * *

* * *

a cuneiform language lies
in the branches
of a sacred wood
it holds no secret
that can be translated to sound
it is not the virtual transposition
of any narcissism
barely a dream
a geographical arrangement
of what we call life

there are trees in my head
around my bathtub
because the universe is much too large
far from my puddle of water.

Algiers, August-September 2016

Samira Negrouche
Born in 1980 in Algiers. Lives and works in Algiers
as a poet and a translator.

translated by Marilyn Hacker

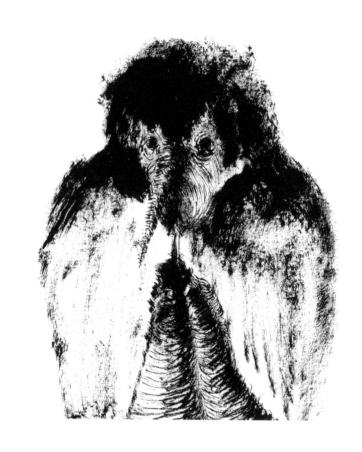

ARTISTS IN
THE EXHIBITION

ALL TEXTS BY
NATASHA MARIE LLORENS

CORPOREAL ENVELOPE

LOUISA BABARI

LOUISA BABARI

BORN IN 1969 IN MOSCOW.
LIVES IN PARIS AND
WORKS BETWEEN PARIS
AND ALGIERS.

Louisa Babari's video installation *Close Combat* is the result of an interview between the artist and the philosopher Seloua Luste Boulbina that focused on Frantz Fanon and particularly on what Boulbina calls "the colonial *corps-à-corps.*" This concept relates to Fanon's observation of the way colonization marked the bodies of his Algerian patients in a mental health facility in Blida, a town just outside Algiers, in the 1950s. *Corps-à-corps* is a French expression that literally means body-to-body and is often used to describe hand-to-hand combat, but it could also describe bodies pressed together on the subway, in a protest march, or at a crowded concert. The idea of armed conflict is implied in the idiomatic expression, but is not enunciated in order to leave room for the association of another kind of struggle between bodies.

Babari translates this expression to "close combat" for the English version of her work, which takes her recording of the initial interview with Boulbina as its point of departure. Babari's transcription

of Boulbina's analysis gave rise to a text, which Babari had a native-speaking performer read for the work's soundtrack (with different performers for the French and English versions). Babari composed the visuals that go with this voice from fragments of the original transcript.

Babari sees the tripartite collaboration as a key formal element in the work: Boulbina's ideas are dense, difficult to follow without prior knowledge of Fanon's thought. The performer's voice begins slowly but crescendos as the video progresses, articulating the anger and the pain that motivate both Boulbina and Fanon in their analyses of racism. The text flashing on to the screen matches this measured pace at first, highlighting key phrases and terms. It then speeds up and begins to lose direct relationship with the voiceover, which equally loses the relationship with the theoretical matter it is enunciating. The work consists of this dense play of meaning between all three modes of transmission.

Both Babari's and Boulbina's work concern the effect of sustained exposure to racism, in its visceral attacks on the body and in its structural effect—yet the body is entirely absent from this work. Language in white letters tries to explain what is happening to the body in flashes of fragmented sentences. As the voice of the performer grows more urgent, however, one senses that it is failing to account for the body despite its theoretical precision. "We may talk about discrimination and segregation, but how are these manifested in subjects?" asks the voiceover, one minute into the nine-minute video. As these words are spoken, no text flashes on-screen to structure the question visually. The question is posed into the void.

The voiceover also points out a contradiction in Fanon's use of language in his psychiatric work: he did not treat patients in their native language, a point which is particularly salient to the practice of a psychiatrist trained to work with subconscious injury. As a result of his impartial understanding of the Algerian context (according to Babari's take on Boulbina), Fanon's attention remained centered on his patients' "literal" bodies, on their skin. He did not fully attend to their sociolinguistic experience of violence. What is the viewer meant to understand about the relationship between the injured body and language; or between the colonized and racialized body and language; or between the spoken text and the fragmented transcription of an oral argument, as either of these relates to the body? The work does not answer these questions. Instead, it opens Fanon's thought to the viewer with intellectual subtlety, which brings him back from the brink of empty iconography, the contradictions in his thought intact.

LOUISA BABARI

Close Combat, 2016
(English version)

Stills from video, black
and white with sound
9:06 minutes

LACTIFICATION REHABILITATES THE BODY

FAYÇAL BAGHRICHE

BORN IN 1972 IN SKIKDA,
ALGERIA. LIVES AND WORKS
IN PARIS.

A bronze arm leans against the nearest wall, hollow-cast and truncated at the elbow. Phantom fingers grip the cross, the index finger slightly separated so that it appears to point skyward and hold on for support at the same time. The sculpture seems out of place, floating in the exhibition hall like the trace of an obsolete belief system. Purposefully purposeless.

In 1925, Lucien Saint, then Governor of Tunisia, commissioned a statue of the Cardinal Lavigerie on what would have been his hundredth birthday from the Marseillais sculptor Élie-Jean Vézien. The cardinal had been a monumental figure in the French colonial world. A fierce opponent of the slave trade, he served as the archbishop of both Carthage (Tunis) and Algiers and founded the Roman Catholic society of missionaries, the White Fathers. Vézien's rendition of a man renowned for his humanitarianism and his respectful demeanor appeared imposing and aggressive, as was characteristic of French colonial policy on public monuments at the time. Swathed in

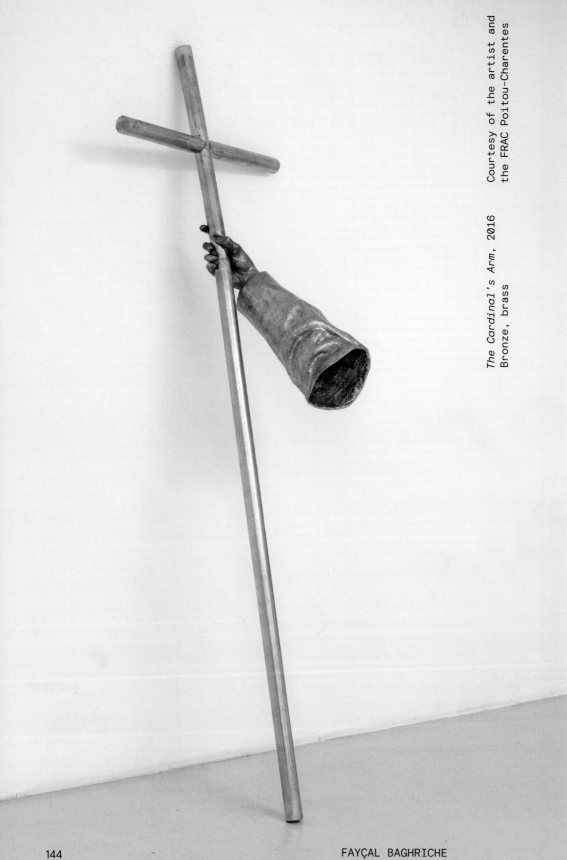

The Cardinal's Arm, 2016
Bronze, brass

Courtesy of the artist and
the FRAC Poitou-Charentes

FAYÇAL BAGHRICHE

heavy layers of bronze garments, one of the cardinal's outstretched arms held an enormous volume, the other brandished a crucifix that stood as tall as he.

Vézien had three copies of the statue cast in Rome. One remained in Italy and the two remaining copies were sent to Tunis and Algiers, the two cities where Lavigerie served as archbishop. In Tunis, the statue provoked violent demonstrations by local inhabitants and students at Zitouna University, in part because of the colonial authority's choice of its location at the entrance to the ancient Muslim city, close to the historic Zitouna Mosque. According to some accounts the Tunisian statue was disassembled and melted down following the country's independence. In Algiers, the cardinal fared better. His statue remains in place in the square of the Notre Dame d'Afrique, though it has lost the arm brandishing the cross.

Fayçal Baghriche's sculpture *Le bras du Cardinal* (The Cardinal's Arm) (2016) reproduces the ghost of the limb of Lavigerie's sculpture in bronze. "Having watched the videos of the wreckage by ISIS, I suddenly thought of this statue with a missing forearm," the artist remarked in an interview with Caroline Hancock.[1] The consensus among Algerians is that the arm went missing during the Black Decade, one of several instances of iconoclasm against colonial-era public monuments perpetrated by associates of Islamist groups. Baghriche explains that this consensus did not bear close inspection:

I was told several different stories. Father Tarpaga who currently officiates in the basilica explained the arm had been accidentally struck by a rubbish truck in the 1970s. Another version came from Father Marioge who started his work there in the nineties: the arm and the cross had already disappeared before he arrived and therefore before the years of terrorism in Algeria. He had been informed that the arm had been torn by the Islamist husband of a woman in great distress who had been given support by the Fathers. Supposedly this man buried the arm and the cross in one of the cemeteries above the basilica, along the road that leads to Bouzaréah. Even though these versions are different, the Fathers agreed that the disappearance was no bad thing. According to them, the menacing gesture is unrepresentative of the White Fathers and disrespectful of the Muslim community. The Mayor of the district of Bologhine offered a reconstitution, but the Fathers did not consider this to be necessary. The statue will be restored in 2018—but without the arm.[2]

Baghriche's reconstitution of the arm and its burden is also a reconstitution of the form power took in the early twentieth century in the French colonies, which people on both sides of its traumatic effect would prefer to obliterate.

1 Fayçal Baghriche, *"La nuit du doute,"* exhibition text (Paris: Galerie Jérôme Poggi, 2016), http://galeriepoggi.com/cspdocs/exhibition/files/2016_fayc_807_albaghriche_galeriepoggi_lanuitdudoute.pdf.

2 Ibid.

BARDI

BORN IN 1985 MAKOUDA,
ALGERIA. LIVES AND WORKS
IN ALGIERS.

The *Fajr* prayer, or the dawn prayer, is the first of the five prayers that structure the daily lives of practicing Muslims. It is recited when the body is still heavy with sleep from the beginning of dawn until sunrise, the time depending on the season and latitude. Mehdi Djelil, whose artist's name is Bardi, created a diptych, *El Fajr* (2015) that depicts the dawn prayer in a contemporary world. A microphone plugged in next to a bed, or plugged into the body at the level of its heart. A body struggling to free itself from the bedsheets, arching toward duty with a monstrous lack of corporeal clarity in one half of the diptych, or a body bound tightly together with yellow ribbon in the other half.

Bilâl Al-Habashî, also known as Bilal ibn Rabah, is said to have been chosen by the Prophet Muhammad as the first muezzin, the person tasked with calling Muslims to prayer five times a day. Very little is known of Al-Habashî's life other than that his father was an Arab slave, his mother was an Abyssinian princess who had been captured and enslaved, and that he had a gorgeous voice. In each half of Bardi's diptych, a mouth gapes open, and though the implication is that the being is calling, there is also the suggestion that he is gasping for air or crying out in desperation. To whom is the former slave calling with his crimson foot draped across the bottom of the bed frame, this half-rooster man with giant thighs who is bleeding from the chest in delicate rivulets of paint? Whose small extremity is reaching to the edge of a black aureole as it screams its song, its ass in place of its mouth?

Two factors condition Al-Habashî's lack of representation in the historical record. First, as a slave, he fell beneath the threshold of visibility for most. Second, as a close companion of the Prophet, he was encompassed by the interdiction of figurative representation that attended the Prophet and other divine figures. On account of this structural block to the imagination of Al-Habashî, he remains a

blank space with a deep and melodious voice in Muslim cultural mythology. This visual absence before the dawn prayer, which lasts from the end of the night through to the beginning of day, fascinated Bardi, especially as this space and time is structured by song, by a voice that is calling forth from that breach in both the day and in figuration.

Into this breach, Bardi pours colors in the process of seeping into other colors and a body made grotesque by the effort involved in calling the prayer. There is faint reference to Al-Habashî's aniconic symbol, the white rooster, which broadly represents the call to prayer in Muslim culture. The overwhelming impression is not one of salvation but of the struggle to become otherwise against society's codes. Checkerboards suggest the existence of an overarching structure, a pair of angel's wings hang in a tangle of feathers off a volume that looks as though it is stuffed with many bodies, and placid green leaves seem positioned to paper over the speech acts of each half of the diptych with the flat look of art deco wallpaper. And so the day begins.

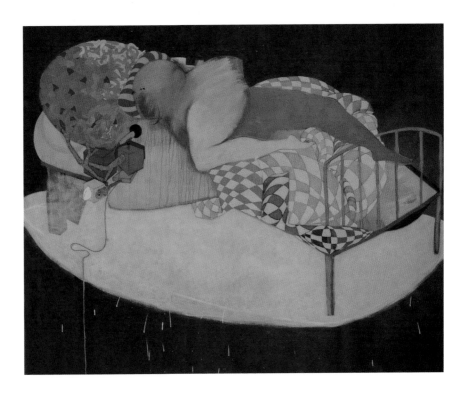

El Fajr, 2015
One part of a diptych.
Acrylic on canvas

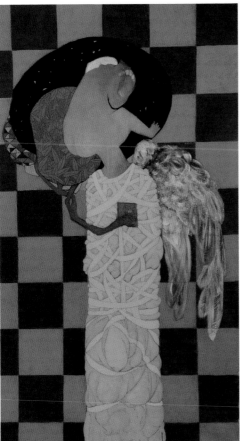

El Fajr, 2015
One part of a diptych.
Acrylic on canvas

MOUNA BENNAMANI

BORN IN 1989 IN ALGIERS.
LIVES AND WORKS IN DELY IBRAHIM,
ALGIERS.

Mouna Bennamani's practice sits between figuration and abstraction. She works with an old confrontation between the body's ability to hold a person's identity—their history, their memory—and that identity's impact, in turn, on the integrity of the body.

One way to conceptualize the ground of this confrontation is the idea of a wound and the scar that follows. A wound is an event. It occurs in the moment that the body is breached, or that a living volume is compromised, but a wound does not always end, not even when it heals. Its inexorable quality is due to the fact that it betrays the body's vulnerability. To be wounded is to reveal that the skin can tear and that the mind can break. A scar is what remains after this revelation is made. The wounding and scarring, the revealing and the living-with, are equally present in Bennamani's bodies, which do not stay bodies, and in her abstractions, which do not stay abstract. There is a constant shifting in her sculptural work and painting, between event and form, or between the memory of motion and the body.

Vuelo (2018), for example, is a sculptural installation composed of four

figures made from large rolls of white paper, which float along the horizontal axis of a wall. Considering the work's alternate title is *Selective Chastity*, it is hard not to see the forms as faceless and semi-embodied figures draped in the traditional white veil—the haik—worn by women in some parts of Algeria. But Bennamani's haunting paper forms could also be read as a sculptural close-up of the marks left by a gun shot at point blank range, each oval shaping the hole a bullet left as it tore through layers of wall or flesh in its momentum forward. In either case, the forms are witnesses to an event outside the frame. They are silent, like ruins or statues that have been abandoned by their public squares.

Metamorphosis (2018) takes the same gestural play as *Vuelo* as its point of departure. The top half of the canvas is taken up by a white form unfurling in every direction. The color staining the canvas's bottom half suggests that the breach it marks is still active. Alternatively titled *Nocturnal Flowering*, the silhouette of a white flower is barely visible, the edges of its bloom heavy with the colors of the shadow threatening to engulf it. There is a frantic quality to the painting, or the sense that whatever flight observed in *Vuelo*'s wall-relief is in crisis in *Metamorphosis*—that the pain of transformation still animates these forms.

MOUNA BENNAMANI

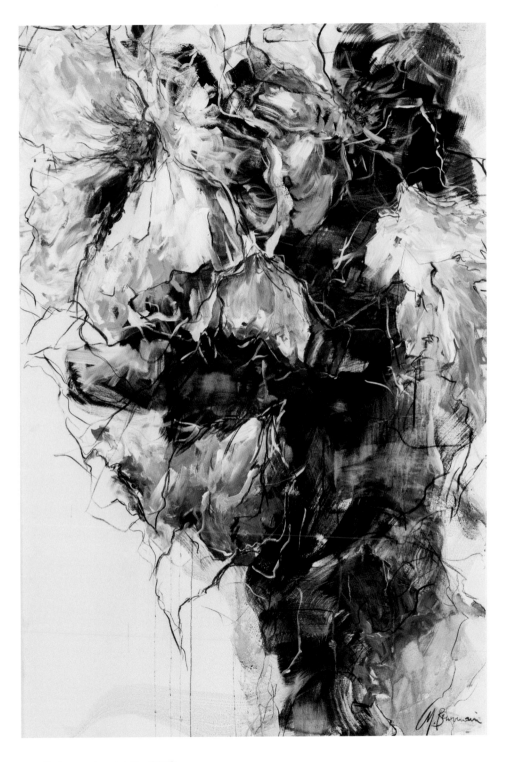

Metamorphosis 3, 2018
Acrylic on canvas

ADEL BENTOUNSI

BORN IN 1982 IN ANNABA,
ALGERIA. LIVES AND
WORKS IN ANNABA.

A curriculum vitae is a document that represents a person's professional qualification usually in list form and an expression that translates from Latin as "course of life." Its shortened form, *CV*, is also the title of a 2019 sculpture by Adel Bentounsi. The artist has reproduced a computer keyboard on the stainless steel of his mother's pressure cooker using decal stickers. The keyboard is bilingual, meaning each key represents both a Latin letter or symbol and an Arabic letter or accent. The double image is standard for those who live between languages and alphabets, as is the cognitive dissonance produced by letter pairings based on the frequency with which each letter is used rather than any sonic or semiotic similarity. The key for the letter *Y* is also the key for a sound that does not exist in the English language, pronounced in the back of the throat like a gritty *R*. The key for *L* also produces the mathematical sign for division. And so on.

"It started with my mother," the artist explains. They were sitting together at the computer formatting her CV in a Word document. Bentounsi was asking

his mother questions about the work she had done over the course of her life, transcribing her answers into a standard form. Then a sharp whistle sounded from the kitchen, the sound of the pressure cooker. "For me, it was a kind of warning whistle," Bentounsi says, a reminder to pay attention to how an instrument shapes the information it is designed to process. He sees the pressure cooker, which is called a *cocotte* in French and Derija, as an analog to the computer in the sense that both reduce and compress the elements placed within them.

Bentounsi does not stop at analogy but combines these mechanisms, illustrating what is untranslatable about the process of synthesis entailed by each. Bentounsi's keys are attached to a device that is meant to produce smell and taste, precisely those senses that the computer can neither capture nor reproduce. To use the pressure cooker in any practical sense would burn the decal stickers, filling the room with the acrid smell of melting plastic. The keys are usually attached to a machine that shares their values, connected to myriad users who also share the philosophical ground that has produced them, and the idea of value attached to a given course of life.

Bentounsi's mother left the room to attend to the cooker, interrupted in one kind of work of synthesis by another. Bentounsi describes a hesitation on her part to submit to the logic of the keyboard and the Word document, or to a description of the course of her life based on the exclusion of so much of it. It is as though, with *CV*, he is trying to invent a mode of producing meaning that could encompass competing forms of expression: the kitchen and the office, language and sensation, a life spent making food to share and a life spent accumulating lines on a page under a single name, even if each line also contains multitudes.

ADEL BENTOUNSI

CV, 2019
Pressure cooker with
keyboard stickers for PC

ZOULIKHA BOUABDELLAH

BORN IN 1977 IN MOSCOW.
LIVES AND WORKS IN
CASABLANCA AND PARIS.

"Today, everybody wants to be able to see everything, preaching transparency as worship, so that everyone can have the power to be able to satisfy their need to observe and supervise," says Zoulikha Bouabdellah on her approach to art. "Under these conditions, the artist has to resist the will to control and classify." Bouabdellah is interested in women's experience of multiplicity, the way they feel in their bodies when they are freed from the constraint of being "women" and are allowed—even if momentarily—to exist as lives. To be seen as a life, a presence in flesh and time, is also to escape the scopic drive without becoming invisible.

Perfection Takes Time (2012) is a four-minute video of a middle-aged woman dancing at a wedding party in Yemen. Though she wears layers of black satin, she seems light, open to herself. The camera stays close to her face as she moves, catching the light as it glints off the rhinestones that hem the fabric of the hood she wears over her headscarf. The camera is focused on her pleasure in movement, the sense she demonstrates of belonging to the rhythm. It does not linger on the men that dance in a loose circle more slowly than her, though it does catch their faces as it tries to follow her, and occasionally a camera flash crosses the screen. There is no contradiction between her swathed form and the freedom of her body, neither in her expression nor in theirs. When she finishes, she presses her hands to her neck and casts a smile about her in appreciation for the way they have held her pleasure with their presence.

"She can be very warm. Or very cold." The voiceover is spoken in British English, and describes a woman who jars with the slow-motion abandonment to movement captured by the camera. "A wise virgin is always impeccable," the British woman intones. "She sees herself as a perfect housewife, a perfect mother." Her voiceover places a firm precision on the *ct* sound at the end of "perfect." She goes on to describe the existence of the wild virgin, who has a critical mind. "The wild virgins can emerge from the shadows and exhibit

ZOULIKHA BOUABDELLAH

themselves on the screen." Apparently, she is a woman capable of violence.

What does the viewer really know of the codes governing the appearance of women in public in Yemen, at any given social class, at any given moment in the last twenty years? Could this woman be a wild virgin? The examples of such women given by the voiceover are Ingrid Bergman, Greta Garbo, Sophia Loren, and Romy Schneider, two of whom—Garbo and Schneider—were openly homosexual. How are we to read their juxtaposition with the image of this confident woman, who holds the center of the room and the attention of a hundred people, as well as the viewers. It is a question that falls without an answer into the spinning space of her dance.

Perfection Takes Time, 2012
Still from video, color with sound
4:07 minutes

HALIDA BOUGHRIET

BORN IN 1980 IN LENS,
FRANCE. LIVES AND WORKS
IN CHOISY-LE-ROI,
FRANCE.

Halida Boughriet's video *Corps de Masse* (Body Mass, 2014) was shot during workshops at the Musée d'art et d'histoire in Saint-Denis, located in a refurbished convent of the Carmelite Order for nuns in what is now a northern suburb of Paris. Boughriet invited participants from the local community to lie on the floor and embrace one another to the point of becoming one, and then to slowly separate. These moments of intimate coming-apart are edited together to form the final video, as well as a series of eponymous photographs. The video's soundtrack is a high-quality audio capture of the fabric of participants' clothes moving against each other, or the sound of their hair shifting across a terracotta-tiled floor. Corporality is constituted by their bodies, but also by the natural light that pools around them, and the way they mirror the poses depicted in the historical paintings that surround them on the museum's walls.

Boughriet's invitation was addressed to families, especially families with children, as well as to friends, who would be willing to move together before a camera. It was also addressed to organizations like Foyers de l'enfance (Homes of Childhood), which provide support for children separated from their families for various reasons. Groups were asked to come dressed in the same color. Boughriet was particularly keen to involve people who did not already have an established relationship to art: teenagers, immigrants and their children, working-class families. After screening documentation of previous performance work to give participants a sense of her aesthetic, she invited participants to wander through the museum in a way that would make it theirs, and find a place they felt comfortable in. It could be any space as long as it was near a window and had natural light. The particularity of the museum is its history as a convent; it is architecturally composed of small rooms ideal for solitary contemplation, which facilitated the feeling of intimacy between participants. Her work reveals humanity as fragile and precarious, hovering between accomplishment and constraint.

Boughriet asks: "How do we construct ourselves out of our relationship to and confrontation with others?" She describes the difference between the families and the groups of friends in physical terms: families know each other, have an elaborate language of gestures and tactile histories at hand to build a common form with one another. Even if these are difficult histories, riven with conflict, the

family structure is itself already a physical connection—or a corporal archive—between people that can be drawn upon to improvise choreography. For groups of friends, there is a different set of relationships at play, and what interested the artist was the way these young people came to know each other anew in an embodied sense.

The participants were directed to separate at a moment of their choosing. Boughriet sees both the process of coming together and the process of eventual disentanglement as one that reflects the processes of life. Rather than capturing the performance according to a script, she sees the video as a record of their remembered languages for physical communion and separation, gestures deeply imprinted in their bodies through daily repetition. A ready-made grammar of social movement, slowed down to become more visible.

The value of slowness is that it allowed participants to know each other alternatively, even if the language of their gestures was habitual. The work's slowness also engenders another kind of spectatorship, one less concerned with the mastery of time.

Corps de Masse, 2014

Still from HD video, color with sound
15:51 minutes

HALIDA BOUGHRIET

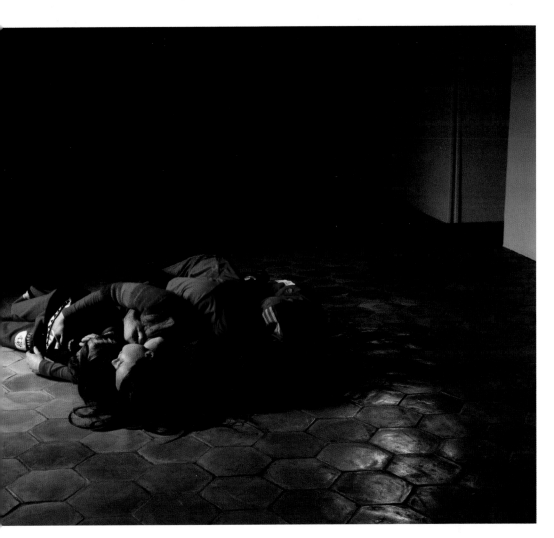

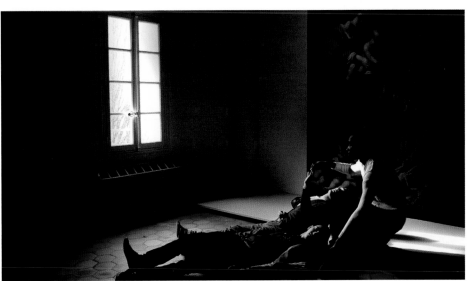

FATIMA CHAFAA

BORN IN 1973 IN ALGIERS.
LIVES AND WORKS IN ALGIERS.

Fatima Chafaa spent her childhood with a painting of Joan of Arc, which was undated and unsigned but probably owed its existence to the heroine's revival in European popular culture in the 1940s. In the Chafaa family painting, Joan of Arc is a beautiful young woman with dirty blond hair loosely tucked into her helmet. A battle wages in a blur behind her figure, which takes up most of the canvas. Her gloved hands are clasped to her armored chest and clutch the top of a sword. In composition and in the figure's attitude, the painting strongly resembles a nineteenth-century rendition of the saint by French orientalist painter Charles-Amable Lenoir: the same body armor, the same hands clasped on a sword hilt, the same upward gaze. The difference is that Lenoir's Joan of Arc stands next to a stone column in a cathedral, her head ringed with a slender halo, making the reference to Catholicism unavoidable.

The painting belonged to Chafaa's father. He valued it so highly it moved with the family from one residence to another,

placed prominently in the living room of each home. He told his family that it was a painting of Lalla Fatma N'Soumer, an Amazigh woman born around the time of French colonization in 1830 who came to embody Algerian resistance against the French and to whom near saintly status was accorded by Algerians. Chafaa writes: "She lived in the Djurdjura mountains in northern Algeria and took up arms against the French in combat with a leadership role. She is reputed to have been as beautiful as the moon, as strong as an Amazon, and an authoritarian leader and strategist in charge of the resistance for her region at the time of the Napoleonic Wars. The French military command presented her with arms at the time of her arrest as a sign of respect for her courage and bravery. The French army nicknamed her 'the Joan of Arc of Djurdjura.'"

It was not until the artist was twenty that she realized the painting her father had cherished was not actually of N'Soumer, but of that first Joan of Arc, who had fought the English on the side of the French in the fifteenth century during the Hundred Years' War. Chafaa realized that her father had conflated the women on the basis of their commitment to the freedom of their respective countries, disregarding the fact that one belonged to the history of France and the other to the history of Algeria.

Chafaa attributes this semiotic elision to the collective unconscious of the Ait Sidi Moussa—the artist's ancestral tribe—around the foundation of their community by three powerful women.

The three villages with which the tribe is still associated, Fetala, Taourirt, and Takamra, were established by the three daughters of a marabout, a saint or holy man in North African Muslim traditions. To this day, in the main hall of each house in these villages, three rectangular holes are dug into the wall facing the door, in honor of these women and as an altar for their worship.

Powerful women are common in Amazigh culture, with figures such as Dihya (Kahina), Tin Hinan, Fatma Tazoughert, and Julia Urania. Chafaa's installation addresses how the representation of strong femininity circulates, is substituted, and is transformed over several centuries as a cultural practice, allowing for the continuity of women's traditionally central role, despite the tribe's displacement and forced migration by the French military during the War of Liberation.

FATIMA CHAFAA

My Father's Painting: Fatma d'Arc or Jeanne N'soumer, 2019

Family photograph.
One element of a photographic installation
Dimensions variable

EL MEYA

BORN IN 1988 IN CONSTANTINE, ALGERIA. LIVES AND WORKS IN ALGIERS.

Maya Benchikh El Fegoun, whose artist's name is EL Meya, conceives of painting as a language with a fraught vocabulary. The orientalist tradition shaped this language, both for artists who returned to Europe and those who stayed in Algeria; its legacy can neither be discarded nor sanctioned. Émile Deckers, Roger Guardia, Jean-Auguste-Dominique Ingres, and Eugène Delacroix, among many others, prolifically painted women with precise if stereotypical attention. It is from this paradoxical situation that EL Meya, as a figurative painter of women, begins each work. "If I do not see myself in these paintings," she asks, "and yet they are about me and continue to represent me, where am I in painting?"

In Émile Deckers's *Un café sur la terrasse* (A coffee on the terrasse) from 1934, for example, none of the women are looking at any of the others, each appearing lost in thought. The dusty red carpet, their brightly colored robes, and the fuchsia bougainvillea creeping over the terrace's low wall are rendered in more precise detail than any of the women's faces. The painting is more a study of fabric and the way light falls on the city than a portrait of women spending time together. Deckers, like so many other orientalists, was concerned with architecture, light, and patterned abstraction. Women served as figurative props to animate these aspects of the Algerian landscape. He was not particularly concerned with what the women might have to say to each other, their interiority, their sin, or their desire.

EL Meya's *The Eves* (2018) reimagines women gathered on a roof terrace, only now including that which orientalism excluded—notably women's deep interiority and the conflict this produces between them. EL Meya maintains the notion of the terrace as a space that opens up the domestic sphere while keeping it in view, and her figures retain a symbolic function. She deviates from Deckers in that her women are positioned in relation to one another, but on the level of allegory rather than narrative.

Each of seven women of *The Eves* is engrossed in her own expressive struggle. There is a saying in Arabic that a person should turn their tongue about in their mouth seven times before speaking for their words to be better measured. Each woman represents a revolution in the artist's metaphorical mouth, made just before something about the representation of the woman can be expressed. Each woman also represents a cardinal sin. There is a similar index of transgression in the Muslim tradition, but EL Meya chooses to refer to the Christian version in part because she considers the legacy of painting she is responding to as one that understands sin in the Catholic sense.

 The Eves is organized around cannibalistic violence: a pigeon eating the insides of another on a low table. The Eves are gathered around this center, three of them forming a triad at the heart of the painting. Lust is on the floor with Sloth's foot in her mouth. Her gestures and abandon dominate the six other women, yet she does not belong to herself. "I am the center," she seems to say, "but I am no longer able to integrate experience into myself." Sloth arrives at the same conclusion by different means. She does not react to the pigeons beyond extending her arm in limp rejection. She doesn't need anything, she has no energy left, and she has lost the will to leave as a result of some implosion inward. Envy closes the inner triangle, moving with determined self-destruction toward Lust. Her fingers reach toward Lust's inner thigh, barred by a table leg from going further.

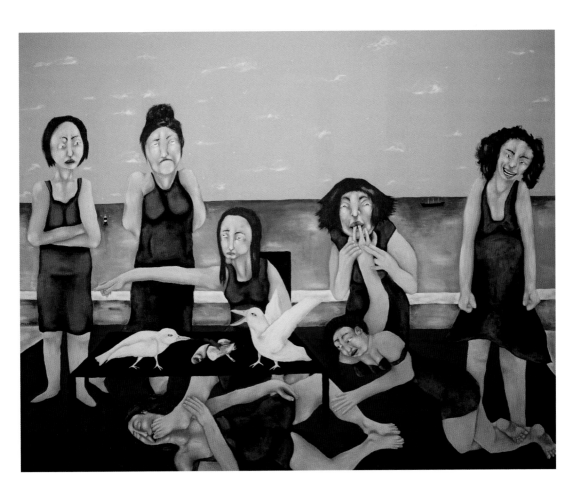

Les Eves (The Eves), 2018
Acrylic on canvas

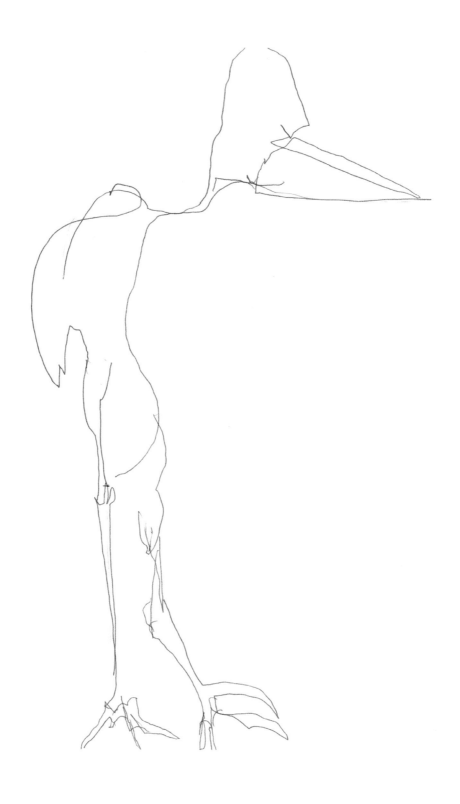

HAKIMA EL DJOUDI

HAKIMA EL DJOUDI

BORN IN ANGOULÊME,
FRANCE. LIVES AND WORKS
IN PARIS.

The title of Hakima El Djoudi's sculpture *Guérite* (2014) means sentry box in English. A sentry box is usually a small structure made of wood or sheet metal built to provide just enough protection to shield a sentry from the weather, placed at the entries to buildings where there are official guards, from government offices to military bases. El Djoudi's sentry box, by contrast, is cast out of concrete with large PVC piping.

It stands as tall as the artist at 168 centimeters, but with a diameter of 40 centimeters on the exterior and 30 centimeters on the interior, it is too narrow to accommodate a body.

There is a narrow slit in the sculpture's front face, but with such impossible dimensions and no door through which a sentry could leave to respond to alarm, it appears to be a form deluded about its own capacity. The sentry box has no

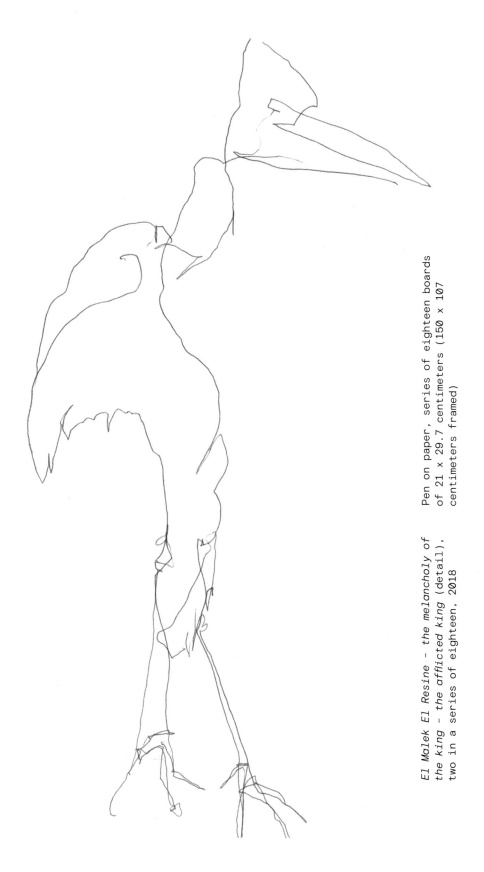

El Malek El Resine – the melancholy of the king – the afflicted king (detail), two in a series of eighteen, 2018

Pen on paper, series of eighteen boards of 21 x 29.7 centimeters (150 x 107 centimeters framed)

HAKIMA EL DJOUDI

roof either, just metal rebar sticking out of the top of its circular concrete walls like communication antennae.

Guérite derives from the old French term garrette, which is in turn an evolution of guarant, meaning to heal and protect. But any sentry posted to El Djoudi's sculpture would be that architecture's prisoner, alternately rained upon and scorched by the sun. Or perhaps the sentry box represents the remains of the sentry, posted to warn the viewer that there is no one left to ceremoniously guard against whatever threatens the old institutions.

"El Malek El Resine" is a series of panels begun in 2018, each composed of eighteen drawings of a stork drawn without lifting pen from paper. The Arabic title is translated in the work's subtitle: "the melancholy of the king – the afflicted king." The figure of the stork stutters across the panel, multiplying across a grid of three rows, each with six versions of the bird drawn in line from left to right. Each stork king has the same pose, its wings tucked to its sides, one foot out slightly as though to test the ground.

Is the afflicted king figured in the stork, or are these drawings a record of the monarch's compulsion to remember something symbolized by the stork, a moment when it stopped to pose before him that is he is trying to retrieve with each new sketch? Each figure is rendered quickly to capture some live quality; the only clarity is that of distortion. The difference that emerges from her repetition also speaks to the stork's vulnerability in the act of drawing, or in the attempt to remember him in line. His body bends and twists to accommodate its representation, which is just vivid enough to hold him on the page.

Though nominally about the monarch, El Djoudi's work seems to train the viewer's attention away from the danger of any potential despotism on the part of a deflated king and toward the danger of being caught in a compulsion to repeat, or to redraw the figurehead over and over again.

KARIM GHELLOUSSI

BORN IN 1977 IN ARGENTEUIL,
FRANCE. LIVES AND WORKS
IN NICE, FRANCE.

Karim Ghelloussi began constructing paintings out of wood fragments in 2011. The first of these works were made exclusively with salvaged wooden planks, which had already been painted, or else pieces of his own sculptures, which he had broken apart for this purpose. When he ran out of brightly colored fragments, Ghelloussi began to touch up neutral-tone plywood from packing crates with salvaged paint. Eventually, even the paintings themselves were broken apart to be reused when the composite image they rendered failed. This process is what gives the work the feeling of being at the bottom of the sea amid the splintered remains of once confident vessels. "What remains of the balance of power in a world that assigns fixed identities, forms, and semiotic systems to the movements and multitudes that are its most tangible manifestation?" Stéphane Léger asked in relation to Ghelloussi's work in 2018.[1] "Remnants, fragments, particles, and disparities are the most powerful resistance to this domination of a market that reifies vitality to what the market would like it to be, and which goes against the grain of how life is realized." Ghelloussi accumulates his images without dissembling how makeshift the process has been, without sanding away the splintered breaks, and without a promise that the result will be stable.

Mémoires de la jungle (Au désert j'ai dû me rendre) (Memories of the jungle [In the desert I had to surrender], 2017) is a wood painting depicting an architectural form inspired by the Sahara Museum in Ouargla, eastern Algeria. Completed in 1936 and opened in 1938, the museum building dates back to the colonial period. It was conceived as an ethnographic museum dedicated to the desert region around it, a repository of artifacts gathered by colonial archeologists and photographic documentation of the nomadic tribes that have used Ouargla as a trading post for centuries. Ghelloussi's father is from an adjacent region, but the artist himself has never been to Ouargla or seen the iconic neo-Sudanese-style

1 Stéphane Léger, "[Prologue]_Karim Ghelloussi. Le monde est toujours assimilable à un reste," http://karimghelloussi.blogspot.com/2018/01/stephane-leger.html. Translation mine.

building in person. The image was inspired by a postcard affixed to the wall in his childhood home in France, sent from Algeria to a family member long before his birth.

Ghelloussi built a model of the museum using the postcard as reference, then propped the sculpture on to two chairs in his studio. The sculpture was destroyed when the artist moved studios, but the photograph remained to serve as a visual referent for *Mémoires de la jungle*. A sculptural translation of the memory of a building built to correspond to another place and its transient peoples becomes a collection of brown-tone wooden fragments nailed together on plywood.

Born in Argenteuil, a northern suburb of Paris, Ghelloussi moved to Nice when he was six or seven years old, and has practically never set foot in Argenteuil since. The series of paintings dedicated to public spaces in the Parisian suburb, such as *Argenteuil* (2017), are therefore just as close or as distant as a painting referring to Ouargla. They are exercises in stretching memory to account for the loss of architectures. They are studies of spatial echoes that mirror the processes by which they are made. Ghelloussi renders the imprint of space on the mind by collecting its fragmented afterimages and loosely reassembling them.

KARIM GHELLOUSSI

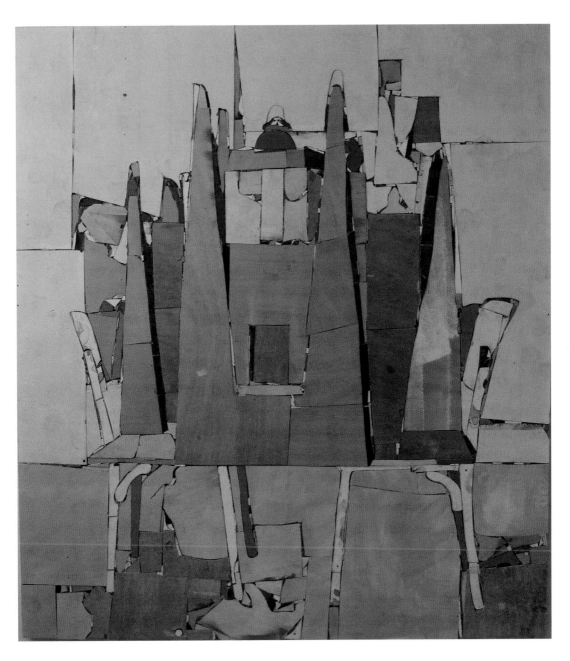

*Mémoires de la jungle (Au désert
j'ai dû me rendre)*
(Memories of the jungle [In the
desert I had to surrender]), 2017

Wood fragments on
wood panel
170.5 x 153 centimeters

MOUNIR GOURI

BORN IN 1985 IN ANNABA,
ALGERIA. LIVES AND
WORKS BETWEEN ANNABA
AND PARIS.

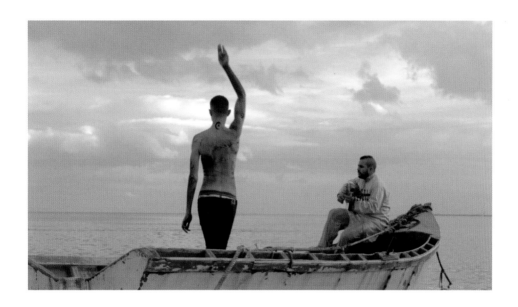

Mounir Gouri's *Naufrage* (Shipwreck, 2016) opens with wide shot of a man sitting at the helm of a small fishing boat playing an oud, a traditional Middle Eastern instrument that resembles a lute. The boat is tethered by rope to a shoreline located just outside the frame. The black-and-white video renders the Mediterranean Sea a muted shade of gray.

At first, it appears that Gouri's work stays firmly in the nostalgic register. The boat sways gently in the swelling water. The oud's music drifts lightly over the sea. The musician is patient and focused, his attention centered on his instrument, seemingly oblivious to the sun slowly descending toward the horizon. Then another man steps into the frame, which widens slightly to accommodate him; he stands on the land watching the boat, a crescent star drawn in charcoal on the nape of his neck. This man is different: his movements are not that of a fisherman or a traditional musician. His gestures are decisive, as though propelled by an internal sense of direction.

This second man wades out to the boat and climbs into it. His back to the

camera, he takes off his shirt to reveal a torso marked with words and symbols, also in what appears to be charcoal. When he begins to dance, the video metamorphoses from picturesque to something stranger, more discordant. His gestures are sharp, made with straight lines, like those of a techno dancer or raver. His body stutters in response to the music. His performance is not graceless, but his movements are not aligned, drawn from a different repertoire.

The rest of the roughly nine-minute video is a portrait of these two men coexisting on the boat, moving with the sea. Each of them is present to the moment in their own way. Like the boat that is tethered to a seashore out of frame, each man is connected to an aesthetic language grounded in some other context—that of a wedding party or a warehouse concert. The work is a portrait of their simultaneity in music and their mutual alienation.

The work's title begs the question: What shipwreck? The boat does not move through the sea, there are no rocks in sight, there is no dramatic climax. Perhaps the title refers more to the years that follow a catastrophe, like when algae and fish find a habitat in the sunken skeleton of a boat long forgotten by its makers. The piece is a metaphor for the perception of the future by an overwhelming proportion of Algeria's youth. How will these young women and men synthesize history with contemporaneity, in music or in the body? With nowhere to go and nothing to do, they go to the edge of the land and improvise in the face of the disaster that was announced, experienced, and inside which there are still lives to live.

MOUNIR GOURI

Naufrage (Shipwreck), 2016 Stills from black-and-white
 video with sound
 9:00 minutes

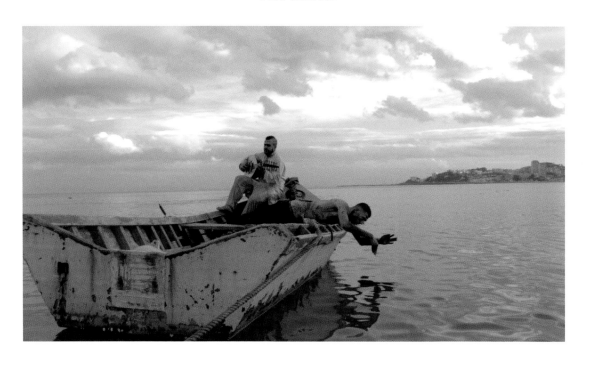

MOURAD KRINAH

BORN IN 1976 IN ALGIERS.
LIVES AND WORKS IN
ALGIERS.

In the 1990s, Mourad Krinah was a biology student at the University of Science and Technology Houari Boumédiène in Bab Ezzouar. Brazilian architect Oscar Niemeyer built the university's campus on 105 acres of land just outside Algiers between 1968 and 1974. The complex is one of twelve architectural projects Boumédiène commissioned from Niemeyer during the early years of his presidency, and it is considered a modernist masterpiece. The wide, open lawn and austere lines of the buildings represent a understanding of the way individual graphic elements contribute to an ideal form, which was central not only to the modernist project but also to Boumédiène's vision for a modern, postindependence Algeria. Krinah remembers this period as the "grunge" era, with regular rock music concerts on the lawn and a lot of sitting around and playing guitar in the shadows of Niemeyer's perfect geometry. Though the artist does not make the connection himself, there may be a relationship

between his formative exposure to an architecture conceived to encourage democratic relationships between its users and his work around how mass media influences individuals' behavior.

Krinah works with images that come to him in the course of his day-to-day life: mass-media images documenting political events, as well as cultural icons and more mundane aesthetic forms that structure the visual landscape of North Africa, such as *zelliges*, the small ceramic tiles that are ubiquitous throughout the region. The daily repetition of this kind of imagery, according to Krinah, produces alienation from their content. The way such images are circulated or framed by their given context engenders disinterest and dis-identification for their viewers. In response, the artist turned to wallpaper, which he sees as the "innocuous decorative object par excellence," because it is intended to occupy broad surfaces of space without becoming an object of attention. The dual function of this medium as figuration and as environment allows Krinah to create iconic visual elements and then multiply them to the point of graphic abstraction. He uses individual signs to create a perceptual system that at the same time contains each sign and is entirely contained by signs.

Krinah's first wallpaper, *(They) Occupy Algiers* (2011), was inspired by the Occupy Wall Street movement in New York. He was fascinated by the way the police managed the crowds and how this management was visible in the photographs of the protests.

There was a dynamic interdependence between the movements of the protesters and the police, and Krinah translated this into a single iconic graphic of Algerian policemen in riot gear and the head of a woman in the traditional white veil worn in Algiers. Facing each other, the figures intertwine, and merge together completely when the image is multiplied to the scale of a wall.

The result of such multiplication is the same across Krinah's wallpapers, though the motif and the subject change. At a distance, the pattern appears to be a variant of arabesque decoration, fluid geometries that reflect balance and order. Stepping closer, it becomes clear that the foundation of the geometry is not, in fact, abstract. Step closer still, and political actors emerge from the wall in clearly drawn lines. The effect produced by his work is analogous to the effect of representation in mass media: viewers stop seeing the specificity of one life because they see so many. Krinah's work invites the viewer to perform a re-sensitization to the image through an incremental analytical encounter.

MOURAD KRINAH

(They) Occupy Algiers Wallpaper, 2011
Wallpaper
Dimensions variable

NAWEL LOUERRAD

BORN IN 1981 IN ALGIERS.
LIVES AND WORKS IN ALGIERS.

There are two bodies per frame in the first section of *Regretter l'absence de l'astre* (To Regret the Absence of the Star), Nawel Louerrad's 2015 book of graphic work. One is a giant bird, the other is human, though its gender is not categorical. The drawings are square, six per page, and devoid of language. Throughout the roughly twenty-five pages of sketches, the human and the bird struggle to define their relationship to one another, sometimes using graphic violence to communicate.

Louerrad has been drawing since she was a child. "From age four, I had this tendency of repeating phrases in my head before speaking them aloud. My speech became a kind of duplicate reply that I had to give to my mother and to others," she remembers.[1] For twenty-five years, she drew obsessively, filling notebooks with the same image, which failed to evolve into the next but stayed, rather, a replica of its precursor. "It was at the moment that I went to France to study and saw a dance performance that I felt suddenly liberated," Louerrad recounts. "The performance was presented in an obsessive type of gestural language. The choreographer works with artists, among others, using psychological motion techniques. I was able to develop a proper form of my own obsession through that means of expression."[2]

1 Nawel Louerrad, "Sublimation et mise en scène de la violence," *Naqd* 33/34, "L'esthétique de la crise II, Par-delà de la terreur" (December 2016): 126. All translations mine.

2 Ibid., 125.

Over the course of four years, Louerrad worked in performance and experimental theater as a means to embodiment, which was also a process through which she came to understand what was at the foundation of symbolic form and gesture. "Working on bodies, on dismantling the body, and on its disarticulation, I realized that I was talking about my own body. I understood that I was asking questions about violence as a primary or elementary phenomenon, violence in its primordial state."[3]

Writing in the context of a discussion about the Black Decade and the violence Algerian society internalized during the course of it, Louerrad makes a direct connection between coming to know the body as a form which experiences violence, as she did in the theater and on stage, and the work of tolerating difference in others. In her drawings, she tries to communicate this imperative to begin with the body as the foundational site of memory and of an ethical engagement with society. This imperative does not make her drawings pedagogical or light-handed. Rather, they are an inchoate return to the scene of an internal fight, almost to death, with those mythical structures that bind body and mind to repetition.

The section from Louerrad's book reprinted here is entitled "The Bird." Who is the bird? Louerrad suggests that she is the archetypal mother. Or, the bird could be some instantiation of Horus, an ancient Egyptian deity. Known as the Distant One, Horus's function was to leave Ra, and upon his return, inaugurate transformation. There is menace in the bird's looming figure, but perhaps only in the sense that she is all-powerful until the human transforms herself in her image.

3 Ibid.

NAWEL LOUERRAD

Nawel Louerrad
Regretter l'absence de
l'astre (To regret the
absence of the star)

(Editions Dalimen, 2015)
Section of a graphic novel

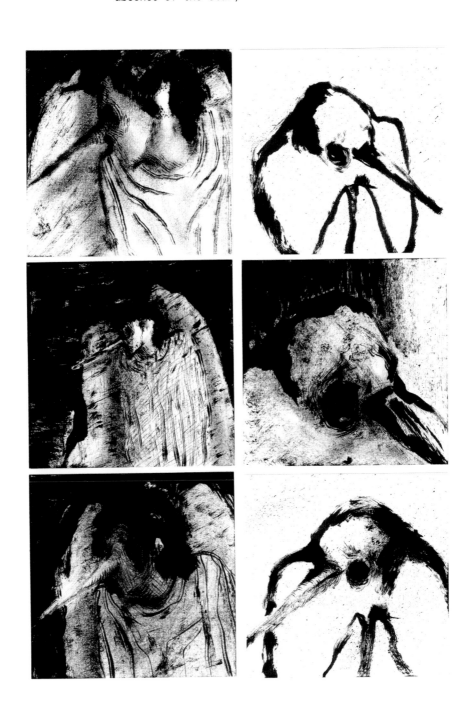

AMINA MENIA

BORN IN 1976 IN ALGIERS.
LIVES AND WORKS IN ALGIERS.

The Chrysanthemums Project (2009–ongoing) comprises photographs of commemoration stelae, erected to inaugurate the construction of bridges or public buildings, and of monuments to the martyrs of the War of Liberation that dot the landscape of Algeria's coastline. Amina Menia photographs the monuments in straightforward documentary style and reproduces them as close to life-size as possible, so that the viewer might be confronted by them as public objects. In one version of the work, she mounted the photographs on a wooden frame, the self-consciously sham version of a sham monument. Of her intention, she writes: "I want to document public commissions that carry a political ambition or are willed by a community. What is this 'public' art in a country which is so badly lacking in democracy? What is the intention of these popular expressions? What are the aesthetic references of the artists who made them?... I am frustrated that Algerian art in the public sphere limits itself almost exclusively to bitter subjects from the past."[1]

The French expression inaugurer les chrysanthèmes (to inaugurate chrysanthemums) is used to describe the actions of an official who acts without real power, a person who represents a political body, such as a government, but who is not vested with the power to make consequential decisions. It was first used by Charles de Gaulle in 1965 during a press conference at the Élysée Palace. Speaking of himself in the third person, he remarked: "Besides, who has ever believed that General de Gaulle, having been summoned to the bar, should have been content to inaugurate chrysanthemums... ?"[2]

1 Artist website, http://www.aminamenia.com/?-browse=Chrysanthemums.

2 https://www.ina.fr/video/I00012497. Translation mine.

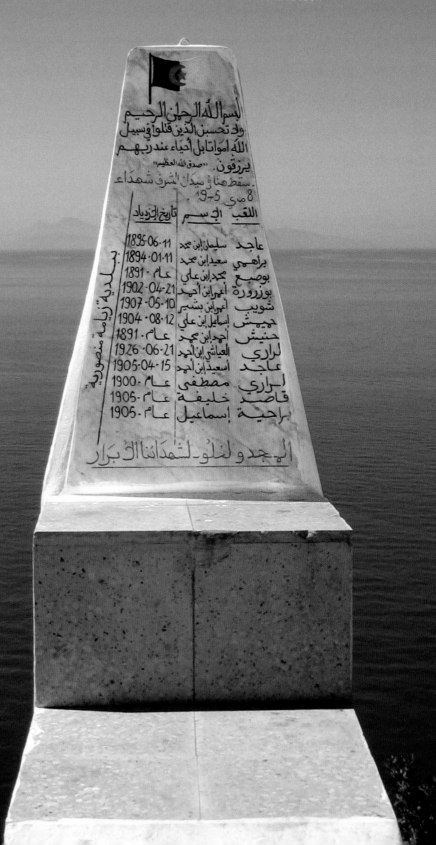

AMINA MENIA

De Gaulle was called back to power more than a decade after he retired to lead France into its fifth republic in 1958. He presided over the end of the Algerian War and, despite his protestations to the contrary, he did inaugurate the chrysanthemums. He represented the French in Algeria at a moment when the French had lost their authority to rule. Today in Algeria the proverb has come to describe the act of commemorating an unrealized ambition. It is in this sense that Menia borrows it as the title for her series of photographs.

The Chrysanthemums Project was born of frustration, but is nevertheless a homage to popular aesthetics. The monuments are often abandoned, worn down, half erased either by time or by vandalism perpetrated "when expectation starts to rot," in the artist's words. The work touches on the traces of memory in a context that remembers some events, like the victims of the War of Liberation, with a rigid, authoritarian determination, while this single-mindedness offers little place for historical nuance. The difficulty of these monuments is that if the building or bridge are not constructed, if the liberation for which the dead are remembered is only partially achieved, stony symbolism cannot adapt or evolve. The memorial stays fixed, stuck in a state of waiting for the only outcome for which it is prepared to stand.

SONIA MERABET

BORN IN DJELFA, ALGERIA.
LIVES AND WORKS BETWEEN ALGIERS
AND ORAN, ALGERIA.

Sonia Merabet's *Self-Portrait, Draping* (2011) is a pair of freestanding light boxes that show the artist draped in white muslin cloth tied at the waist and covering her entire head. In one image, the fabric is gathered so that it is precisely symmetrical along a vertical axis down the center of her body. In the other, the balance of fabric falls to the left of her body, making room for a rectangle of dark cloth that resembles a large suit-jacket lapel. The lapel refers to another mode of dress, an exaggerated nod toward women's power suits from the 1980s. In both shots, the fabric unfolds outward as though to reveal the body's core, but under each layer comes another layer. Only the hands are visible. In one image, they are suspended to precisely mirror the drape of the fabric. In the other, they are poised on the artist's hips, reinforcing the division of her body along the horizontal line marked by a rope belt.

Sonia Merabet conceives of the work as revolving around cellular memory, or the idea that memory is stored in cells throughout the body and not only in the brain. This implies that memory

is exterior to the mind as it has been classically conceived; that it is worn as a layer or embedded in the tissues of our arms, knees, and ankles. If the ability to recall experience is decentralized, then everything that touches our body also potentially comes into contact with its memories.

Self-Portrait, Draping evolved out of the artist's family photographs as well as media images of Algerian women throughout the twentieth century, which she collects in sketchbooks. Some of the women in these sketchbooks wear the haik, a veil typically associated with Algerian women during the French colonial period: a large white rectangle of cloth was wrapped about the lower half of the body first, then draped over the head and shoulders, the precise draping technique varying by region and social class. In a family snapshot, two women and a man stand for a portrait. Their faces are smudged to retain their anonymity, their posture straight and firm. The women wear high-waisted dresses that are open at the neck and hemmed with embroidery. Their arms are bare, falling loosely into generous folds of fabric formed at their sides.

As the sketchbooks illustrate, Merabet's self-portrait amalgamates existing and remembered representations of women, as though she had stored their memories in fabric to wear as an external appendage to her own body. The vertical axis of the body upright, or the memory of a woman with her hands on her hips in the sun, flicker to life in Merabet's images. Equally, the arch of muslin above the artist's head imitates the shape of woman engulfed in a haik. Two experiences in folds of fabric, both metaphors for the way a body remembers its place in the world.

SONIA MERABET

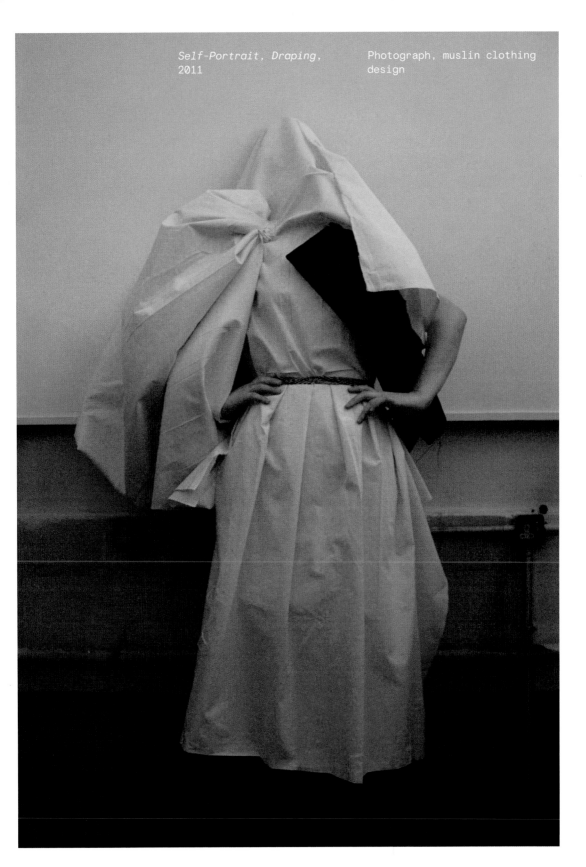

Self-Portrait, Draping,
2011

Photograph, muslin clothing
design

YAZID OULAB

BORN IN 1958 IN SEDRATA,
ALGERIA. LIVES AND WORKS
IN MARSEILLE, FRANCE.

There are two instruments in Yazid Oulab's installation *La Halte* (The Halt, 2013): a large tambourine from the Iranian musical tradition and a ney, which is originally Turkish. The tambourine is made of goat's skin stretched over wood, and the ney is a reed flute played by blowing into one end, like a long recorder. It is one of the oldest instruments still played today. Both the tambourine and the ney function in the artist's formal vocabulary as the material foundation for a trance that is as ancient as it is rudimentary. In *La Halte*, Oulab has altered each instrument to the edge of

recognition or to the point just before it loses its visual relationship to sound.

The artist placed an iron gun sight (the device that allows someone using a gun to gauge the weapon's alignment with a target) over the surface of the tambourine. In Arabic script at the center of the sight, *do* is written, the first syllable in the tonic solfège. The other syllables—*fa, sol, la,* and so on—are scattered across the tambourine's face, along with floating Arabic vowels and tonal accents. Oulab describes the impetus for the piece as a meditation on the notion of touch. In

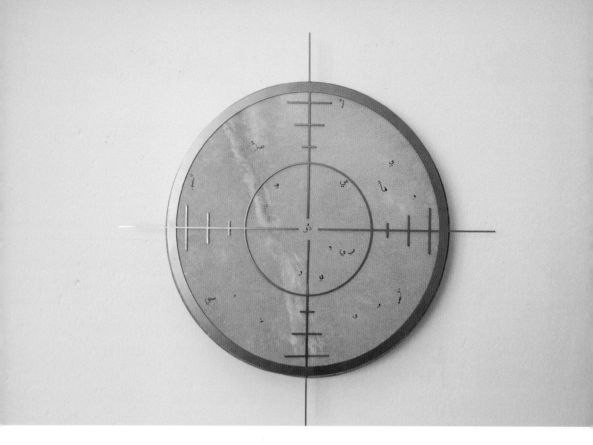

Le Halte (The Halt), 2013 A large tambourine with
gun-sight painted Arabic
letters

YAZID OULAB

French, you say a person is touched by violence, and also by music and by God. The expression describes a transformative encounter, a moment when the subject or their understanding of the world shifts to accommodate that which is outside of themselves. The piece also speaks to the complexity of the process of finding one's place in sound—the right note, the right tone, the right space in an aural universe. How does someone playing the tambourine know where that sound falls without a graphic to help them aim, and is this existential problem solved if a military solution is imposed?

The reed sculpture sketches the wavelength of a tenor voice singing the syllable *la* through the same reed that is used to make the ney, materializing the effect of the instrument. Traditionally, the ney musician chooses and cuts the reed for their instrument; they detach the plant from the ground and from its roots, and then reconstitute the link symbolically when they breath into the instrument to produce sound. Oulab's reimagination of the ney, however, follows the horizontal logic of a sound scale, and is made up of many different cuts and sharp angles. It hovers above the ground, semiotically untethered from its roots, a floating signifier for breath. To sing the syllable represented, a singer must take a breath (*ahh*) and exhale it (*la*), inadvertently speaking the Arabic word for God, Allah. The artist's recourse to spiritual simplicity and its reflection in form originates in his interest in Sufism, a mystical tradition within Islam focused on meditation and the power of poetic vibration to create the conditions for transcendence.

LYDIA OURAHMANE

BORN IN 1992 IN SAÏDA,
ALGERIA. LIVES AND WORKS
IN LONDON AND ALGIERS.

your presence disturbs us is centered around a conflict over the door lock of Lydia Ourahmane's parents' property in the Kabylie region of Algeria. In May 2019, the Algerian government ceremonially sealed the building by pouring red wax into the lock of the front door, stamping the wax with an official seal. It is illegal to tamper with this seal under any circumstances, punishable with imprisonment. *your presence disturbs us* began the moment the door to the property was sealed and will end when the property is reopened by the government.

The project's conceptual point of departure is the archaic symbolism of sealing a lock with wax. Official letters were once sealed with wax and stamped with a crest in order to ensure they were read only by the addressee. The seal was a guarantee against illicit reading and the possibility of meaning being misdirected. In an Algerian context, officials pour wax into a lock to signify that no one may

access the space except the state. The lock is rendered useless from a practical point of view by virtue of its transformation into a symbol of the state's power.

The official justification given for sealing the home was that the structure exceeded building regulations. There are over 600 buildings in the region that were given no permission to be built at all, including schools and other municipal buildings, which suggests the state's justification may disguise another kind of sanction, related to an ongoing campaign against the Christian minority in Algeria. The Église protestante d'Algérie (EPA), the umbrella organization for the interests of Protestant churches in Algeria, has documented a series of church and church-affiliated property closings since November 2017. Such closures are typically justified by the fact that the building in question lacks a permit from the National Commission for Non-Muslim Religious Groups. In reality, this commission never issues such permits, which creates a feedback loop in the system: to exist as spaces of worship, churches must acquire a permit from an inoperative commission. Therefore, they are forced to exist outside the state. The EPA is in the process of lobbying for international pressure to open previously closed buildings and promote religious freedom.

The work's title comes from the sentiment expressed by the local authorities responsible for sealing the Ourahmanes's lock, *your presence disturbs us*. Presence disturbs because it is proof of the intangible difference of belief, as Christians living in a majority Muslim country. The sealed lock is a materialization of the Algerian state's program to isolate and exclude those it perceives to be different, especially those it perceives to hold beliefs that diverge from the party line. Sealing the locks of churches and the homes of Christians not only makes them physically disappear. On a symbolic level, it arrests their access to space.

your presence disturbs us presents photographic documentation and correspondence illustrating the process of attempting to have the door unsealed, with the intention of showing the actual sealed lock in the exhibition. Ourahmane brings the weight of the exhibition's symbolic space of representation to bear on that of state power.

LYDIA OURAHMANE

your presence disturbs us,
2019

Documentation of
correspondence, photographs,
and a sealed door lock

SADEK RAHIM

BORN IN 1971 IN ORAN, ALGERIA.
LIVES AND WORKS IN ORAN.

Sadek Rahim's conceptualism is grounded in an Algerian semiotics. This is part of his response to an Algerian public, whether or not such a public considers itself interested in contemporary art. Cube shapes, for example, recur throughout his work, borrowed from the huge concrete cubes piled up to create artificial dikes to partition the harbor of the artist's native port city, Oran. Fishermen, bored teenagers, clandestine lovers, would-be *harragas* (the Derija word for migrants), and picnicking families clamor over the giant shapes, which serve as a vantage point to look out over the sea. The cube is a form laden with art historical and mathematical connotations, but here it grounds the relationship the Oranais have to the sea. Rahim is particularly interested in these kinds of forms, which stand between universalist and vernacular significations.

Rahim's *Cube* (2019) is an ephemeral work made of rug fragments that have been pressed into a cubed mold. The work does not involve adhesive; the pieces

attach on their own. Composed of very fine synthetic filaments, the fabrics are industrially produced to hold together, creating a composite image on the surface of a rug. They are never intended to separate or leave the floral or geometric pattern they make. Individually, each seems insignificant, but a single absence would result in a gap in the weave, making it vulnerable to further unraveling. Rahim's cube changes over the course of time, depending on the conditions of exhibition, like humidity and air flow. Its central axis may lose its formal rigidity, giving the impression that it is collapsing in on itself. A corner might buckle, its filaments may splay out. The idealism that gave formal purpose to errant strands of rug frays under the weight of time.

Liberty Enlightening the World (2019) extends the artist's insight into abstraction to the Statue of Liberty. Depicted in an amalgam of carpet fibers, the icon of American idealism is blurred, becomes faceless, the upward thrust of her arm toward the sky loses its characteristic dynamism—a visual analogy for the experience of contemporary immigrants to the US.

Mankind; 2 points (2016) is more direct in its critique of idealism. The artist burned the Eurovision Song Contest logo from the time of his childhood, a circular design of twelve stars radiating lines outward that was in use between 1954 and 1994, on the reverse side of a rug he bought in Syria in 1999. The Eurovision is an enormously popular international competition inaugurated in 1956 by the Swiss European Broadcast Union at a time when European states were looking for ways to establish apolitical, family-oriented forms of common interest among the countries of the European Economic Community which was founded the following year. It has been broadcast every year since 1956, and has grown to include over fifty participating countries, including Australia, Israel, Morocco, and Turkey. Algeria has never participated.

Rahim sees the work as a comment on the contradictory response to those seeking refuge in Europe on the part of its citizens. He watched hundreds of German citizens holding up signs saying "Refugees Welcome" on the evening news, while in Poland those who sought refuge recounted horror stories of inhumane treatment. He considered the news coverage about different national responses to heightened migration in comparison to the coverage of voting in the Eurovision Song Contest. The artist explains: "Throughout the decades the results of the contest demonstrate solidarity between some countries in the EU; this is surely due to historical and cultural ties that have been established between these countries for centuries."

In all three works, the rugs function as a signifier of social coherence and an object that marks the interior dimension of social life. In *Cube*, the rug disintegrates and is reinvented as an abstraction. In *Mankind; 2 points*, the rug is reversed to reveal that while it seems whole, it too is branded with an imagination of apolitical and contradictory forms of belonging to Europe and its vision for the world. Rahim seamlessly integrates geometry and its attendant ideology across disparate sociocultural landscapes.

SADEK RAHIM

Mankind; 2 Points, 2016 Syrian circular carpet,
burned
160 centimeters (diameter)

DANIA REYMOND

BORN IN 1982 IN ALGIERS.
LIVES AND WORKS IN ANGOULÊME,
FRANCE.

Le Jardin d'Essai du Hamma (The Test Garden of Hamma) is a botanical garden in Algiers, built by the French in 1832, two years after the colonization of Algeria in 1830. The colonial authorities drained swamp land in order to establish an open-air showcase for exotic plants from throughout the African territory, and to establish a model farm. One of the garden's primary purposes in the early period was to provide seeds to public organizations and to European settlers, and it was a laboratory for colonial botanical science and agriculture throughout the French occupation. From 1842, the garden was also used as a zone of acclimatization or adjustment for animals from Sub-Saharan climates on their way to France. There is a widely accepted rumor that, in 1932, the park served as the set for the scene in W. S. Van Dyke's *Tarzan the Ape Man* in

which Tarzan roars spectacularly before sweeping down from a dragon tree to save Jane.

Filmmaker Dania Reymond was attracted to the Jardin d'Essai because of its function as a projection (and transformation) of the colonial imagination on to the existing Algerian landscape. She conceived of the garden's history as a mise en abyme inside a mise en abyme, or a living testament to the dialectical nature of colonial fantasy. Reymond played in the park as a child, as did many others before it was closed to the public during the Black Decade. Like other examples of architecture and infrastructure left behind by the French in 1962, the garden is still maintained, and continues to signify a space for fantasy in new ways for those who grew up in it.

Le Jardin d'Essai (2016) is a film about what people in Algiers want, what they dream of being, and how they negotiate their dreams given the context in which they live, which has few opportunities for young filmmakers and actors following the state's infrastructural abandonment of the medium after the 1990s. Reymond intersperses the film with small yet significant contradictions in the lives of these young people. One actor has an accent when she speaks Derija, because she was raised in France and only recently returned to Algeria, "to see how it goes." Rehearsing a scene with her boyfriend, she asks him to take her with him if he leaves. The reality of immigration and the lack of recognition that Algerians face, especially in France, is legible in the fact of this young woman's return, even as she projects anxiety at the idea of her lover's departure to chase his dreams elsewhere.

The central question posed by *Le Jardin d'Essai* is where to locate the reality of lived experience among the cacophony of fantasies about Algeria and the fantasies of Algerians. What is in the film script, itself drawn from an Algerian fable, and what is in the minds and lives of its actors? What role does each level of the film's structure play in producing the Algerian context today? Reymond reminds the viewer that "these projections cannot be reduced to the order of fantasy. Nation building involves the circulation of myths, stories that Algerians have perpetuated or reclaimed. Projection implies that they are passive in this process, whereas they are, on the contrary, the question is how to reclaim these legacies of fantasies, as well as their interaction with myths and other contradictory narratives."

Le Jardin d'Essai
(The Test Garden), 2016

Still from video,
color with sound
42:00 minutes

SARA SADIK

BORN IN 1994 IN BORDEAUX,
FRANCE. LIVES AND WORKS
IN MARSEILLE, FRANCE.

Sara Sadik examines the semiotics of "beurness," a term derived from the term "blackness" and borrowed from a US context. *Beur* is pronounced like the French word for butter, *beurre.* The word originates from an inversion of syllables in the French *arabe*, transforming it to *be-ar* in a linguistic play at the root of much *verlan*, a form of French slang (itself a reversal of *l'envers*). Beurs are second- and third-generation immigrants from North Africa, particularly from Algeria, Tunisia, and Morocco, regardless of religion or ethnicity. Sadik draws on beur visual aesthetics, economic systems, and language to create surreal representations of this group's social experience and structuring contradictions.

Sadik uses the term *Mektoub* as the title for her 2018 installation that riffs on the existence of Maghrebi-Muslim dating sites like mektoube.fr and inshallah.com. She reimagines these intra-diasporic initiatives as a fictional urbanism project launched by a generic French municipality. In a press release inaugurating the speculative venture, the artist writes: "The HFCity mayor has launched a new municipal project: a dating area to allow young citizens to find their soulmates while respecting Islamic rules." *Mektoub* is an Arabic word meaning "it is written," implying that whatever has just taken place was already decided by they who write the world, that any event is God's will. It is used in times of crisis and celebration, a polyvalent resignation to fate and an acknowledgment that an individual is not in control of their destiny.

The idea is based on existing governmental initatives in French social housing projects that fill empty lots with gym-like structures designed to entertain and distract the youth of these neighborhoods, in order to "fix the problem" of free time. Sadik imagined the endgame of such initiatives, or what kind of proposal a municipality might dream up

Mektoub, 2018
Aluminum installation with video and headphones
Dimensions variable

SARA SADIK

to "fix the problem" of gender segregation in neighborhoods with high North African immigrant demographics.

"It is as though," the artist explains, "town hall officials were saying: 'Girls and boys in the projects do not talk to each other and do not mix (because of their culture...) therefore it is necessary to create situations that allow them to meet, promoting gender diversity (white savior), and we will do that by respecting their culture and their religion (while they spit on it as soon as they are able)'." Sadik's installation consists of an aluminum frame resembling that of the outdoor exercise equipment, but rather than offering passersby the chance to cycle or do push-ups, a flat-screen TV strapped to the exercise equipment's bed is playing a short promotional video. The video presents a dating service in conformity with Islamic law, or within the *deen*, Arabic for faith.

As architectural renderings of the sculpture spin against a neon-green background, an off-camera voice promises that it provides a space that is 100 percent secure for the activities of the faithful. It is designed, the voice flatly claims, to respond to the constraints of religious life and of the weather. The voice offers no detail, however, on how the structure will attend to the dating needs of people who, in the strictest understanding of religious law, are not meant to meet each other's gazes or have any contact outside the family. Neither does the script give any indication of what sort of weather this aluminum frame might protect from.

In the video, Sadik plays the fictional city's deadpan mayor, wearing the French national soccer jersey, red lipstick, and big gold shell earrings. The jersey bears the name of Zinedine Zidane, the phenomenally talented soccer player born in Marseille to Algerian parents who ended his career by head-butting an Italian player during the 2006 World Cup Final in response to what was widely suspected to be a racist slur. The dissonance produced by the piece is dizzying: Sadik, a beure artist, plays a white French mayor who is trying to signal "integration" into the immigrant community by wearing the Zidane jersey and using language the municipality assumes will land favorably with the population it addresses.

FETHI SAHRAOUI AND LA CHAMBRE CLAIRE

BORN IN 1993 IN HASSI R'MEL,
ALGERIA. LIVES AND WORKS
IN ALGIERS AND MASCARA.

Closed, *Triangle of Views* by Fethi Sahraoui forms an equilateral triangle. Open, it is roughly the size of two outstretched hands, placed next to one another, palms facing up. The photography book is published by La Chambre Claire, founded by Youcef and Zohor Krache in 2018. Sahraoui and Youcef Krache belong to Collective 220, a group of photographers who first congregated in room 220 of Albert Premier Hotel in Algiers in 2015 to discuss the need to create and circulate representations of Algeria that surpassed stereotypes: the veil, the Kabyle people, the migrant, religious extremism, and so-called underground scenes.

Sahraoui was born in 1993 in the southern town of Hassi R'Mel. He belongs to a generation with unprecedented access to visual media, both materials for its production, like high quality phone cameras, and a wealth of references from film and fine-art photography easily accessible online. The book's design mirrors the platforms on which Algeria's emerging photographers trained and reflects a shared awareness of photography's relationship to the body in the contemporary landscape of images. Thick square pages are folded at the diagonal center of a book only about three or four times the size of a smartphone. Its scale is crucial: large enough to dissociate itself from the banality of the phone screen, small enough to produce a similar haptic relationship to the object. The reader's hands sense what to do with the images, although now they are not quite scrolling or swiping: one hand beneath the book's central binding and the other moving from right to left, or left to right, flipping through a sequence of square photographs printed in full bleed. It is the viewing experience Instagram can only dream of.

Triangle of Views pairs two related long-term documentary photo projects:

"Stadiumphilia," begun in 2015, focuses on the male collective experience of time and space in Algerian football stadiums, while "Escaping the Heatwave," begun in 2016, chronicles the same group in the western Algerian cities of Mascara and Relizane during the hottest period of the year, as they dream of the beach as a final refuge.

"Stadiumphilia" is about what the stadium contains in terms of affective and visceral levels of male experience. Football is wildly popular in Algerian culture. Since the Black Decade, the infrastructure for public mass entertainment has largely disappeared outside the major cities, with the exception of football stadiums, which have become one of the only places apart from religious services where large crowds are permitted to congregate for hours in public. Sahraoui is especially interested in unaccompanied minors, who are usually barred from entering the stadium but who come anyway, cheering from beyond its walls if they fail to find a way past the guards.

Sahraoui sees the football supporters' enthusiasm and fierce desire to participate as spectators as an allegory for social conditions in Algeria, rather than simply as an allegiance to the game itself. He also understands the public protests that took place in Algeria in the lead-up to the presidential elections as having been rehearsed in the stadium, born of the solidarity learned as fans.

"Escaping the Heatwave" documents this same demographic in search of relief from the heat of the summer. Algeria has roughly 1000 miles of coastline, yet for those living even forty miles inland, the sea can feel inaccessible during the height of the season. Without public pools and other such amenities, children find abandoned water towers, irrigation channels, and streams of agricultural runoff to cool themselves in. If "Stadiumphilia" revolves around a collective experience that bears political fruit, "Escaping the Heatwave" traces the same generation's ingenuity and willingness to invent solutions to systemic problems on a quotidian level. This latter series centers on the body's experience of the extremes of the Algerian landscape, and the inexorable range of responses of which this generation is capable.

FETHI SAHRAOUI

"Stadiumphilia,"
2015-ongoing
Photograph from
the book *Triangle
of Views*, 2019
Published by La
Chambre Claire,
Algiers

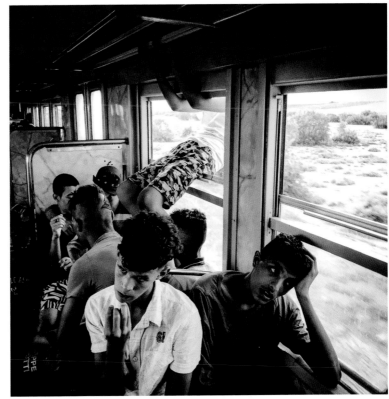

"Escaping the
Heatwave,"
2016-ongoing
Photograph from
the book *Triangle
of Views*, 2019
Published by La
Chambre Claire,
Algiers

MASSINISSA SELMANI

BORN IN 1980 IN ALGIERS.
LIVES AND WORKS IN TOURS,
FRANCE.

A man in a long, loose garment with a rough cotton scarf wrapped around his head stands with his back to the viewer and his arms outstretched, head craned to the left, while on his right, partially blocked from view, a soldier dressed in camouflage grips the man's wrist. Massinissa Selmani's drawing *Teyara* (2010) is part of the "Alterables" series in which the artist appropriates media images, photocopies them, and then alters them using layers of translucent tracing paper, effectively animating the photocopies or rendering each one a point of departure for a thought exercise in alternative reality.

Selmani traces the contours of the body of the man being searched, reinforcing the integrity of the outer limit of his personhood. The artist draws his arms in three positions: the original position of submission to inspection, his arms stretched out along the horizon, and two other positions above and below this line. Reproducing the delicate arch of the man's hands as they move against gravity,

Selmani shows him preparing to take flight. This reading is reinforced by the work's title, *Teyara*, Arabic for airplane, derived from the root for the concept of flight. "*Teyara* was also a word we used when I was little in Algiers to designate an elusive person," Selmani explains, someone who was difficult to pin down.

The sociopolitical details of the scene are largely absent, but Selmani leaves the viewer enough information to identify an act of force on the part of the soldier and an act of imagination on the part of the interpolated man. With this image, Selmani stages a subtle and absurd confrontation between authority—here markedly unspecified—and the power of non-oppositional resistance.

In Selmani's words, his work is an invitation "to fill in the gaps, to question the way we remember and write history, beyond any linear structure." His tripartite installation *Unexpected Distances* (2017) evokes this subtle resistance to the logic of progression by reimagining the space

Teyara, 2010
Drawing on digital print

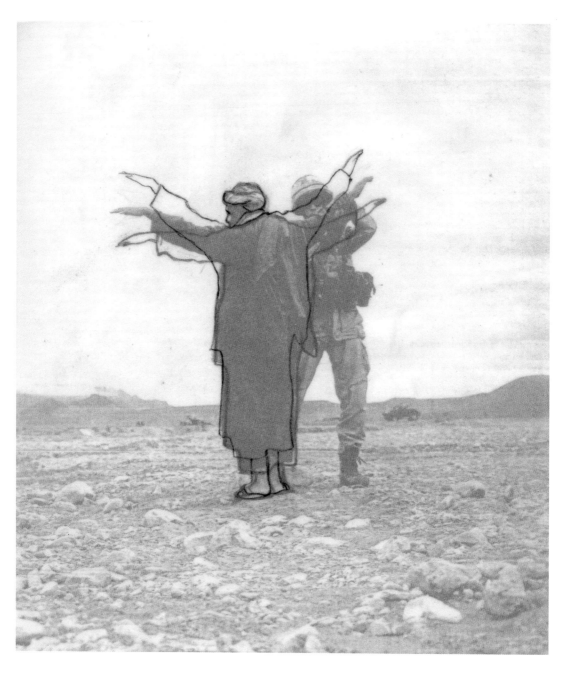

MASSINISSA SELMANI

of the line. Element one: a torn piece of tracing paper, taped to the floor with white masking tape, a rudimentary scale measurement sketched along one of its axes. Selmani projects on to this paper a video of running water that is partially obstructed by a branch. The wood's resistance to the flow of water creates an oscillating movement on the surface of the tracing paper, like the movement of a cursor. Element two: a sheet torn from a ringed sketchbook on to which a butane gas canister—typically used in homes to fuel cooking ranges—is sketched in red pencil. The sheet is affixed directly to the wall without a caption. Element three: a large, thick, blank piece of drawing paper curling in on itself, pinned to the wall with a metal rod, which leans against the paper and the wall to connect the paper to the floor.

Unexpected Distances speaks to a form's capacity to endure constraint, or to return to its own material center after having been stretched or compressed. The broader stakes of his formal inquiry concern an existential persistence to sociopolitical circumstances beyond one's control. Selmani's work responds to the standard organizing principle of linear progression, which endangers the future because it threatens people with the dispossession of their own processes of perception.

FELLA TAMZALI TAHARI

BORN IN 1971 IN ALGIERS.
LIVES AND WORKS IN ALGIERS.

Trio (2014) is a painting that plays on spaces, which is unsurprising given Fella Tamzali Tahari's training as an architect. *Trio* asks where light lands, and who it lands on. Who is playing with who, and how to end that game. The work is a ballet of gazes: a man looks at his daughter, a dog at his master, and a girl at the viewer. The checkerboard floor stretches between these actors, obstructed in its plane across the canvas by a gray wall in the background.

Tamzali Tahari's work figures the moment when an unconscious power play is forced into the consciousness of the painting's inhabitants. There is apprehension in the daughter's gaze, perhaps even fear. There is grace in the man's silhouette, but there is also the potential for violence. There is curiosity and playfulness in the dog's stance against the tiled floor, but there is also caution born of an experience of rejection. He is ready to jump backward into the safety of

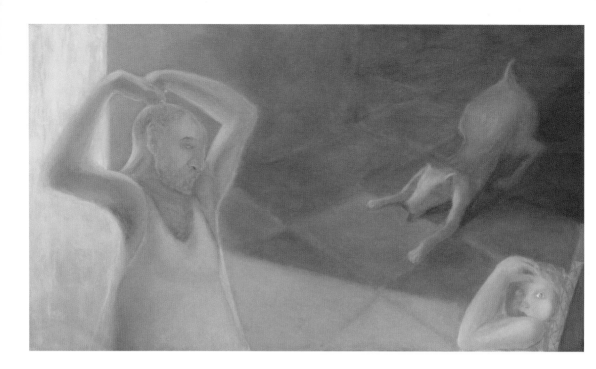

Trio, 2014
Acrylic on canvas

the deeper shadow behind him. Each of the figures in the work's triadic structure is watching, on the brink of movement, but the realization of how power is structured between them is only avowed in the girl's appeal to the viewer.

The artist's work is often understood as a meditation on the realm of small domestic instances in an Algerian context. The split second in which the day's potential is gauged. The man in *Trio* leaves the bedroom, catches the light from an open window and decides, on some level deep inside his body, the weight of the air that day, how it will act on him.

The painting's most mysterious figure is also the most direct in her address to the viewer: the girl tucked claustrophobically into the canvas's lower right-hand corner. A rounded arm reaches along the picture's edge, bent at the elbow to frame her face and protect it from the light and the man standing in it. Or perhaps she has shielded her gaze in order to look out at the viewer, to see what is beyond the painting's border. The light on her face does not come from the window but from someplace beyond the frame, a source which nevertheless leaves the dense shadows behind her intact.

Trio's emotional tension is supported by a tightly organized pictorial ground. Light cascades across the floor on the painting's left side, enveloping the male figure from behind and illuminating the object of his attention. The dog's body casts a deeper shadow than the objects around him, as though he were issued from a denser space in the room. The tiles are huge, disproportionately so, with one measuring the man's entire chest and abdomen. Yet in the work's ambient tension, their size seems both reasonable and stable in comparison to the figures that quiver in anticipation in the still, flat air of the room. The fact that these figures cannot be counted on for a realistic sense of scale suffuses everything else in the painting with the possibility of distortion.

DJAMEL TATAH

BORN IN 1959 IN SAINT-CHAMOND,
FRANCE. LIVES AND WORKS
IN PROVENCE, FRANCE.

According to Djamel Tatah, identity is canceled in his paintings. His works are not representations of people in the proper sense, they do not strive to reveal individuality. They are compositions made with the lightest reference to the external world, representative of the slow evolution of perception. They function like afterimages, the imprint left on the retina upon the perception of event. His paintings have a vague relationship to the ways reality is usually mediated, whether through photography or narrative forms. Memory is something else. It requires the mind's effort to seal the meaning of an event. Tatah's work seals nothing, offers no narrative synthesis, and guarantees no meaning.

"My painting is silent," the artist writes of his intention, "and imposing silence on all the chaos of life is almost like making a political statement. It allows one to step back and examine one's relationship to others and to society as a whole." Tatah offers the viewer an experience of the associative interval, that small space of time between a gesture and its implications. He also proposes that such an experience of perception is profoundly solitary.

Untitled (2018) is a diptych and a triptych simultaneously—two panels that partition the pictorial space into thirds. Flush to the edges of the canvas, burnt ochre expanses frame the work's opening onto a deep blue central chamber. Prostrate bodies line the floor in the room's foreground, ranged in orderly layers that fail to recede proportionately into its depth. The figures are dressed in muted primary tones, their foreheads resting on the ground before them. Their arms are outstretched in a final form of submission, the recumbent consequence of war and its violence. It is crucial for Tatah that these figures do not belong to any specific geography or faith.

Three female figures in loose clothing stand against the ochre wall to the far right of the painting. They are the same women without appearing quite identical. Loose dark hair frames each pensive face. Each observes the violence to which the prostrate bodies respond in a different manner: on the left, the woman watches the scene, the middle figure seems caught in mediation about both the scene and her own position with respect to it, and the woman on the right watches the viewer.

This third figure stands awkwardly at the very edge of the painting, as though she were arrested in the act of leaving it. Head slightly cocked to one side, she gazes out at the viewer with an abstract and unreadable expression on her face. Her gaze functions as a reminder to the viewer of their spectatorship of war and its human consequence, of their simultaneous

Untitled, 2017
Oil and wax on canvas

Courtesy of the artist and ADAGP,
Paris

DJAMEL TATAH

complicity and exteriority to the painting's central theater.

If the painting is an experience of spectatorship materialized, from whose perspective is it issued? Put otherwise, with whom is the viewer expected to identify? In the stillness of Tatah's work—in its silence—the space of the watcher expands to encompass even the most casual passersby. Arms crossed, the woman on the far left considers the bodies laid out below her impassively. It is a moment in which no decision is imminent.

SOFIANE ZOUGGAR

BORN IN 1982 IN ALGIERS.
LIVES AND WORKS IN ALGIERS.

Sofiane Zouggar began his ongoing investigation of representations of Algeria's Black Decade, entitled *The Memory of Violence*, in 2013. The project emerged out of a conversation between the artist and a man who had fulfilled his compulsory military service during the conflict about what the man remembered and in what places such memories were located. The exchange grew into a research project that brought Zouggar into contact with a former terrorist whose official status since 1999 is that of a "repentant."

The term refers to effect of the Civil Concord Law put to a popular referendum and then enacted by Abdelaziz Bouteflika. The law granted amnesty to Islamic Salvation Army (AIS) fighters who had not "committed crimes or murder." They could come down from the mountains where they had been hiding, weapons in hand, and be assured of government assistance with housing and employment meant to reintegrate them into society. Though there was overwhelming popular support for the referendum in 1999, known as

"In-Out," 2015–ongoing
Photographic series,
presented as an
installation

SOFIANE ZOUGGAR

El Rahm (the mercy), and despite the law's qualification to the contrary, some people found themselves living next door to people known to have murdered hundreds and who were sometimes responsible for the deaths of those who lived close by. This unarticulated proximity—one that also existed with former members of the military—contributed to a lack of anamnesis, or collective memory-work.

Zouggar's work is based on the assumption that, in his words, "collective and personal memory have an inherently social dimension and involve a collaborative process. This process aims to affirm or strengthen crucial elements that are rooted in the past yet which represent a common memory." He is interested in traumatic amnesia, a condition under which social factors force an individual to repress memory for self-defense and/ or out of rejection. Zouggar's installations render the objects from an Algerian context that have come to embody memories that are still unspeakable.

His series of photographs "In-Out" (2015–ongoing) are shots of the severe cement structures built to provide shelter and a vantage point to the Algerian military, and which signified the presence of the army during the Black Decade. Because they were permanent, it could be assumed that the terrorists had mapped their locations and then avoided them, making the area around them a relative safe-passage zone. In the fifteen years since the end of the conflict, some of these structures have been abandoned by the army. A few have been informally repurposed for use by migrants or local youth, but others avoid looking at them, perceiving them as reminders of an extremely painful period.

In an adjacent installation, *Traces*, Zouggar has transferred roughly fifty photographs given to him by his repentant interlocutor to slides set into a carousel projector so they play in a loop. The photographs were taken during the former terrorist's trips back to the base camp his group set up in the mountains during the Black Decade. They are as banal as the empty guard-posts: semi-ruined stone buildings under the snow, mountain vistas shot in the early morning, the entrance to a natural cave, an empty field covered in the fresh green of early spring growth. The slide projector layers the traces of life spent outside of society with the sound of a faint machine click at regular intervals, and the soft whir of the device's fan.

The juxtaposition of "In-Out" and *Traces* represents two parallel processes of forgetting that are nevertheless embedded in the physical world, juxtaposing two different architectures of abandonment. Zouggar's juxtaposition grants one frame of reference for anamnesis. On the one hand, the structures that remain and bear the memory of the army's omnipresence in people's lives. On the other hand, the ruins of camps for those who had left society to live along ideological lines in the mountains. In each context, the buildings represent traces of a social process that was violent, continuing to bear witness to it even in the face of the pressure to forget.

Dania Reymond
Le Jardin d'Essai
(The Test Garden), 2016

Still from video, color
with sound
42:00 minutes

Thinking about Art in Disorderly Times

Khaled Bouzidi

TRANSLATED BY OLIVIA CUSTER

I write this essay at a particularly interesting and crucial time in Algerian history: for the last few weeks, millions of Algerians have taken to the streets to demand true democracy and the rule of law. My political involvement is linked to my role as a cultural actor—in this Algerian context, art and culture are often driven by social and political engagement.

If one wants to analyze the development of the "new generation of Algerian artists" today, it is important to take account of the dynamics that allowed this generation to develop as individuals and collectively in a variety of complex ways. Since there is little research on this subject, perhaps because the context does not lend itself easily to research, I decided to approach it from a personal angle, using my own experiences as my main reference point.

It all began for me in 2013, with my experience with a platform called Trans-Cultural Dialogues, which brought together young artists, activists, and cultural workers from various countries in the Mediterranean region with the aim of organizing cultural and artistic events that would promote artistic practice in public spaces and broach contemporary sociocultural problems through a participatory approach. The first event was DJART'14, which took place in Algiers in November 2014. This interdisciplinary event tried to revitalize public space to create common spaces that would involve the local community, as well as bring together a great many Algerian and international artists. The idea was to leave a visible trace on the walls of the city and a lasting, if immaterial, trace in people's minds. While we were doing on-site research to prepare for the event, we raised a series of concerns regarding major obstacles to the implementation and development of independent projects in the field of visual art in Algeria: too few independent initiatives, too little quantitative and qualitative data, no mapping or proper documentation of many projects, and no visibility for the few local and international initiatives that there were. We also observed a lack of training, and of knowledge and know-how, in visual arts professions, as well as difficulties with and constraints on mobility (for both artists and their work), and the neglect of spaces abandoned by the state.

We continued to investigate these abandoned spaces through an event called El Medreb in September 2016. El Medreb involved us taking over abandoned warehouses in the neighborhood of El Hamma and transforming them into spaces for exchange and artistic expression. This event called for us to research former industrial buildings in Algiers, starting with El Hamma, studying the area's social, architectural, and historical context.

The challenges we saw were also reflected in the policies of the Algerian state, particularly the implementation of the urban planning policy, the Plan Directeur d'Aménagement et d'Urbanisme de la Ville d'Alger (PDAU), and the creation of a national agency for culture, the Agence Nationale de Gestion des Réalisations des Grands Projets de la Culture (ARPC), in 2007. The latter is a public institution devoted to conceiving and setting up cultural infrastructures to provide a springboard for national cultural production. However, the ARPC

1 See the distribution of
budgets across ministerial
departments between
2015 and 2018.

continues to plan and build imposing, often expensive infrastructure, which citizens find difficult to identify with. To wit, most of the structures that have been built have already been deserted by the public.

Consider, for example, the Musée National d'Art Moderne et Contemporain d'Alger (MAMA). The museum was initiated in 2007, in the context of a festival called "Alger, capitale arabe de la culture" (Algiers, Capital of Arab Culture), without consulting Algerian artists at all. Today, the institution claims to be an example of a collaboration with the private/independent sector, which it says is essential for the museum's viability and sustainability. In practice, the institution contradicts this statement, as it has opposed any ideas that would facilitate the museum's supposed goals of servicing the art community and the general public. Indeed, the museum has rejected many exhibition proposals on the basis of a lack of funds, which may be true given the budget cuts to the cultural sector. When solutions and alternatives that would allow these projects to materialize are put forth, the institution clams up, offering only pretexts or vague excuses, which go to show how lax it is about what should be its primary role: promoting contemporary Algerian artists. Since the beginning of 2019, only two exhibitions have been mounted at MAMA: the first was organized and financed by the Dutch embassy in Algeria, the second by the German embassy. These facts are emblematic of how, in the twelve years of its existence, the museum has never had a well-thought-out medium- or even short-term development strategy to support a genuine political will to democratize art.

There is, furthermore, a vast neglected and underused architectural heritage that could be mobilized to respond to the need for creating common spaces for social and cultural gatherings. This could go some way toward meeting the expectations of the artistic community in a sustainable way.

The next step in my experience involved moving from a role in civil society to one in the private sector. In 2017, Myriam Amroun and I cofounded Rhizome, a cultural enterprise that aims, among other things, to accompany Algerian artists on their way to becoming professionals. I experienced some of the challenges private actors face. Our growth was seriously slowed down by the incredible opacity surrounding the procedures and rules set out by the Ministry of Culture to govern cultural businesses. The Ministry of Culture, let's remember, is both the only entrepreneur and the regulator for this sector; its own financial management is incomprehensible, to say the least, and yet it has full authority over these matters.

On the subject of financial management, it should also be mentioned that the Ministry of Culture's budgets have been drastically reduced—by 45 percent between 2015 and 2018.[1] This can, in part, explain the significant decline of funds earmarked for festivals in Algeria, which now receive a tenth of what they used to,

reduced from 5 billion dinars (or around 37 million euros) in 2013 to 500 million in 2017.[2] Without any strategy for promoting cultural activity in the private sector or for encouraging the independent sector, the Ministry of Culture seems to favor a particular image of Algerian art and to be mainly concerned with its international outreach, since it busies itself planning Algerian participation in international events. In 2019, the ministry spent much of their budget on participation in events such as the 28th edition of the International Book Fair in Havana, the 26th Pan-African Film and Television Festival of Ouagadougou (FESPACO), the XXII International Design Triennale in Milan, and the 58th Venice Biennale, where the smallest national pavilion costs between 300,000 and 500,000 euros. The Algerian pavilion at the Venice Biennale was canceled shortly after it was announced, after the indignation expressed in an open letter signed by artists and art professionals and published on social media on March 21, 2019, which referred to "the opacity of the organization, nepotism, favoritism, censorship, abuse of power, and lack of transparency, ethics, and accountability."[3] This case embodies the stronghold certain protagonists have over the sector, acting in ways indistinguishable from the practices of patronage.

The Ministry of Culture is not the only body to lack transparency and operate in a legal vacuum. Some collectors, art spaces, and galleries also practice a form of despotism on which artists are dependent. They have managed to grasp, in a rather malicious way, the frightening lack of information concerning artists' rights and the mechanisms through which artworks are sold. This sometimes turns into a hold over certain artists, who firmly believed in the good intentions of their "benefactors." These artists can become drawn into abusive practices that sometimes go as far as to strip them of their essence, not to mention the various artworks that are subtly taken away, their true value played down by these same executioners of the budding art market who portray themselves as philanthropists.

There are a number of solutions that would allow the visual arts in Algeria to develop if there was genuine political will behind this. It would require, firstly, the state to restrict itself to the role of regulator, rather than also being an entrepreneur, and to be more open to private and independent actors by revising the regulations in place in a way that would free cultural institutions from the strict supervision they currently experience. Not only would this be more efficient in involving the private sector in the financing of the arts, particularly through tax exemption, it would also give cultural institutions greater financial and moral autonomy. Secondly, the state should create academic training programs for artistic professions (arts education, arts administration, and so on) and reinforce the independent sector's capacities (cultural communication, fundraising, administration of cultural and artistic projects).

The popular movement that began on February 22, 2019, has shaken people's habits, and the gust of freedom blowing through Algeria has enabled this independent community to organize and provoke debates in several sectors. For example, the Collectif pour

2 Khelifa Litamine, "Culture: le ministère réduit le budget des festivals de 90%," *Algerie Eco* (January 10, 2019), https://www.algerie-eco.com/2019/01/10/culture-le-ministere-reduit-le-budget-des-festivals-de-90/.

3 See the open letter on Facebook: https://www.facebook.com/lettreouvertedela communauteartistique/.

un Renouveau Algérien du Cinéma is working to set up a platform that could help analyze the situation in film, the Corporation des Musiciens Algériens is doing the same for the music sector, and various open letters, to which I have contributed and helped distribute via social media, are having similar effects in the visual arts. The artistic community would be more active if all these changes were to take place; that would provide a real springboard for the prosperity of the arts ecosystem in this country.

Khaled Bouzidi
Born in Algiers in 1992. Lives and works in Algiers as a cultural manager and cofounder of Rhizome Culture.

Zoulikha Bouabdellah
Perfection Takes Time, 2012
Still from video, color with sound
4:07 minutes

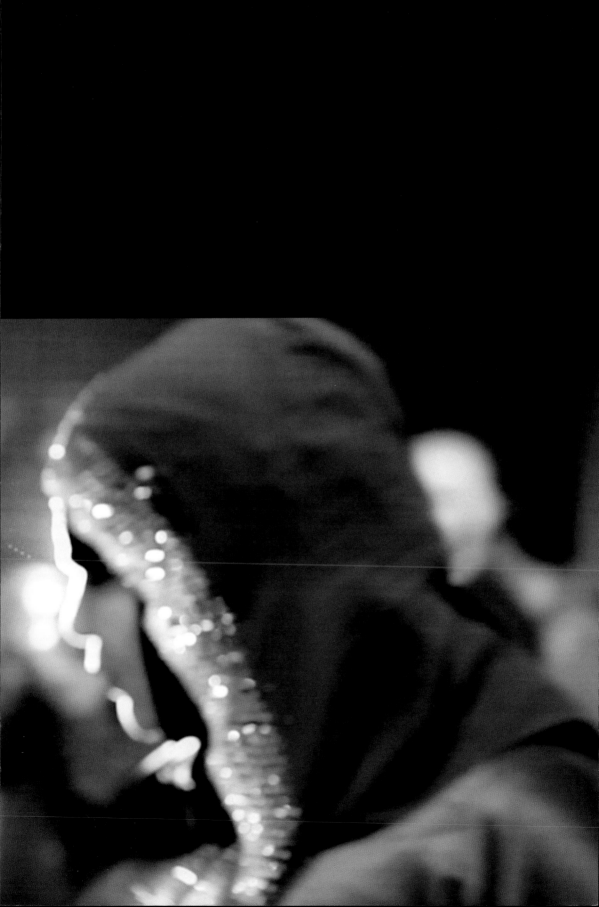

Photographic series,
presented as an
installation

Sofiane Zouggar
"In-Out," 2015-ongoing

I owe Orit Gat an inexpressible debt. This project has entailed leaving New York, the city that made us the thinkers we are, in order to encounter a place which makes both our histories, the ineluctable edges of the Mediterranean. Neither the book nor the exhibition would exist without her. When you hold it, you hold a testament to her rigor.

This project would also not exist without Maya Benchikh El Fegoun. She is forthright in her criticism and also exceptionally generous with her understanding of art in Algiers. This project's complexity is the direct result of her unwavering dedication to the work of her peers.

Khaled Bouzidi and Anna Dasović discussed this project with me in exhaustive depth. Bouzidi's hospitality, his balanced structural analysis, and the care he takes with the integrity of others are all reflected in the intellectual lines sketched here. Dasović's ethical radicalism and her relentless curiosity have deeply marked both my thinking and my ability to convey that thinking to others.

Wish that I could work with a designer of Eider Corral's caliber and intellectual subtlety on every project. I also thank Olivia Custer for her careful translation and expertise, Hannah Gregory for her attention, and Max Bach from Sternberg Press for all his help.

Waiting for Omar Gatlato is built on many hours of conversation. In Algeria, particularly with Mehdi Djelil, Lydia Ourahmane, Hassan Ferhani, Nadira Laggoune-Aklouche, Hellal Zoubir, Daho Djerbal, Denis Martinez, Walid Aïdoud, Wassyla Tamzali, and Myriam Amroun. In France, particularly with Djamel Tatah, Zahia Rahmani, Fayçal Baghriche, Neïl Beloufa, Oussama Tabti, Zineb Sedira, Hélène Quinou, Lotte Arndt, Emmanuel Lainé, Marie de Gaulejac, Céline Kopp, Benjamin Valenza, Arthur Eskenazi, and Madison Bycroft.

I am grateful to Juliette Pollet, Stéphanie Fargier, and Christine Velut from the Centre national des arts plastiques for their support of this work in a different form, and to Anne-Claire Duprat from the Cultural Services of the French Embassy in New York for funding the curatorial research for this project in the French context. I am also grateful to the American Institute for Maghrib Studies for their support of the dissertation project I originally went to Algeria to research and, by virtue of adjacency, for their support of this work as well.

Deborah Cullen called me long-distance from New York to tell me that we got a Warhol grant to make a book. It was late afternoon and I was standing in the shadow of Cathédral La Major in Marseille. I could barely hear her on account of the connection but I heard her joy and what still feels like an inexplicable faith in this project, and for that I will remain grateful to her far beyond this exhibition.

I thank my dissertation advisor
Alexander Alberro for many things,
but especially his belief in the value
of curatorial research in parallel
to traditional scholarship. Thomas
Keenan insisted on the importance
of fieldwork, and that is ultimately
what has produced the depth of
this exhibition. Zoë Strother and
Remi Onabanjo sustained my belief
in the necessity of this intellectual
work in the academy. I also thank
the staff of the Wallach Art Gallery:
Eddie José Bartolomei, Evan Clinton,
Clare Fentress, Sophia Geronimus,
Emily Gross, Stephanie Litchfeld,
Daniel Lopez, Marion Kahan, Lewis
Paul Long, Jennifer Mock, Jeanette
Silverthorne, and Zachary Valdez,
for their collective effort on the
exhibition.

To the artists in the exhibition
and the writers in this catalogue,
I am especially grateful for their
willingness to take this risk,
both with me and each other.

And finally, thank you, Anna.
For getting on so many planes
and on a boat to Algeria with me.

Texts:

The Birth of a Cinematographer:
Merzak Allouache's Omar Gatlato
WASSYLA TAMZALI
　　First published as "Naissance
　　d'un cinéaste : « Omar Gatlato »
　　Merzak Allouache," in
　　En attendant Omar Gatlato
　　(Algiers: En. A.P., 1979).
Translated by Olivia Custer
Reprinted with permission
from the author

History Writing as Cultural and
Political Critique, or The Difficulty
of Writing the History of a
(De)Colonized Society
DAHO DJERBAL
　　First published as "De la
　　difficile écriture de l'histoire
　　d'une société (dé)colonisée:
　　Interférence des niveaux
　　d'historicité et d'individualité
　　historique," *Naqd* Hors-série 3
　　(February 2014): 213–31.
Translated by Madeleine Dobie
Copyright by The Trustees
of Columbia University in the
City of New York
Reprinted with permission from the
author and from *Romanic Review*,
vol. 104, no. 3–4 (2013).

Structures of Reappropriation
NADIRA LAGGOUNE-AKLOUCHE
　　First published as "Structures
　　de la réappropriation," *Rue
　　Descartes, Réflexions sur la
　　postcolonie*, no. 58
　　(Novembre 2007): 111–17.
Translated by Olivia Custer
Reprinted with permission from
the author

View of the Fine Arts: Interview with
Nadira Laggoune-Aklouche
ZAHIA RAHMANI
　　First published as "Vu des
　　Beaux-Arts: Entretien avec
　　Nadira Laggoune," in Zahia
　　Rahmani and Jean-Yves Sarazin,
　　*Made in Algeria: Généalogie
　　d'un Territoire* (Vanves: MUCEM/
　　Hazan, 2016), 209–11.
Translated by Olivia Custer
Reprinted with permission from
Nadira Laggoune-Aklouche and
Zahia Rahmani

The Impact of the Arab Revolutions
on Artistic Production in Algeria:
Between Saving the Local Model and
Denouncing Foreign Interference
FANNY GILLET
　　First published as "L'impact
　　des révolutions arabes sur
　　la production plastique en
　　Algérie: Entre sauvegarde du
　　modèle local et dénonciation de
　　l'ingérence étrangère," *in Arts,
　　médias et engagement: Actions
　　citoyennes et soulèvements
　　arabes*, ed. Fathallah Daghmi
　　(Paris: Editions L'Harmattan,
　　2018).
Translated by Olivia Custer
Reprinted with permission from
the author, editor Fathallah Daghmi,
and series editor Nicolas Pelissier

Images:

Frantz Fanon, an Icon? Thoughts to
See: Fanon's Algeria in the Visual Arts
ÉMILIE GOUDAL
 First published as "Frantz Fanon
 iconique? Pensées à voir, l'Algérie
 de Fanon dans les arts visuels,"
 Perspective, 2 (2017): 211–20.
Translated by Olivia Custer
Reprinted with permission from
the Institut national d'histoire de l'art,
Paris

Seven Little Jasmine Monologues and
Six makeshift trees around my bathtub
SAMIRA NEGROUCHE
 First published as "Sept petits
 monologues du jasmin" and "Six
 arbres de fortune autour de ma
 baignoire," in Samira Negrouche,
 *Six arbres de fortune autour de
 ma baignoire* (Paris: Éditions
 Mazette, 2017).
Translated by Marilyn Hacker
Reprinted with permission from the
author, translator, and publisher

Nawel Louerrad, pages from
Regretter l'absence de l'astre
(Algiers: Dalimen, 2015).
Reprinted with permission from the
artist and publisher

Images by Walid Bouchouchi,
Mourad Krinah, and Sofiane Zouggar
in Fanny Gillet's essay all printed with
permission from the artists

Images accompanying the artist
entries all printed with permission
from the artists

WAITING FOR OMAR GATLATO:
A SURVEY OF CONTEMPORARY
ART FROM ALGERIA AND
ITS DIASPORA

Editor
Natasha Marie Llorens

Managing Editor
Orit Gat

Copy Editor
Hannah Gregory

Design
Eider Corral

Publishers
The Miriam and Ira D.
Wallach Art Gallery,
Columbia University
in the City of New York
615 West 129th Street
New York, NY 10027
USA
wallach.columbia.edu

Sternberg Press
Karl-Marx-Allee 78
10243 Berlin
Germany
sternberg-press.com